MEDIUM-
FORMAT
HANDBOOK
A GUIDE TO ROLLFILM PHOTOGRAPHY

MEDIUM-FORMAT HANDBOOK

A GUIDE TO ROLLFILM PHOTOGRAPHY

Roger W. Hicks

BLANDFORD

For my father, who encouraged me to take photography seriously.

Series editor: Jonathan Grimwood
This paperback published 1989
First published in the UK 1986 by Blandford Press,
an imprint of Cassell plc,
Artillery House, Artillery Row, London SW1P 1RT.

Copyright © 1986 Roger W. Hicks

Distributed in the United States by
Sterling Publishing Co., Inc.,
2 Park Avenue, New York, N.Y. 10016

Distributed in Australia by
Capricorn Link (Australia) Pty Ltd,
PO Box 665, Lane Cove, NSW 2006

British Library Cataloguing in Publication Data

Hicks, Roger W.
 The medium-format handbook.
 1. Photography—Films
 1. Title
 771'.5324 TR283

ISBN 0 7137 2097 2

All rights reserved. No part of this book may
be reproduced or transmitted in any form or by
any means, electronic or mechanical, including
photocopying, recording or any information storage
and retrieval system, without permission in
writing from the publisher.

Typeset by Graphicraft Typesetters Ltd, Hong Kong
Printed by South China Printing Co, Hong Kong

Contents

Acknowledgements

My warmest thanks are due to Colin Glanfield for his continuing support in his and other projects, and for reading and commenting upon the original draft of the manuscript; I should also like to thank Tim Hawkins and Peter Anthony for their contributions of ideas. I must emphasise, though, that if there are any mistakes, they are my own.

I should like to thank the following people — in alphabetical order — for permission to reproduce pictures in this book: Peter Anthony; Ian Desborough; De Vere Ltd; Mike Fear; Colin Glanfield; Hasselblad (UK) Ltd; Tim Hawkins; Johnsons of Hendon; Latiff; May and Baker Ltd; Pentax (UK) Ltd; Photax Ltd; Jan Podsiadly; Promandis; W. Arthur Schultz; Frances Schultz; Stafford Miller Ltd; Matthew Ward; David Whyte.

I am normally suspicious of writers who thank their wives, but I suspect that few are married to such a combination of skilled photographer, first-class photographic printer, meticulous proofreader and patient picture librarian. My deepest thanks, therefore, to Frances Schultz.

I should particularly like to thank J. Osawa Ltd, and their successors Johnsons of Hendon for the loan of Mamiya RB67 and Mamiya 645 equipment, and the following manufacturers or importers for information and assistance: Hasselblad GB; Linhof Professional Sales; Pentax UK; Promandis. Shadowless lighting enclosures, like the one shown on page 168 are available from Matthew Ward, PA-V Ltd, London.

Photographs other than those specifically credited to other photographers are by the author. I should like to thank Fotobank Colour Library International, London, for assistance in retrieving my work and that of Frances Schultz from their files.

TECHNICAL DETAILS

On a technical note, in order to save repetition, Kodak film types are referred to by their Kodak identifications, namely ER (Ektachrome ISO 64) and EPR (Ektachrome Professional ISO 64): Kodak's ISO 100 film (EPN) was only introduced during the writing of this book. The only other colour film that I have consistently used is Agfa's ISO 100

Professional, though I have recently changed to Fuji's ISO 50 material.

In black and white, I habitually use Ilford materials — FP4 (ISO 125) most of all, but also Pan F (ISO 50) and HP5 (ISO 400). Because my enlarger is a diffuse-light type, I habitually develop to a high contrast index (Gamma 0.70), using either Microphen (which gives a speed increase of 2/3 stop when used like this) or Perceptol (which gives a speed loss of 1/3 stop), so the effective film ratings are FP4, ISO 100 or 200; Pan F, ISO 32 or 64; and HP5, ISO 320 or 650. I always print on Ilford materials.

Although camera, lens and film type are given for my own pictures, I have not given exposure details, because I never record them: it may come as a surprise to some readers that in many books the exposure details, film type and even camera and lens details are completely fictitious but are there because people expect to see them. In any case, a good meter, plus experience (which I hope you will get from using this book), is much more use than information about someone else's picture, taken with someone else's camera, in some other place, of some other subject. On the rare occasions that there was any technical data for other photographers' pictures, I have given what information was available to me. I have not given any technical information about pictures taken to illustrate cameras, film loading, etc, as this seems irrelevant, but in the main they were shot with a Mamiya RB67 on Pan F or HP4.

Film speed used to be in ASA for the American index and DIN for the European rating and this was eventually combined as an ISO rating. This meant that a film of 400ASA/27DIN became known as ISO 400/27°. This has now been shortened in everyday use to ISO 400 for a film of 400ASA/27DIN, so, in effect, we are back to ASA rating! This most recent usage has been used throughout this book.

Photo Credits

References to colour photographs are given in **bold**.
Peter Anthony: pp. 185, 187; De Vere Ltd: p. 75 (right); Mike Fear: pp. 130, 132; Colin Glanfield: pp. 25, 37 (right), 116, 140 (twice), 147 (courtesy of), 149 (twice), 152, 153, **175**; Hasselblad (GB) Ltd: pp. 37 (left), 41 (left), 47, 77; Tim Hawkins: p. **167**; Johnsons of Hendon: p. 125; Latiff: pp. **43, 134, 135, 138**; Pentax (UK) Ltd: p. 38; Photax Ltd: p. 89 (left), Jan Podsiadly: p. **143**; Promandis: pp. 89 (right), 92–3; Frances Schultz: pp. **39, 59, 103, 119, 122, 155**; W. Arthur Schultz; p. 11; Matthew Ward: p. 168; David Whyte: pp. 141, 169.

8

PART ONE

1 · Moving up

The debate between the users of 35mm cameras and the users of larger formats is at least as old as the Leica, and probably a good deal older; a dozen years before the Leica's introduction in 1925, the 35mm Tourist Multiple and Simplex cameras were aimed at American tourists who were doing the grand tour of Europe, wanted a light, handy camera for snapshots, while professionals were still using glass plates and making contact prints. Plate-camera users scoffed at 'postage-stamp sized negatives', while 35mm photographers denigrated the stuffy and stiff pictures which were so often taken with the large slow-handling tripod-mounted cameras. The argument between 'miniaturists' and the rest has often been heated and, to this day, you can still find people who will try to persuade you that the 35mm format can equal rollfilm (or even 5×4in or 10×8in) in every way.

There are, however, a number of good reasons for using larger formats than 35mm. The first and most obvious is, of

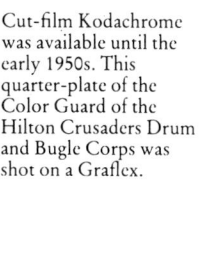

Cut-film Kodachrome was available until the early 1950s. This quarter-plate of the Color Guard of the Hilton Crusaders Drum and Bugle Corps was shot on a Graflex.

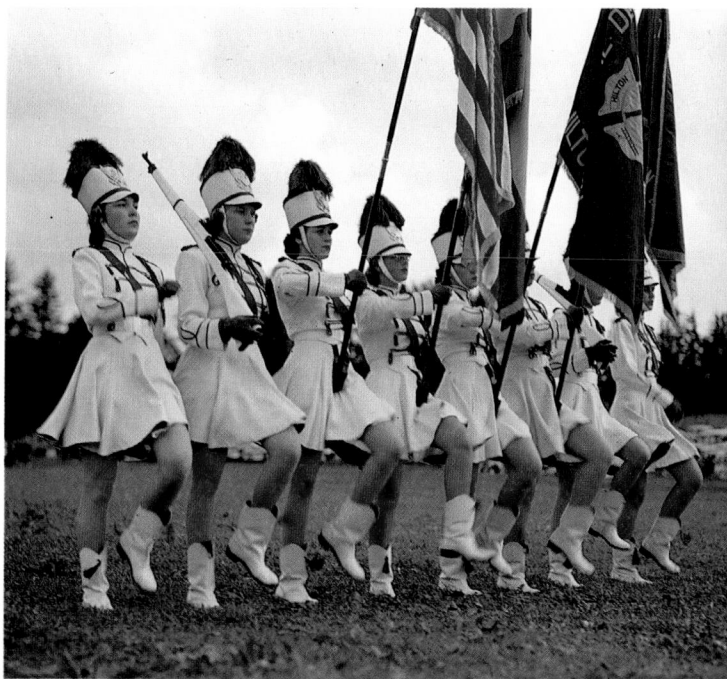

course, quality. The old saying about a good big 'un beating a good little 'un every time is as true now as it ever was; we shall come back to this later.

Secondly, if you want to sell your pictures there is no doubt that a rollfilm transparency is more impressive than 35mm. For a start it is easier to 'read' without a magnifier, and if you watch someone going through a stack of transparencies you will notice that they almost invariably go through the larger ones first.

Thirdly, rollfilm encourages you to live up to the camera; there is always a temptation to use 35mm like a machine-gun, hoping to strike a few lucky hits among all the misses, whereas the increased cost per exposure and the general atmosphere of professionalism of a rollfilm camera means that you are more likely to think about each individual shot. The 'professional' image produced by use of the rollfilm camera also means that you are likely to be accorded more respect by other people, which rarely does any harm!

Fourthly, the cameras themselves are often more durable and less gimmicky than 35mm. Because they are aimed at the professional market, the emphasis is on performance rather than on features, and there is not the endless turnover of new models.

Fifthly, many rollfilm cameras allow the use of a Polaroid Land back for instant pictures, which is invaluable for checking carefully set-up shots; this facility is only available for a very few 35mm cameras and, even then, the

If you find yourself taking this sort of picture, where detail and texture matter, you ought seriously to consider medium format — see next illustration. (Nikon F, 55mm Micro Nikkor: Pan F/Perceptol: printed 'all in')

This is not strictly a fair comparison with the previous shot, because it shows rather more of the surroundings (a locked gate determines the camera position, so that pictures have to be taken through the bars of the gate). It does, however, show the greatly increased detail which is available with rollfilm. *(Mamiya RB67, 90mm Sekor: Pan F/Microphen: printed 'all in')*

24×36mm image is hardly big enough to be of use.

Finally, there are some rollfilm cameras which offer camera movements that are not available on 35mm at any price: not just rising and cross front, which can be (poorly) duplicated by 'shift' or 'PC' lenses, but also front and back swings and tilts, which can be used to control both sharpness and shape of the image, as well as changing apparent perspective.

Of course, there are drawbacks. Rollfilm equipment is undoubtedly bigger, heavier, slower-handling, and more expensive than 35mm. On the other hand, a typical rollfilm outfit is rather smaller than a typical 35mm outfit, with perhaps two bodies and three or four lenses rather than two or three bodies and five or six lenses, so the strain on both your wallet and your shoulder may well be less than you expect. If you are honest about it, then you probably have to admit that the vast majority of your photographic needs are served by two or three lenses, while the more exotic ones are rarely used. If you really do *need* super-telephoto lenses and motor-drives, then of course you should stick with 35mm, as do most professional sports photographers. Do not forget, though, that if you already have a darkroom you may need new developing tanks, enlarger and other accessories if you do change up to medium format.

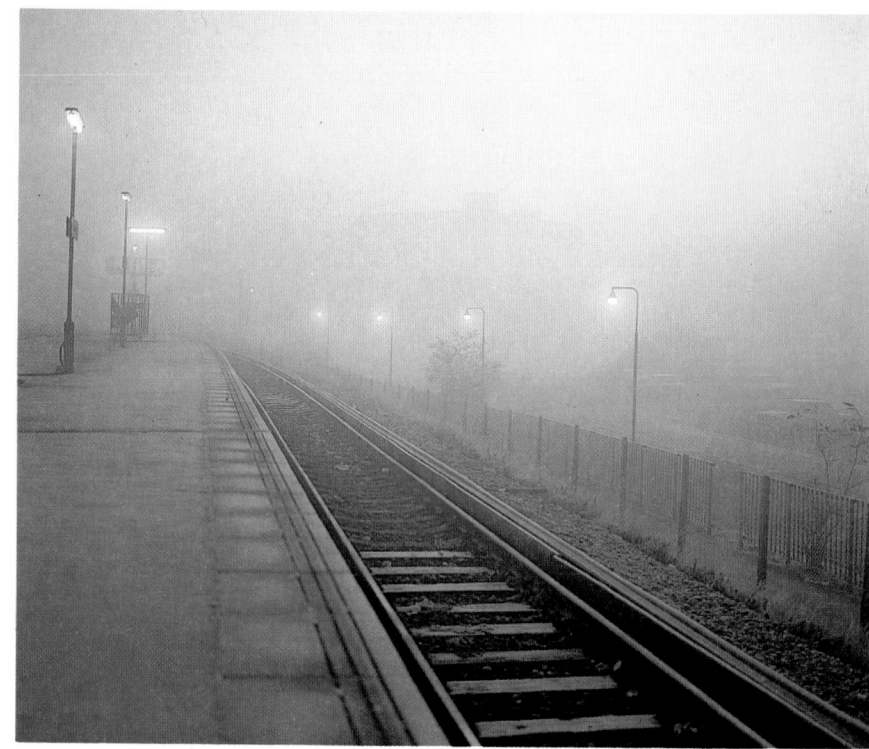

There is also no getting away from the fact that the greater magnification on the film (which is what a larger image size means, though this is not necessarily immediately obvious) means decreased depth of field; so more careful focusing or more stopping down (or both) are the order of the day. Nor can you deny that it is less convenient to have to reload more often; the 36-exposure 35mm load is certainly handier in many cases than having to reload after ten, or twelve or fifteen exposures. If you do need long loads, though, you can always use 220 film (which makes it 20, 24 or 30 exposures) or even 70mm, which allows 50 exposures or more per load.

There are other 'drawbacks' of rollfilm which also turn out to be more apparent than real. For example, rollfilm lenses are often woefully slow by 35mm standards; the usual maximum speed for a 'standard' 80 mm or 90mm lens is f2.8, or even f3.5 or slower, but the increased size of the rollfilm image relative to 35mm means that you can use faster film, and still deliver first-class quality. The only transparency films which can seriously be considered for high-quality 35mm work are Kodachrome and ISO 50 Fuji. Using ISO 200 film with an f2.8 lens is the equivalent of using Kodachrome 25 at f1 or Kodachrome 64 at f1.6. If

It is not always the conventional resolving power of the larger formats which gives them the edge. Here, the bigger transparency conveys the openness and lightness of dawn mist. No filter was used in this picture, which was taken at Reading Station, England. *(Mamiya RB67, 90mm Sekor: ER)*

Trees on the road near the Grand Canyon, Arizona. The resolution and gradation of the larger formats shown here simply cannot be matched on 35mm. *(Mamiya RB67, 90mm Sekor: EPR)*

14

you use ISO 200 film with the fastest rollfilm lenses available, such as the 80mm f1.9 for the Mamiya 645, or the 110mm f2 for the Hasselblad, you would need an f0.6 lens for Kodachrome 25, or f0.9 for Kodachrome 64, to use the same shutter speed. Again, the increased cost of film tends to be offset by the increased care which you take in composition, metering, etc, so that the absolute cost may be very little more, and the cost *per successful exposure* may well turn out to be lower.

It is possible to make out a perfectly good case for using large format cameras, of 5×4in/9×12cm and above; and such cameras are in fact used by many professionals, in formats up to and even beyond the mighty 14×11in of Imperial, Deardorff and De Golden Busch. The trouble with all these cameras is not just that they are expensive to buy and to feed with film; the single-sheet cut-film loading system also makes them slow to use, and very few can be hand-held at all, so they are only suitable for tripod use. They do have their place, and they can certainly deliver superb quality, but they are not so generally useful as their rollfilm brethren. Furthermore, although the image quality obtainable from (say) 5×4in is better than that obtainable from rollfilm, the difference is nothing like so great as that between 35mm and rollfilm.

The trouble with 35mm is that it is right on the border-line as far as quality is concerned. This is not a matter for argument; it can be demonstrated quite easily. The normal size for high-quality original prints is *at least* 10×8in or 18×24cm, which implies about an 8× enlargement of the full 35mm frame. Most people would agree that a 10in/25cm viewing distance was fair for such a picture, and at that distance, the human eye can resolve about 8 line pairs per millimetre (1p/mm). Assuming a *perfect* enlarger lens, this means 8×8=64 1p/mm on the negative. Anything less than a perfect enlarger lens — and any lens is bound to be less than theoretically perfect — will mean that the image on the film must be still sharper, if it is to survive the degradation introduced by the enlarger lens. It is hard to put a figure on this, but 80 1p/mm is the very least which we might look for, while 90 1p/mm would be more realistic. Experiment will show that this is just about the very best which can be achieved in normal use, with first-class lenses and Kodachrome 25 or Fuji ISO 50, while slow black-and-white film may actually allow a small margin of safety at the centre (110 1p/mm or better), though 90 1p/mm at 50% contrast at the edge would still be a major achievement.

If we assume the same reproduction size, the comparable magnifications for rollfilm formats are about 4.5× for

12-on-120 and 15-on-120, and 3.6× for 10-on-120 and 8-on-120. The square 12-on format, and the long, thin 8-on format mean that a certain amount of the film area has to be cropped out in order to fit on the normal rectangular paper, book and magazine formats (though 8-on does have the same aspect ratio as full-frame 35mm, which may endear it to some people).

These magnification ratios require an on-the-film resolution of 36 1p/mm and 29 1p/mm for our hypothetical 'perfect' enlarger lens, or about 50 1p/mm and 40 1p/mm for a realistic system. As 60–70 1p/mm should be readily achievable with any reasonably designed lens, this gives a comfortable safety margin which is completely lacking with 35mm.

In fact, there is even more to it than this. The resolution of colour negative film is notoriously poor, and the faster ones are hard pressed to provide acceptable results at 8×10in from 12-on-120: at 35mm even ISO 100 films have no chance at all, so for professional-quality portraits or wedding photography, rollfilm is essential. And to return to the theoretical side again, you can get a very fair idea of the diffraction-limited resolving power of any lens (at 50% contrast) by dividing the f-stop in use into 1000. It is not hard, therefore, to see that you can only stop a lens for a 35mm camera down to f11 or so before quality begins to deteriorate, whereas you can stop a lens for a 120 camera down to f22 or so before theoretical considerations limit lens performance enough to affect the final image. As almost any modern lens for a rollfilm camera should be diffraction limited by around f11–f16 (in some designs by f8), it is quite feasible for the designer of a rollfilm camera lens to use a less sophisticated lens design, intended to work at a smaller aperture, than would be needed for 35mm. Incidentally, this optical fact of life also accounts for the way in which view-camera lenses are often used at very small apertures: not only does it allow adequate depth of field, but you can stop down to f128 before you have problems with diffraction limits on a 10×8in contact print, or f45 or so before you need to worry about a 5×4in enlargement to 10×8in

There is no doubt that rollfilm is every bit as much a compromise as 35mm — but it is a different compromise, and one which is well worth investigating. A great deal will, of course, depend on the type of photography which interests you. For many photographers, and many types of photography, rollfilm is far better than 35mm, which is why medium-format cameras are so widely used professionally: on the other hand, remember that most professional sports photographers use 35mm rather than rollfilm,

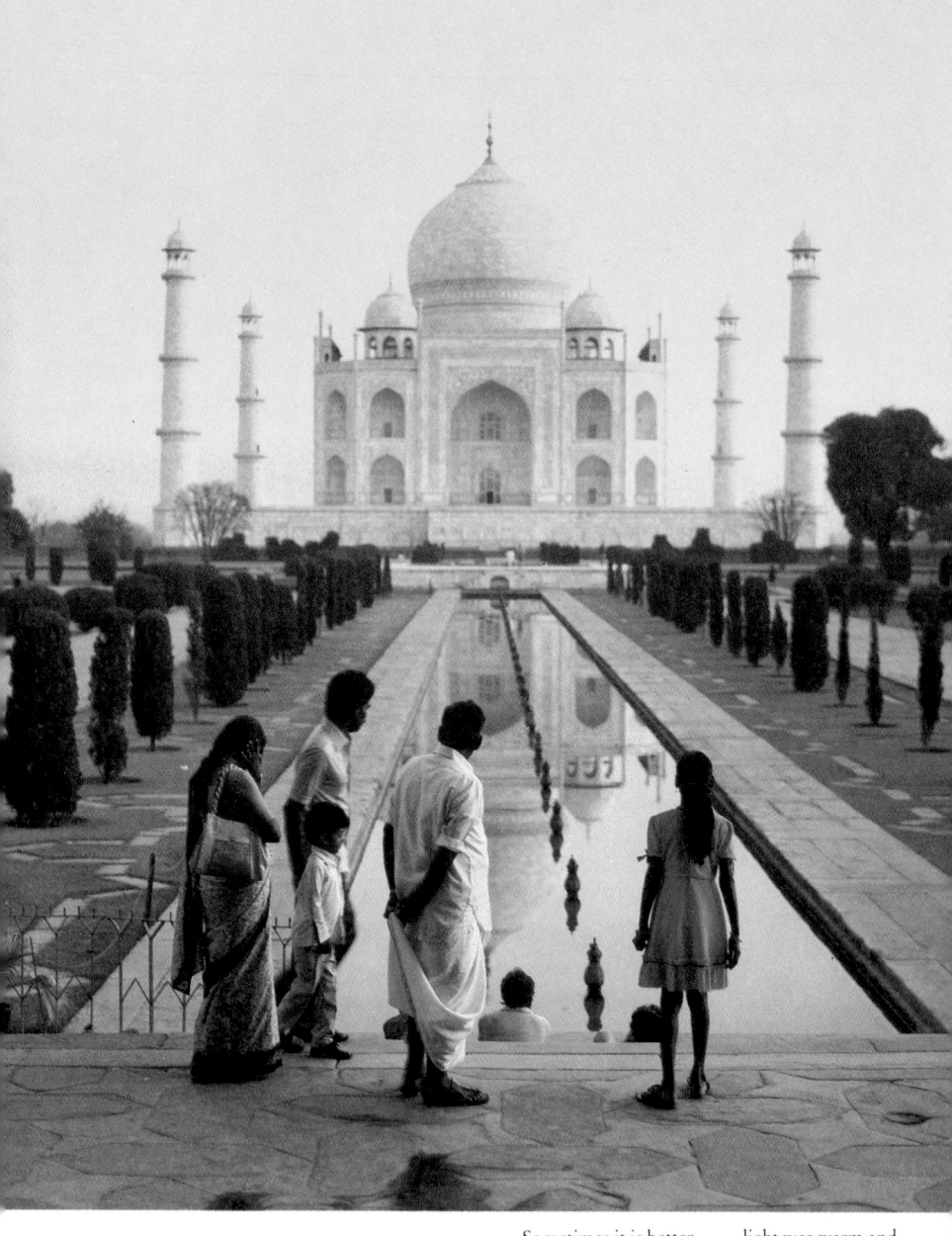

Sometimes it is better to add effects at the duplicating stage, though this is only practicable if you have a first class original. In the original picture the sky was white but the dawn light was warm and coloured both the Taj itself and the figures in the foreground. A graduated effects filter put some colour in the sky and transformed the picture.

and that for certain types of natural history photography 35mm reigns supreme. It may be that you will do best of all to run 35mm and medium-format systems side by side, as so many professionals do, or it may be that you would be happier with an 11×14in view camera than with either 35mm or medium format. But if you are contemplating moving up to medium format, there is no need to be put off by the fear that rollfilm equipment is too expensive or too complicated, or simply too sophisticated for your needs; and if you have already made the decision, you have opened up new possibilities for your photography.

FORMATS

In the bad old days the largest camera size commonly regarded as amateur for taxation purposes was quarter-plate (3¼×4¼in) this seems a reasonable definition of the upper limit of medium format. At the other end of the scale, 35mm is nowadays regarded as the standard 'minia-ture' format, so we may accept that medium format is somewhere between 35mm on the one hand, and 'quarter-plate' on the other.

Much as I hate to disappoint the devotees of Thornton Pickard Ruby Reflexes and other quarter-plate delights, I have to admit that the popularity of quarter-plate is not what it was, and other small cut-film sizes (6.5×9cm, 2½×3½in, etc) are scarcely looking any healthier. Nor are 828, 127 and 620 rollfilm much better placed. In fact, the choice in current production cameras comes down to roughly three and a half options. There is the 62mm wide 120/220 (counting as one and a half options); 70mm perforated film; and instant-picture material.

Of these, 120 and 220 are far the most important for serious medium-format photography. The only difference between the two is that 120 is paper-backed from start to finish and about 32in (82cm) long, while 220 has only a

This illustration clearly shows the disadvantage of leaving film in the camera for too long: in two weeks, this roll of HP5 had acquired a kink which could hardly fail to detract from ultimate sharpness.

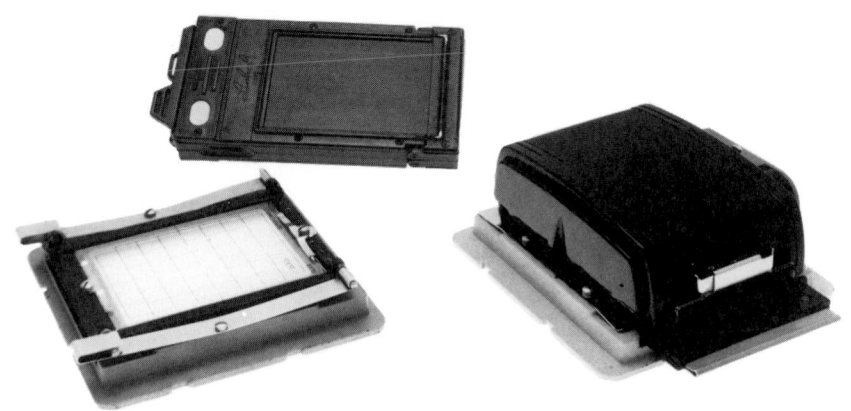

For perfect film flatness cut film is hard to beat, but loading 6×9cm film holders with 9×12cm film cut in half is time-consuming and tiresome. Rollfilm holders, such as this Graflex 8-on-120 model are much easier. Although the format size is nominally 6×9cm, in this case it is actually 58×84mm.

paper leader and trailer, which allows roughly twice as much film to be packed on the same spool. Because of the difference in thickness between the film-plus-paper sandwich of 120 and the unadorned film of 220, some form of interchangeable or moveable pressure-plate is essential, in order to maintain optimum film flatness. Some cameras provide this, others have separate magazines for 120 and 220, and some are 120-only. Although 120 films are still numbered on the back, the old red-window system of film transport is now a thing of the past (except in some communist and third-world countries), and an arrow on the leader is lined up with an index mark in the camera at the beginning, with frame spacing thereafter being automatic. Obviously, unbacked 220 film cannot be used in any camera which relies on red-window frame counting.

Modern 120 cameras do not use the old 'red window'; instead an arrow on the film backing is lined up with a *start* mark in the camera back. The back is then closed, and winding-on and spacing is automatic thereafter. Some Rolleiflexes have an auto-sensor device which 'feels' the extra thickness of the film on the backing paper, but the film leader has to be fed between two rollers.

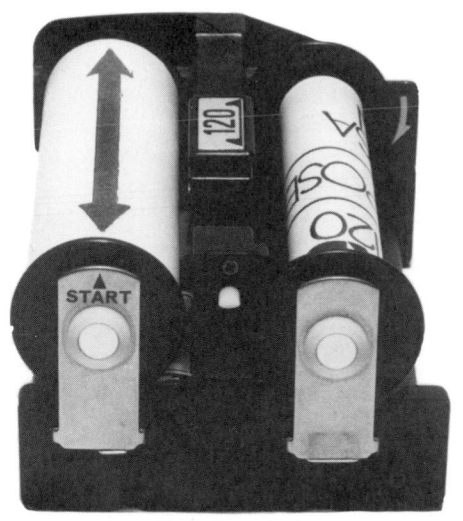

Incidentally, 620 film is the same as 120, except that it is wound tighter on a narrower-diameter spool, which obviously makes a mess of automatic film-counting, and prevents the larger 120 spool being used in most 620 cameras.

Although it offers the potential of very long loads — typically 50 exposures or more for 6×7cm, and 70 exposures or more for 6×6cm — 70mm perforated film is surprisingly little used. The main reasons for this are; the relatively limited range of emulsions available; the unwillingness of most shops to stock 70mm; the fact that you have to load the film yourself into a sort of scaled-up 35mm velvet-lip cassette; the difficulty of getting 70mm film processed; and the increased risk of scratching compared with 220 and (especially) 120. Those who do use 70 mm swear by it, but few even bother to try it and only the major medium-format systems offer 70mm interchangeable backs. Because of the perforations in 70mm film, the maximum image height is about the same as for 120, and formats are usually kept the same, for convenience in enlarging and transparency presentation.

The formats normally used on 120/220 and 70mm film are known by a wide variety of names, including nominal imperial and nominal metric sizes (the imperial sizes are nearer the actual dimensions) and by the number of frames that can be fitted onto 120. They are best shown on a chart:

Nominal size		Actual size	Number of exposures
Metric	Imperial	Metric	on 120
6×9cm	2¼×3¼in	56mm × 82–88mm	8-on-120
6×7cm	2¼×2¾in	56mm × 68–72mm	10-on-120
6×6cm	2¼in square	56mm square	12-on-120
6×4.5cm	2¼×1⅝in	56mm × 40–45mm	formerly 16-on-120; now usually 15-on

The **6×9cm format** is obsolescent, and found mostly in reducing backs for 5×4in. and larger cameras. Its long, thin shape means that it is usually cropped for reproduction, so the effective area is about the same as the **6×7cm** 'ideal' **format**, which enlarges onto common paper sizes and print formats with the minimum of waste, and is the largest 120 format whose area is normally exploited to the full.

The **6×6cm format** really owes its existence to the waist-level finder of the twin-lens reflex. Obviously, an oblong format leads to problems when you want to use it both 'portrait' and 'landscape' (vertical and horizontal). Turning the camera on its side is inconvenient, revolving backs add weight and expense, and pentaprisms add even more weight and expense. In the days when most TLR users shot black and white only, they could crop the square

format to a more pleasing or convenient oblong during enlarging, and some art directors prefer square transparencies to this day because it gives them the same freedom, but most people agree that unless you are used to composing on a square screen, it is something of a disaster area. Furthermore, when the 6×6cm image is cropped for use, the effective area is reduced to the same as that of the 6×4.5cm format.

Although the **6×4.5cm format** is also touted as 'ideal', and does in fact enlarge conveniently onto most paper sizes and publication formats, it does have the drawback that it is only about two-thirds as big as the other 'ideal format', and therefore cannot deliver quite the same quality. A 6×4.5cm transparency also looks much less impressive than 6×7cm or even 6×6cm, though this really only matters when you are trying to sell your work. On the other hand, 6×4.5cm cameras are smaller, lighter, cheaper and handier than most larger format models (though they do need a pentaprism if they are to be used conveniently), they have the advantage of 15 exposures on a roll, and the smaller image area means that faster and more complex lenses are available than for their bigger brethren. The Mamiya 645, for example, offers an 80mm/f1.9 lens, the fastest standard lens available for any rollfilm reflex and easily the most affordable. The modern 15-on format allows considerably more margin around the edge of each image than the old 16-on, which is why it was adopted. The extra room is particularly useful when cutting and mounting transparencies.

There are actually two more formats which are used for panoramic cameras, namely **6×17cm** (4-on-120) and **6×12cm** (6-on-120), but they are very unusual. Both formats were introduced by Linhof, though they have subsequently been copied; the cameras which take these extraordinary pictures are covered at greater length on page 33.

Instant picture materials are little used in serious photography. They are not easily enlarged or reproduced; and if they are enlarged the quality is often poor, although the Polaroid Land pos/neg black and white films can deliver first-class negatives and a useful contact print, at the cost of some loss of instantness (the negatives have to be soaked, washed and dried before they can be used). Some artists have explored instant picture films, attracted both by their immediacy and by the uniqueness of each image, but much of this work has been pretentious and tiresome. Cameras which accept only instant-picture materials are not covered in this book.

Many medium-format cameras are, however, capable of

accepting Polaroid Land backs, and these are very useful indeed for checking exposure, lighting, composition and camera functions. The 'Rolapoid test' is standard practice for many professional photographers, and until you have tried Polaroid testing you cannot appreciate how useful it is. Some cameras give a Polaroid the same size as the actual 120 frame (6×6cm, 6×7cm or whatever), while others give a bigger picture, which is not quite so useful for checking composition (though the picture can easily be folded) but which gives a better idea of lighting and is more useful when an instant picture is the desired end result. In portraiture, or when working with models, or as a means of producing 'thank-you' pictures when travelling, instant-picture backs can be invaluable.

THE ROLLFILM SLR

The rollfilm single-lens reflex is the most widely-used type of medium-format camera, but it is important to remember that there are several different kinds of rollfilm SLR. On the broadest analysis there are the 'giant 35mm' types and the cuboid or box-form types.

The 'giant 35mm' strain, of which the best-known production model is probably the Pentax 6×7, traces its ancestry back to the Reflex-Korelle, the Noviflex and the Karma-Flex of the 1930s. Without a pentaprism, these cameras are fairly inconvenient, but with some form of eye-level viewing they are fast-handling and have many adherents. Because eye-level viewing is the natural way to use these, the 6×7cm format is probably ideal and there are no problems with turning the camera on its side, as there would be with a waist-level finder.

They do, however, have a couple of drawbacks. To a certain extent they trade on the average photographer's familiarity with 35mm, but it is a matter of common experience that a proven design does not always work when scaled up or down. To be blunt, some people find them too big, too heavy and too awkward. This problem is made worse by the sheer mass of glass needed in a pentaprism big enough to cover a rollfilm focusing screen — though most 'giant 35mm' SLRs do their best to overcome this by making their pentaprisms undersize, so that there is an enormous 'safety margin' all around the edges of the film. Sometimes this is an advantage, but more usually it is the opposite. Secondly, although interchange-able lenses are no problem, interchangeable backs are either impossible or so difficult that they are not worth the effort. Anyone who has tried to use a Polaroid Land back on the big Pentax will endorse that view.

The cuboid variety, on the other hand, is usually more than a little inconvenient to use at eye-level unless some kind of grip is added, or unless the body is designed from the start to use with a pentaprism, as in the case of the Pentax 645, the Mamiya 645 or the Bronica GS1 6×7. Even then, it is only the smaller, lighter 6×4.5cm cameras which can conveniently be hand-held at eye-level. The sheer weight of most of the others cries out for either a tripod or a chest-level grip, supported by the camera strap. And unless they are used at eye-level, the problem of using rectangular formats for both vertical and horizontal format pictures again raises its head. Apart from using some form of erecting prism or mirror system, the only way to get around this is to provide a revolving or reversing back, (which is what the Mamiya RB67 and RZ67 do) or to revert to a square format — which, as we have already seen, has its own drawbacks.

The advantages of the cuboid system are equally clear. To begin with, the provision of interchangeable backs is normally very easy indeed. The Hasselblad, the first modern rollfilm reflex showed the way. And when used on a tripod or at waist-level, most of these cameras handle superbly, though some seem better suited to hand-held operation (eg Hasselblad), some are happier on a tripod (eg Mamiya RB67, Rollei SL66), and only a few such as the Rollei SLX seem equally at home both ways. Most cuboid

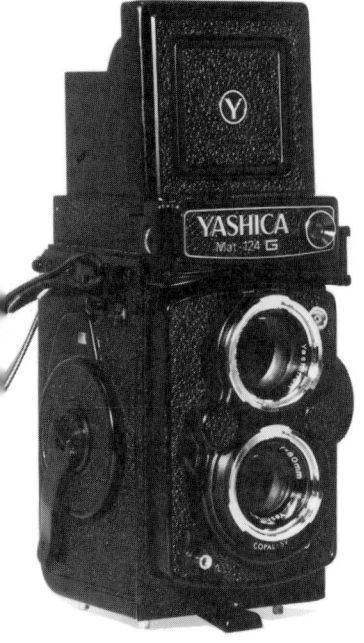

Although medium-format SLRs are the most widely advertised type of rollfilm camera, TLRs like this Yashica are unbeatable value for money and produce pictures at least as good as most SLRs. The Plaubel Makina, which folds down to the size of a thick paperback book, is ideal for most travel applications.

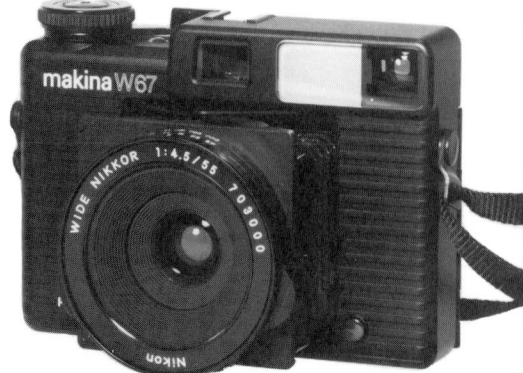

cameras are of all-metal rigid construction, though the RB67 and SL66 use bellows for focusing, which makes them bigger and heavier but also makes for easier close focusing. The SL66 also has the unique feature of a (limited) front tilt facility; the use of camera movements is discussed in the chapter on *Architecture*.

There is, however, another major consideration when choosing a rollfilm SLR, which is the type of shutter fitted. Some rollfilm SLRs have a leaf shutter built into each lens, while others have a focal-plane shutter. At first sight, the focal-plane shutter would seem to have all the advantages. There is not the expense of buying a new shutter every time you buy a new lens; the speed range of the shutter is usually appreciably greater (a genuine $\frac{1}{1000}$ or even $\frac{1}{2000}$ instead of a dubious $\frac{1}{500}$ which is actually nearer $\frac{1}{350}$); the lenses can be faster and often focus closer because they do not have to be fed through leaf shutters; the design of the camera itself can be simpler because it does not need so many complex linkages to the lens; and the response time between pressing the button and taking the picture is often quicker, because it is merely a matter of raising the mirror and firing the shutter rather than closing the leaf shutter, raising the mirror, opening the auxiliary shutter (which protects the film during viewing and when lenses are being changed), and then firing the leaf shutter. Against this should be placed the fact that many rollfilm reflexes are used in the studio, with electronic flash, and here the ability of the leaf shutter to synchronise at all speeds instead of being restricted to $\frac{1}{90}$, $\frac{1}{60}$ or even $\frac{1}{30}$ or slower may be an overriding consideration. Leaf shutters are also invaluable for synchro-sun lighting (fill-in flash), which is mostly how I use flash. A couple of minor advantages to leaf-shutter designs are the faster response time after the pre-release has been used — as described below — and the fact that the simple body design means that even if one leaf-shutter lens packs up, you can usually fit another and carry on working, whereas if the focal-plane shutter goes, you need a spare body. All focal-plane cameras offer at least one leaf-shutter lens in their line up to meet flash-synch requirements, but at the time of writing only the Hasselblad 2000FC/M allowed the use of both F-series (shutterless) lenses and C-series (leaf-shuttered) lenses on the same body, which was equipped with both a focal-plane shutter and all the necessary linkages for leaf-shutter lenses.

In practice, unless you do use flash, the type of shutter is unlikely to matter much; it is a personal decision whether you need the faster lenses and higher shutter speeds, or the flash synchronisation. I find that I rarely need the flash synch, but that I need the other features even more rarely,

The sheer information storage capacity of a 6×7cm negative is impressive; a 35mm shot would look much softer. On the other hand, carrying a Mamiya RB67 outfit up the towers of Notre Dame is fairly hard work! *(RB67, 90mm Sekor: ER)*

so I prefer the leaf-shutter cameras; but if someone gave me (say) a Rollei SL66, I most certainly would not turn it down!

The type of camera which you choose will have a great deal to do with what type of photographer you are, and with the type of photography that you do. There is no doubt that the two different styles each promote a different way of seeing: the eye-level immediacy of the 'giant 35' is very different from seeing the image down there on the

27

ground-glass of a cuboid camera, which is much more conducive to a contemplative and considered style of photography.

This does not always work in the way you might think. To take the example of portraiture, a waist-level finder actually allows you to establish *better* contact with your subject, because you can make eye-contact in the usual way instead of squinting through a camera, and because you can appear to be paying more attention to him (or her) than you are to your camera. Before you decide on the camera you want — and there is more advice on buying cameras at the end of this chapter — you should not only try out the cameras you think you might like; you should also try your hardest to visualise just how you would use those cameras for the sort of photography you do, which is why the second part of this book is devoted to the practical application of medium-format cameras.

It will already be clear which way my prejudices run, and I make no apology for them. I have owned Hasselblads, and while they are beautifully-made cameras producing the ultimate in image quality, I simply do not like using the square format; I feel exactly the same about the Rollei SL-series, though I must admit I have never owned either an SLX or an SL66. I have used the Pentax 67, but was never happy with that eye-level system and found the camera inconvenient without a prism; for the kind of photography where immediacy is all, I prefer 35mm. My wife has a Mamiya 645 system, and although it has some marvellous lenses — she has the 35mm/f3.5, the 80mm/

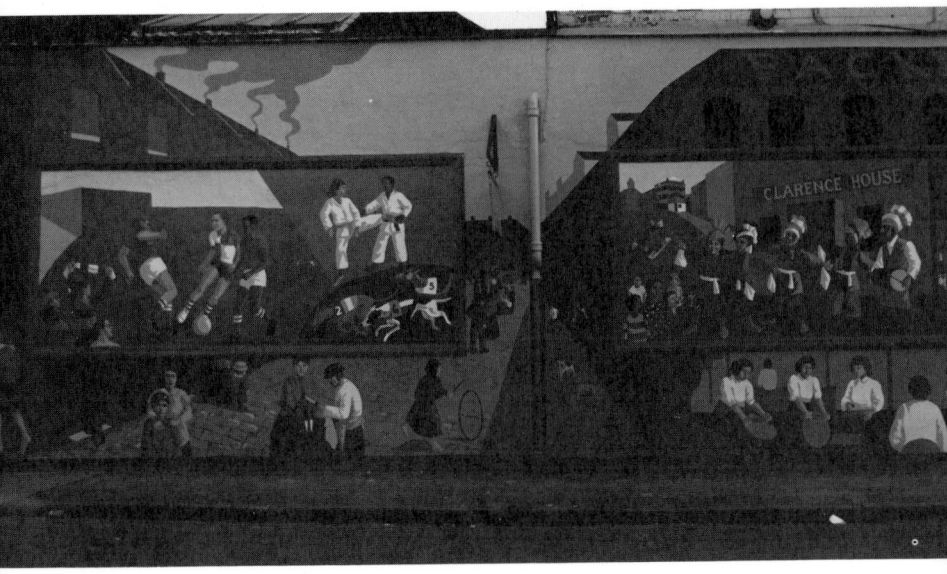

f1.9, and the 150mm/f3.5 — I just prefer the larger format. The Bronica GS1 might tempt me, but it came out after I got my RB67, and, in any case, I prefer the reversing back and waist-level viewing of the older camera, as well as the effortless close-focusing ability; I was always running out of focusing movement with my Hasselblad. As an aside, the adoption of the cuboid shape for the Pentax 645 might be seen as a tacit admission of the shortcomings of the 'giant 35' design of the big Pentax — though photography would be the poorer if the 67 were discontinued.

It may also be important whether the camera you choose is electronic or mechanical. Electronics provide greater reliability and greater accuracy — but if they do fail, they usually fail totally and can only be repaired by the manufacturer or by a few authorised repairers in the world's bigger cities. I travel a lot, and the relatively unsophisticated design of the all-mechanical RB is a major advantage, especially in third world countries where I can, at a push, rely on the local watchmaker.

A third consideration must be whether or not you actually like the camera. We all work in our own ways, and we all have our own requirements. I would not want to use my RB67 for action photography, for example, and if my interests ran that way I would much prefer a big Pentax, a Mamiya 645 or a non-reflex camera. As an aside, one drawback with any big reflex is the sheer length of time between pressing the shutter release and actually taking the picture. With a non-reflex camera of any format, this is usually well under 1/60 second. With a manual 35mm reflex

This picture is reproduced from the central strip of a Mamiya RB67 negative, an area perhaps 22×68mm. This 'panoramic' format is about as wide as 35mm, but nearly twice as long; it also illustrates that unless you shoot a lot of panorams, you might do better to mask down 120 than to buy a special 35mm back. *(50mm lens: Pan F/Microphen)*

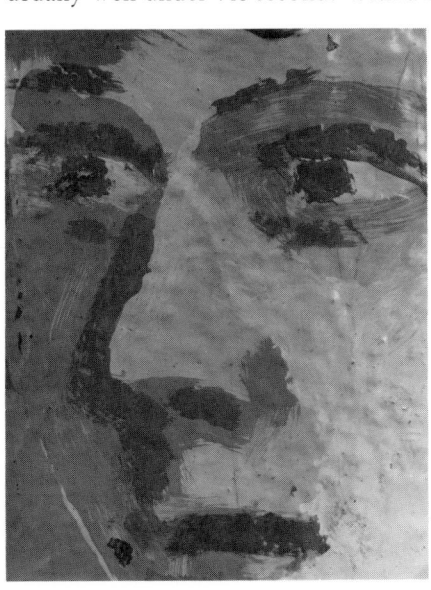

Taken with the same camera and lens as the previous picture, without any additional close-up equipment, this is a detail of one of the faces in the mural. It shows the advantage of the bellows system of focusing on the Mamiya RB67.

it is typically ¹⁄₅₀–¹⁄₆₀ second, with an auto-exposure 35mm reflex it can be ¹⁄₃₀–¹⁄₅₀ second, and with a rollfilm SLR it can be of the order of ¹⁄₁₀ second. Several rollfilm reflexes offer a 'pre-release' which lifts the mirror, stops down the lens, and (in the case of leaf-shutter reflexes) closes the shutter which has hitherto been open for viewing. Then, the response time of the camera is the same as a non-reflex.

I am indifferent to built-in meters and personally prefer a hand-held Weston Master and an incident light reading, but if metering is important to you, something like the Mamiya 645 or the Rollei SLX or SL6006 may suit you better. The rapid-action motor drive of the SLX/SL6006, and the motor-driven multi-exposure facilities, may also be a major consideration for some — I would love to own one for just these features. It is a terrible mistake to be persuaded by a pundit to buy some camera against your better judgement; but it is also a terrible mistake not to at least listen to the voice of other's experience, even if you decide not to heed it.

OTHER ROLLFILM CAMERAS

Although the rollfilm SLR is undoubtedly the most versatile type of rollfilm camera, it would be foolish to equate versatility with suitability for a particular purpose. A family estate car may be a marvellous compromise for everyday life, but it cannot hold its own against a racing car on the circuit, or against a four-wheel drive across a ploughed field. It is also true that rollfilm SLRs are expensive, and that you may well be able to get something which suits your needs at a much more modest price.

These two pictures show the camera positions used for the previous two pictures. You can see that the lens-shade had to be removed for the second picture, because it also shaded the subject. I then forgot to replace it for the second shot, although it was used when taking the picture of the mural. I am a great believer in lens shades!

Twin-lens reflexes (TLRs) are an obvious choice if you want to save money, and it is astonishing just how versatile these old cameras can be. It is true that they do not have interchangeable lenses, except in the case of the Mamiya C-series, but the standard 80mm lens can cover an enormous range of requirements, and you can buy a new Yashica twin-lens reflex for less than the price of a rollfilm back for many system SLRs. Most TLRs are enormously strong, and because there is no 'flipping mirror' there is virtually no delay between pressing the release and taking the picture. Many professionals agree that if they had to earn their living with only one camera, something like a Rolleiflex 3.5F or a Yashica would be their choice; I am particularly fond of my MPP Microflex, a British copy of the Rolleiflex which out-performed the original when it was introduced in the 1950s. Unfortunately, I cannot wax as lyrical as some, because I find the right-hand film crank/shutter wind and the left-hand focusing knob which

are typical of the better TLRs extremely inconvenient; but I still wouldn't get rid of my MPP, because I *know* that it will always provide a reliable back-up if all else fails (mercifully, it never has). Second-hand TLRs can be bought very reasonably indeed, but do make sure that you get a fairly recent model: some camera stores do not bother to distinguish between different types of TLR, but charge as much for a clapped-out Rolleicord with an uncoated lens as they do for a Rolleiflex 3.5F. Also make sure that you have a camera on which shutter cocking and film wind are coupled: on Rolleicords and Microcords, the shutter has to be separately cocked, which can be a terrible nuisance.

Technical cameras are among my personal favourites and in my opinion they are incredibly underrated. These are baseboard cameras with bellows, focusing and absolutely no idiot-proofing. Shutter cocking, film wind and protective darkslide for the back are totally non-interlocked, and there is nothing except discipline to stop you making either double exposures or non exposures! On the other hand, you can set up these cameras on a tripod and make full use of the camera movements (rising and cross front, front tilt and back swings and tilts — see Chapter 8) to provide all the control you would normally require from a monorail, or you can hand-hold them and use the coupled rangefinder for action, reportage and many other kinds of photography. The camera bodies are frighteningly expensive new (though buying used kit can make a great difference), and backs are not cheap, but lenses are usually much cheaper than for reflexes, and occasionally you can pick up an outfit (body, 65mm/105mm/180mm rangefinder-coupled lenses, and a couple of rollfilm backs) at an amazingly low price, because so few people are aware of the potential of these cameras. I use a Linhof Technika 70, and my wife has my old Super Technika IV, and the results on 6×7cm (you can also get 6×9cm backs) are second to none. Linhofs are undoubtedly best, though you can also find 2½ × 3½in 'Baby Graphics' second hand, and the small Horseman technical cameras are also available new (but don't bother with the Horseman Polaroid Land back). A great advantage of the Baby Graphics, incidentally, is their very light weight, which is a result of their wooden construction.

Pursuing the same general line of thought, **medium-format monorails** are a bit more specialised (are rare and alarmingly expensive!) but once again Linhof makes a superb model, and others such as the Arca-Swiss are well worth considering if you regularly need plenty of camera movements. **Large-format cameras** with rollfilm backs are another possibility; they are often cheaper than 6×9cm

models, and give you the option of shooting 5×4in as well, though they are of course larger and heavier than their medium-format counterparts.

You may also find it worth investigating **rigid-bodied cameras.** Interchangeable-lens models include the Koni-Omega/Omega-Rapid and Mamiya Press, which do not offer any movements but can be superb when hand-held, and accept rangefinder-coupled lenses from extreme wide-angle to fairly long telephotos; technical and monorail cameras are fine in the wide-to-medium-tele range, but tend to run out of steam after about 180mm. The main drawback with these cameras is that they are bulky and somewhat awkwardly shaped, which can make it difficult to pack them conveniently. Among fixed-lens cameras, there are the Fujica GS670 'giant Leicas', rangefinder cameras with 90mm and 65mm lenses, and the oddly-shaped and very expensive Linhof 220.

A camera type which has made something of a comeback in recent years is the **rollfilm folder,** several of which now incorporate meters, including the Fuji 6×4.5cm model, which works on the familiar baseboard principle, and the superb Plaubel Makina 6×7cm, which is a 'doppel-klapp-kamera' in which the front and rear standards are supported by scissors-type struts. Plaubels are expensive, but the quality from the fixed Nikkor lenses has to be seen to be believed; there is a choice of an 80mm/f2.8 and a 55mm/f4.5. Older rollfilm folders are not usually a good idea for several reasons. Uncoated lenses (and even some of the simpler coated ones) tend to give a flat, flary, bluish image; viewfinders are mostly awful, though a good accessory finder from a 35mm rangefinder camera can transform this (a 105mm lens on 6×9cm is well served by a 5cm brightline Leitz finder); ergonomics are rarely impressive; red-window film advance is infuriating; and rigidity may not have been good when the camera was new, and it is not going to have improved over the years. There are, of course, noble exceptions: such cameras as the Ensign Selfix 820 and the later Super Ikontas (especially the 6×6cm models) have good lenses, automatic film advance locks, and rigid front standards.

Finally, there are several kinds of **specialist cameras** which just may be what you were looking for. We have already mentioned the 6×12cm and 6×17cm Linhof Technorama panoramic cameras. The 6×17cm has a fixed 90mm/f5.6 Super Angulon, while the 6×12cm model can be fitted interchangeably with a 65mm/f5.6 Super Angulon or a 135mm lens. The latter gives a much more normal perspective but retains the panoram-style format. Fujica also make a 6×17cm camera, albeit with a 105mm/f8 lens

instead of a 90mm/f5.6, which is rumoured to be somewhat more robust than the Linhof version, if not quite capable of the same image quality when properly set up. These cameras are not just useful for panoramic photography and for taking pictures which can be run across a double-page spread: they also provide a sort of 'instant rising front' by the simple expedient of discarding the lower half of the picture. Negatives from the 6×12cm version can be printed in a 5×4in/9×12cm enlarger, and those from the 6×17cm camera require a 5×7in or 13×18cm machine.

Another kind of ultra-wide camera comes from Plaubel, a rigid-bodied 6×9cm model with a fixed 47mm Super Angulon — about the equivalent of 19mm on full-frame 35mm, with the added advantage of some camera movements to boot — and Fuji make two wide-angle models based on the folder already mentioned. You may even be able to find an Envoy wide-angle, a venerable but still usable wide-angle box camera which accepts both rollfilm and plates (make sure that you get the rollfilm insert).

Going from the wide to the long, there are several kinds of aerial camera, which are available either new (at crippling prices) or sometimes second-hand from your friendly neighbourhood government surplus store. Most of these are set for infinity focus only, but if aerial photography is your thing these are worth looking for. Believe it or not, there are still some of the old-fashioned swinging-lens panoramic cameras around which take 120 film; these really are specialised and may require a certain amount of tender loving care to get the best results, but there are some photographers who love them. When checking out any unusual rollfilm cameras, *do not* take the vendor's word that they accept 120: always test them first, because there is a whole forest of other film sizes which are no longer available.

3 · Lenses for Medium-Format Cameras

Anyone who is used to 35mm will immediately notice two things about the range of lenses available for medium-format cameras. First, the range of lenses is considerably smaller, and second, the lenses that are available are mostly a good deal slower. The reasons for this are not hard to find. To start with, it is always easier to design and construct a lens to cover a smaller format rather than a larger one; this automatically means that fast and exotic lenses which are just about feasible for 35mm would be prohibitively expensive for a larger format. Also, lenses for rollfilm cameras are necessarily of longer focal length than lenses covering an equivalent angular field on 35mm. While it is feasible to make a 50mm/f1.4 lens to cover a 24×36mm frame, a 105mm/f1.4 lens for 6×9cm would be huge and unwieldy, and would probably not cover the whole field anyway; you would need to go to something like a 135mm/f1.4, which would have a front glass four or five inches in diameter, cost a fortune and weigh a ton. Such lenses can be made — but not economically, and no-one would want them anyway. Finally, as has already been pointed out, there are some areas where rollfilm does not seek to compete with 35mm, which accounts for the lack of specialised sports lenses that make up so many of the 'glamour bottles' from Nikon and Canon.

Although it is impossible to compare rollfilm lenses (except for 6×9cm) directly with 35mm lenses, because of the different shape of the format, the following rough guide may be useful, with the nearest commonly available focal lengths quoted:

35mm	6×4.5cm	6×6cm	6×7cm	6×9cm
21mm	35mm	40mm	50mm	50mm
28mm	45mm	50mm	58–65mm	65mm
35mm	50mm	60mm	80mm	80mm
50mm	60mm	90mm	105mm	127–135mm
90mm	100mm	110mm	127–135mm	180mm
135mm	180–200mm	200–250mm	250mm	250–300mm
200mm	250–300mm	300mm	360mm	360–480mm
500mm	750–800mm	800mm	1000mm	1000mm

STANDARD LENSES

Traditionally, the focal length for a 'standard' lens was

35

roughly equal to the diagonal dimension of the negative which it was to cover. When the 35mm camera came along, lens designers increased the focal length of the standard lens a little, because that made it easier to cover the format sharply, especially with a fast lens. Consequently, although the standard focal length for 35mm would be about 43mm by the traditional rules, rather longer lenses — of 50mm and even 55mm — became the norm and a lens of 35mm became a wide-angle.

With the slightly slower designs typical in rollfilm lenses, the old convention has been more closely followed. The theoretical standards for 6×6cm and 6×9cm respectively are about 80mm and 105mm, and these were in fact the focal lengths normally used. As a result, anyone who is used to 50–55mm standard lenses on 35mm may well find that the standards in medium format are more like modest wide-angles. In 6×7cm, the situation is different again: some manufacturers offer 80mm lenses, some 90–95mm (the theoretical standard), and some 100–105mm; there are also a few 'long standard' lenses, such as the 100mm for the Hasselblad and the 127mm for the Mamiya RB67, so a fair degree of confusion reigns. With 6×4.5cm cameras, the lenses are a little longer than you would expect, for the same reason as in 35mm; thus, the standard is usually 80mm, though some cameras offer 70mm lenses (the theoretical standard).

The fastest standard lenses for medium format are usually around f2.8 for all formats, though there is an 80mm/f1.9 for the Mamiya 645 and the 90mm Super-Takumar for the Pentax 6×7cm is a scorching f2.4. There are a few fast long standard lenses, such as the 110mm/f2 Planar for the Hasselblad (at a price!), but there are also some rather slower lenses such as the 90mm/f3.8 and 127mm/f3.8 for the Mamiya RB67. As has already been mentioned, this lack of speed is not necessarily the drawback it seems; ISO 200 transparency film at f2.8 requires the same shutter speed as ISO 50 film at f1.4, and rollfilm Royal-X Pan at ISO 1250 probably delivers the same quality as 35mm Tri-X at ISO 400.

Unlike 35mm photography, where many people prefer to discard the 50/55mm standard lens for a wide-angle, the standard in medium-format is likely to prove the single most useful lens. After all, it is half-way to a wide-angle anyway, in 35mm terms. Standard and long standard lenses are also the only hope if you want any sort of speed. You may also have the choice of slightly slower standard lenses which allow even higher image quality than usual; Hasselblad's 100mm/f3.5 Planar is even better than the 80mm/f2.8 Planar, rather in the way that Nikon's 55mm/f2.8 Micro

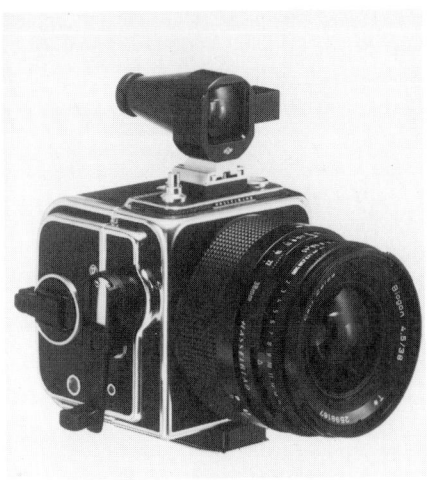

Any lens throws a circular image which deteriorates in quality towards the edges before 'running out of coverage' altogether.

This shows the coverage of a 150mm Symmar on a sheet of 10×8in film: a medium-format camera would only use a fraction of this coverage.

The Hasselblad SWC/M, with its fixed 38mm Zeiss Biogon and its non-reflex viewing, is generally agreed to give sharper, contrastier pictures than any reflex can give.

Nikkor is the sharpest in their range of standard lenses for 35mm.

With lenses for technical cameras, and other cameras having decentering lens movements, you have also to consider *covering power*. As a rule, the slower lenses have better covering power than the faster ones. The 100mm/f2.8 Planar, for example, allows only about 1cm of movement off centre, whereas the 100mm/f5.6 Symmar allows 3–4cm, according to aperture (the more you stop down, the greater the covering power of any lens, until mechanical vignetting by the lens mount provides the ultimate limit). There is no real way around this; I have both lenses for my Technikas, one for speed and one for movements!

WIDE-ANGLE LENSES

The realm of wide-angle lenses for medium-format cameras is something of a jungle. There is little doubt that the very best lenses are non-retrofocus designs such as the Super Angulon and the Biogon, which is why Hasselblad sell both a 40mm/f4 Distagon for their reflex and a complete non-reflex body-plus-lens unit with the 38mm Biogon (the SWC/M). The reason is not the 2mm difference in focal length, which is hardly significant, but the higher contrast and greater sharpness of the Biogon.

On the other hand, reflex viewing allows the picture to be composed right to the edge, which is much more difficult with any optical finder, and very difficult indeed with the awful finder fitted to the SWC/M. Furthermore, although retrofocus-construction lenses are very much more expensive to manufacture than non-retrofocus designs, the demand for the reflex-fitting lenses is usually

greater, which helps to bring the price down: for example, a 50mm/f4.5 Mamiya-Sekor for an RB67 was at the time of writing very similar in price to a 65mm/f8 Super-Angulon for a Linhof. To cap it all, the considerably greater effective area of the 6×7cm format means that you can get away with significantly poorer resolution than you could with 6×6cm or 6×4.5cm, so even if the 50mm Mamiya-Sekor is not quite as sharp as a 38mm Biogon, the results as reproduced are likely to be at least as good. The Mamiya lens, incidentally, uses manually-adjusted floating elements to achieve a surprisingly high performance for such a fast reverse-telephoto design, a feature which is also found on the latest 40mm Hasselblad Distagon.

Your choice of wide-angles will depend not only on the sort of work you do but also on the format you choose and the focal length of your standard lens. With a 6×7cm camera and a 90mm standard lens, you may well find that a 50mm wide-angle will be all that you need, because you can always crop the image slightly if you want the effect of, say, a 65mm lens; if you choose the long standard 127mm lens for the Mamiya RB67, on the other hand, you may find the gap between the two lenses too great, and decide to opt for a 65mm alone, or even a 50mm plus the comparatively cheap 90mm lens. With the 6×6cm format and an 80mm standard, you have three choices: to decide between a modest wide-angle (60mm) and an extreme wide-angle (40mm), to go for a compromise (50mm), or to buy two or more lenses. Alternatively, some people find that they get on best with a 100mm long standard and a 50mm lens. When it comes to 6×4.5cm cameras, especially with the 80mm standard (which is rather long), you really do need two wide-angles for real versatility, probably a 55mm and a 35mm — though there are other possibilities, such as using a 45mm compromise, or even buying a 70mm or 110mm standard lens and combining it with some other wide-angle option.

Even such an excellent lens as the 35mm/f3.5 for the Mamiya 645 is prone to flare when pointed into the sun. Wide and fast lenses (and especially wide, fast lenses) are the worst affected.

The big Pentax is very well supplied with long-focus lenses, which makes it a natural for sports and wildlife photographers.

With technical cameras you really do need to consider covering power when it comes to wide-angles. The 65mm Super-Angulon is almost certainly the best all-round wide-angle lens currently available, because of the considerable movement it allows on 6×7cm and even 6×9cm, even if the angular coverage on the film does not seem too great. The old Angulon was at least as sharp and contrasty, but allowed only about a centimetre of movement, and really needed to be stopped down to f16–f22 for optimum performance. The 53mm Biogon and 53mm Super Angulon, now both sadly discontinued, allowed an even wider angle of view and considerable movement as well, and an f4.5 maximum aperture; good, used examples are a rare and valuable find. The 47mm Super-Angulon is certainly wide, but allows no movement at all, and if you decide to get one make sure that you get a Linhof-tested version (in an engraved shutter) for best performance. There are also wide-angles from other manufacturers, including Rodenstock's Grandagon, various Nikkors, etc.

LONG-FOCUS AND TELEPHOTO LENSES

It is among the telephotos, and particularly among the extreme telephotos, that the lack of choice and speed in medium-format lenses becomes obvious. Many people never buy anything longer than a 150mm or 180mm lens for medium-format cameras, reasoning (with some justice) that they might as well use 35mm for telephoto work. As a personal view, I would suggest that a realistic limit for long-focus and tele lenses on medium-format was 250mm or at most 350–360mm. Anything longer than this is ruinously expensive and (usually) hellishly slow. Few manufacturers offer anything longer than 500mm in any case, though the big Pentax does live up to its 'giant 35mm' image and offers (or offered) a 600mm/f4, an 800mm/f4 and a 1000mm/f8 reflex, which is probably the best possible choice if you are determined to use long telephotos on a medium-format camera, but you will need a very stout tripod. You may also be able to find fast, long lenses for the old Pentacon Six, including a 180mm/f2.8, a 300mm/f4 and a 500mm/f5.6, often at very reasonable prices; a rare gem is the 125mm/f2 ex-Luftwaffe aerial lens, which is sometimes found adapted for these cameras.

The 150–180mm lens is extremely versatile and can readily be hand-held, but anything longer really does need a tripod. You may just be able to get away with 250mm or 300mm, but the sheer weight will get to you. With the 6×6cm and 6×4.5cm formats, you may be able to find 150mm lenses as fast as f3.5 or (at a price) f2.8, but f4 or

even f5.6 will be the limit at 250mm; beyond that, expect f5.6 at best.

With technical cameras remember that while a long-focus lens will normally permit plenty of movement, a telephoto may permit little or no rise/cross. This is worth bearing in mind when selecting a 180mm lens for the 6×9cm or 6×7cm formats, though 240mm telephotos are normally designed to cover 4×5in and allow all the movement you will need on rollfilm.

SPECIAL-PURPOSE LENSES AND TELECONVERTERS

Special-purpose lenses for medium-format cameras include four types which are common to 35mm, one type which is very rare in 35mm and one type which is all but unheard-of in the smaller format.

The four types of lens which are also found in 35mm are zoom, fish-eye, shift and macro lenses.

Zooms are rare and expensive for medium-format cameras, with modest zoom ratios and apertures, for the same reason as the rarity of other exotic lens types: the larger format makes designing and building a zoom very much more difficult. The quality loss in relation to prime lenses typical of zooms is not so critical in rollfilm as in 35mm, but the sheer size and cost of big zooms is more than enough to deter most people. The only format which is likely to see any great expansion in the availability of zooms in the near future is probably 6×4.5cm, where the optical problems are easier to solve and where the 35mm-oriented market is likely to insist on such lenses, almost regardless of quality.

Most medium-format SLR manufacturers offer a full-

Although I am no great lover of the square format, I do find that it is particularly suitable for fish-eye shots. This one was taken with a 30mm lens on a Hasselblad.

For the ultimate in colour fidelity, a colour temperature meter, e.g. the Gossen Sixticolor, will tell you exactly which warming (amber) or cooling (bluish) filters are required to give a 'standard' result in any type of lighting.

frame fish-eye in their line-up, from the 24mm/f4 fish-eye for the Mamiya 645 through the 30mm/f3.5 Distagon F for the Hasselblad to the 37mm/f4.5 for the Mamiya RB67. Circular-image fish-eyes are not available, as these are really special-application recording lenses, with very few uses in normal pictorial photography. And there are not (to my knowledge) any series-production fish-eye lenses for non-reflex cameras. You can, however, use front-of-lens fish-eye adapters if you can find one of sufficient diameter. The inevitable loss of image quality is not as serious on 120 as on 35mm, so you may well be able to get away with it.

Shift lenses are not offered by all manufacturers, but are becoming more common. They are usually modest wide-angles, fitted in a decentering mount which allows up to 2cm of off-axis movement. Although a rising front is without doubt the single most useful camera movement available, if you are likely to need camera movements you might do better to buy a technical camera such as the Linhof, where the movements can be used with any lens — wide-angle, 'standard' or long-focus — and where you have swings and tilts and possibly a cross front as well as the rise, instead of the combined rise-and-cross of the shift lens. You may also find it instructive to compare the price of a second-hand technical camera (including 5×4in camer-as with reducing backs) with that of a shift lens!

Macro lenses for 120 cameras are not always what the 35mm user might expect. Broadly, they fall into three camps. A few, especially for 6×4.5cm cameras, are similar to those for 35mm: fairly slow lenses with a flat field at close range, mounted in an extended-throw focusing mount. The 80mm/f4 macro for the Mamiya 645 is of this type, and focuses to about 7½in. The second type, notably for the bellows-equipped Mamiya RB67 (140mm/f4.5 mac-ro), obviously requires no focusing mount but again is slow, flat-field and optimised for near focusing; a similar design of lens without focusing mount, is also made for use with bellows on other cameras, such as the Hasselblad. The third variety is typified by the 120mm S-Planar for the Hasselblad, and is in a perfectly ordinary focusing mount which focuses only slightly closer than usual, though the lens itself is again slow and optimised for use in the close-up range with extension tubes or bellows. Unless you have some form of through-lens meter, exposure deter-mination with these lenses when they are used in the close range will require some mental gymnastics, and preferably a pocket calculator for working out the necessary exposure increase.

The two lens types which are rare in 35mm are soft-focus and flash-synchronised lenses. The former are designed

A 'trick' filter is a means of enhancing a good picture, not saving a bad one. It took me a long time to find a picture such as this which I actually liked. Rather than adding the effect at the time of shooting, it may be better to experiment at the duping stage. Both orange and blue versions of this picture exist, but limitations of space preclude showing both. *(Latiff: Mamiya RB67: lens and film not known)*

42

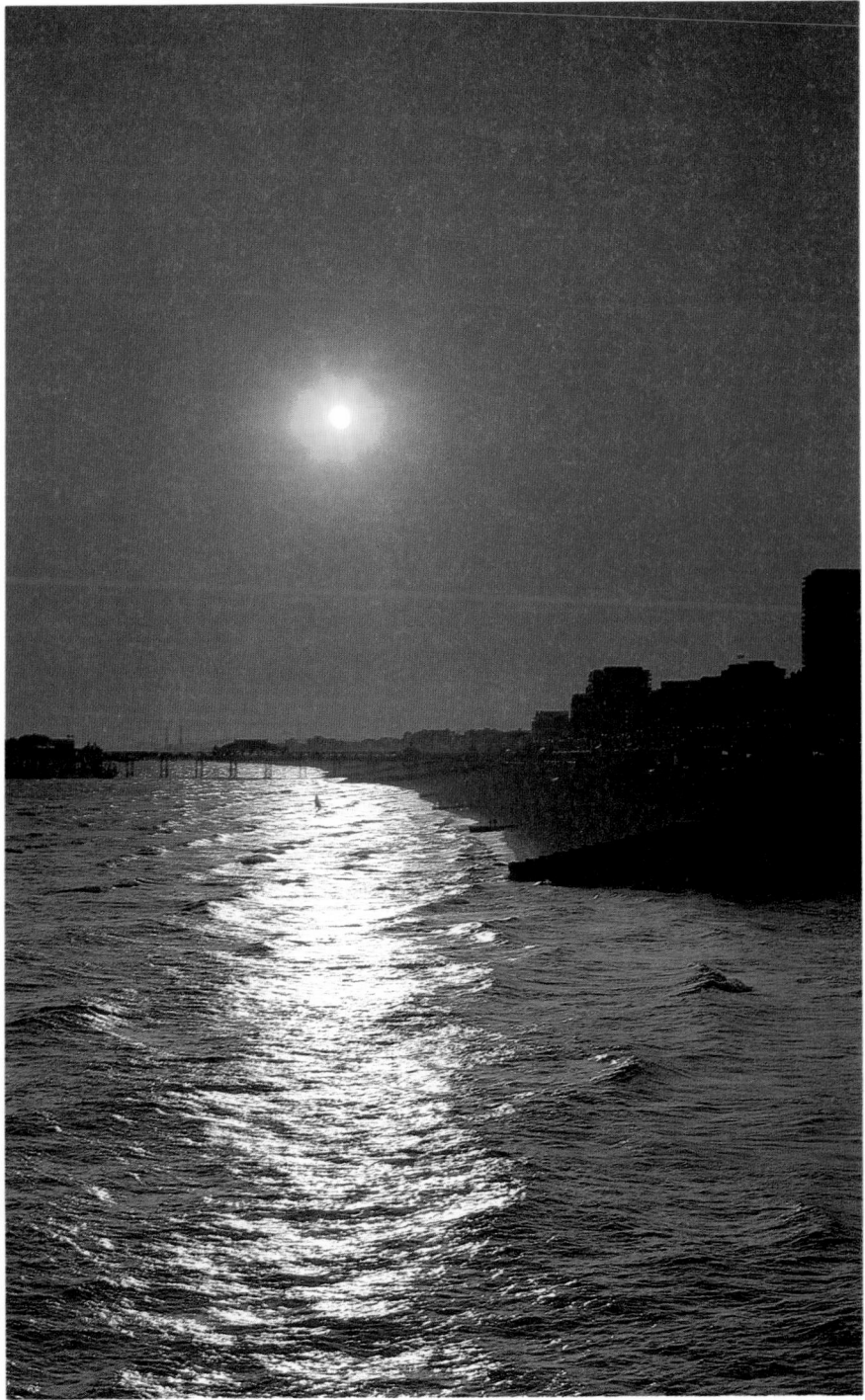

with deliberately undercorrected spherical aberration, so that points of light are surrounded with a soft halo. A moment's thought will show that the larger the format, the more controllable this effect is likely to be, which is one of the reasons why SF lenses are so rare in 35mm, though they are offered for various medium-format cameras. The Mamiya 645 has a 145mm/f4, for example, and the RB67 boasts a 150mm/f4. Because spherical aberration varies with aperture, stopping down reduces the effect, and to emphasise it various forms of 'tea strainer' can be fitted to block off the sharper central rays and ensure that the outer aberrant rays form the image. Soft-focus lenses can be tricky to use and require experience, especially with exposure determination, but they give effects which cannot be duplicated by any form of lens attachment. It is also worth remembering that their use need not be confined to portraiture: there are many other subjects which repay being shown in a different way by the use of this technique.

Flash-synchronised lenses are made for use with cameras having focal-plane shutters, so that flash synchronisation at all speeds is possible. If flash synchronisation is a priority, you would probably do better to buy a leaf-shuttered camera in the first place, but it is worth knowing that most focal-plane cameras offer one or two leaf-shutter lenses as well. Even so, they are no panacea, because they can be inconvenient to use and you are restricted to one or two focal lengths.

Teleconverters are comparatively rare in medium-format, and mostly come from independent manufacturers. As with 35mm teleconverters, there is some loss of quality and the usual loss of speed, but the loss of quality is not so serious as with 35mm, simply because the image is bigger. If you only occasionally need the extra focal length conferred by a converter and do not mind stopping well down (to about f8 indicated, a true f16 with a 2× converter), they can be a useful buy. Remember that in the absence of through-lens metering, you have to compensate for changes in exposure yourself, as with a macro lens.

FILTERS AND LENS ATTACHMENTS

The main difference between filters and lens attachments for medium-format cameras and those for 35mm is that the degradation in image quality caused by optically dubious attachments is less serious in medium-format, so plastic 'effects' filters such as those made by Cokin can be used with a fair degree of impunity.

The other important thing to note is that although most medium-format cameras take large filter sizes, there is

usually a fair degree of standardisation between lenses of a particular *marque*, so that (for example) almost all Mamiya RB67 lenses take 77mm filters. If the filter fitting is unusual, as it is on some Hasselblad lenses, you can usually get some form of adapter from proprietary filter manufacturers to allow the use of standard fittings on that lens. For the price of a single Hasselblad filter you can buy an adapter and a couple of Hoya HMC 52mm filters, and I do not believe that there are any better filters than these.

A type of filter which is rarely used in 35mm photography, but which can be useful in medium-format work for achieving the very highest quality, is the CC (colour correction) filter. These are available in the three additive primaries (red, blue, green) and the three subtractive primaries (yellow, cyan, magenta) and in graded steps from CC05 (the palest tint to make any perceptible difference to the image) through CC10, CC20 and so on all the way to CC50, which is usually a very strong tint indeed. The stronger CC filters are little used, except for effects (though the 30 Magenta (CC30M) is a good filter for when using daylight-type film under fluorescent light), but the weaker versions — CC05 and CC10 — can be very useful for correcting minor colour tints and making the film behave as you wish. Often, a CC05Y will improve a picture taken with electronic flash, and if you batch-test film for studio use you may find you want other weak CC filters. Not all CC filters are available in glass, but they can all be had in gelatine; contrary to some reports, gelatines will last for many years if you look after them.

Finally, it is invariably worth using a lens hood (lens shade) if you want to get the finest quality out of any lens. Most manufacturers of medium-format systems offer excellent bellows lens-shades which can be set to provide optimum shading for a wide range of lenses. These shades are usually surprisingly expensive but are well worth it, and most also incorporate a holder for gelatine filters. There are a few proprietary versions available, such as the Ambico Shade+, and even if these are not quite up to the standard of (say) the Hasselblad bellows lens shade, they are still very good. They are bulky, it is true, and a little inconvenient, but once you have seen the difference they make in difficult lighting, you will surely be persuaded.

4 · Choosing a Medium-Format System

While it may be comparatively easy to choose a bare camera, it can be considerably more difficult to choose a system. It might seem that one follows on naturally from the other, and so it does in many cases, but there are few things more infuriating than realising, when the time comes to expand your outfit, that the lenses or accessories you want are not available for your particular camera.

The range and types of accessories which are available for rollfilm cameras are very different from those which are available for most 35mm cameras, and it can be hard to judge your requirements until you have been using the system for a while. Indeed, the term 'accessories' can be misleading; because of the modular construction of so many rollfilm cameras, it is far more a matter of building the system that *you* need from components, rather than adding accessories to a basic camera.

The most obvious interchangeable components are the lenses (which were covered in the last chapter). In this chapter we are concerned first with interchangeable backs; then with interchangeable and accessory finders and screens; then with close-up accessories; then with other accessories from within the system, including motor drives; and lastly with accessories from outside the system, including tripods, camera bags and small accessories of various kinds. The chapter ends with a section on actually choosing and buying a medium-format outfit, including some observations on the second-hand market.

INTERCHANGEABLE BACKS

Although interchangeable backs are one of the first things that most people consider when moving up to medium format, the way in which you eventually use them may not be quite what you expect. The most obvious advantage is the ability to use two or more different emulsions, and switch between them, but it is surprising just how rarely most photographers actually want to do this. Much more often, the backs are used to speed reloading, especially if you have an assistant; the assistant can be reloading one back while you are shooting with another. This might not seem to be critical in contemplative fields such as landscape photography, but given how fast the light can change, it's

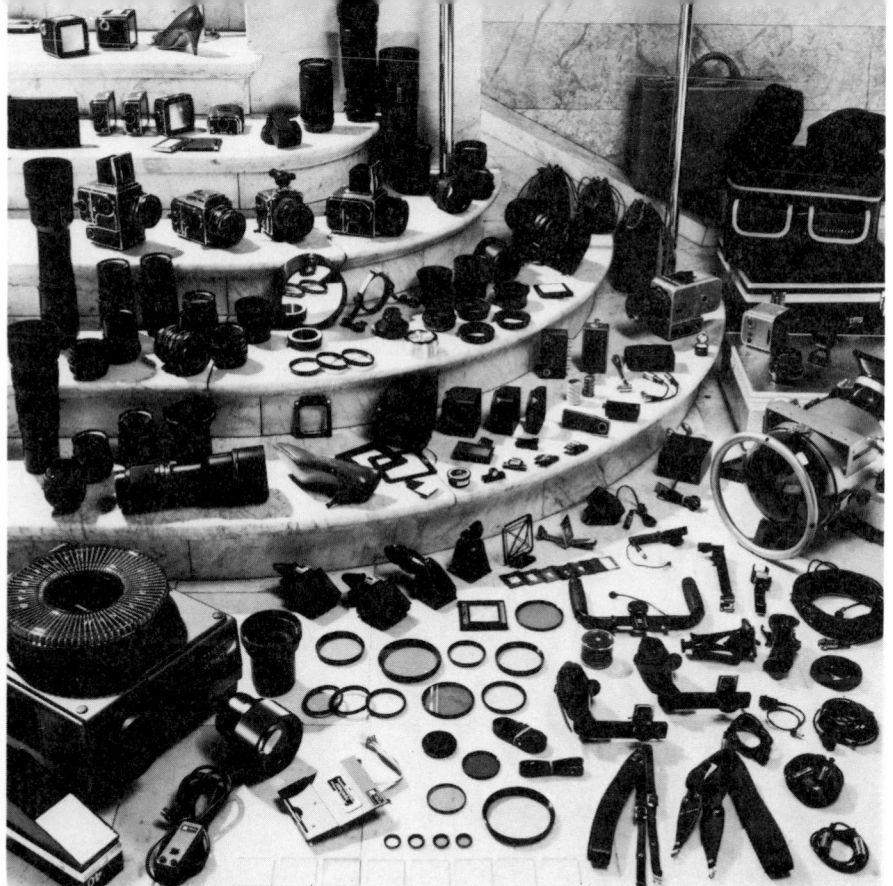

This Hasselblad outfit may be a dream for most people, and it is extremely unlikely that any one photographer would ever find a use for every single item of equipment here (especially the high-heeled shoes!), but it does show the importance of choosing a system which will allow you to 'grow' in any direction you wish.

more useful than you might think! A second advantage is, of course, the availability of a Polaroid Land back, for testing, for gifts or for pictures in their own right. And a final advantage that several cameras offer is a choice of backs for different formats and even film sizes; examples include the 'superslide' (4×4cm) format, 70mm backs and cut-film backs.

Different manufacturers offer many different kinds of interchangeable backs, but the basic choice is usually as follows:

1) 120/220 interchangeability. Some manufacturers offer backs which can handle both — Rolleiflex, for example — while others prefer separate backs for 120 and 220. Those manufacturers who offer separate backs may not offer both 120 and 220 in all sizes: for example, 120 may be available in 6×7cm, 6×6cm and 6×4.5cm, but 220 may only be available in the first two sizes. An interesting aside here is that while the power-drive backs for the Mamiya RB67 are adjustable for 120 and 220, the manual

47

backs are designed only for use with one or the other.

2) A choice of 120 formats. For example, Bronica's GS1 offers 6×7cm, 6×6cm and 6×4.5cm, the Rollei SL66 offers 6×6cm and two kinds of 6×4.5cm (vertical and horizontal), and you can get both 6×9cm and 6×7cm backs for Linhofs. In practice, this choice is seldom as useful as you might think. If you normally shoot 6×7cm, you would need to shoot an awful lot of 6×4.5cm pictures before the savings in film covered the cost of a 6×4.5cm back. There are applications for which this feature is useful — schools portraiture, for example, or 4×4cm 'superslide' — but usually you might as well use the larger size.

3) Polaroid Land backs. The praises of these have already been sung, but it is worth repeating that you will never appreciate how useful they can be until you get one.

There are several dozen different types of Polaroid Land film available, with a surprising range of emulsions available in a wide variety of formats, so it is worth checking first, what sort of film a Polaroid Land back for your camera takes, and secondly, what emulsions are available: colour, black and white, high-speed, high-contrast and so forth.

4) Cut-film or plate backs. These are nothing like as common as they used to be, but there are still times when it is useful to be able to take an individual exposure and process it on its own. Some cameras, such as the Linhofs, Mamiya-Press and Horseman take standard-size 2½×3½in/6.5×9cm cut-film, while others such as Hasselblad and Rolleiflex accept only cut-up films, though with the increasing scarcity of small cut-films, cutting up 5×4in/9×12cm may soon be the only option for Linhof and Mamiya users too. There is an adapter available which permits the use of Mamiya-Press backs on the RB67, though inevitably the full 6×9cm film area is not used. One of the most useful aspects of having cut-film backs is the possibility of using lith and line film for special applications.

5) 35mm backs. Very few of these are available for 120 cameras at the moment, though Bronica are in the process of popularising them with both a conventional 24×36mm frame size and a 'panoramic' 24×54mm size which can be printed and projected using 6×6cm equipment. Whether these 35mm sizes have any more than novelty value is hard to say; as with other reducing backs, you have to shoot a lot of film before you can justify buying another back instead of just cropping the full-size frame.

On most SLRs the backs are coupled to the shutter

Maybe I just like doing things the hard way. After riding my fully-laden 1000cc BMW up a goat-track in Portugal, I took this picture with a Linhof Super Technika IV. The way that this camera folds up like a clam-shell, combined with its inherent ruggedness, makes it surprisingly suitable for motorcycle touring and other tough applications. *(Symmar-S 100mm/ f5.6: original on ER)*

cocking mechanism and interlocked with the shutter release, so that a single action cocks the shutter and winds the film and it is difficult or impossible to make accidental double or blank exposures. It is also usual for there to be an interlock between the shutter release and the darkslide, so that it is impossible to fire the shutter unless the darkslide is at least partially withdrawn, and a further interlock between the darkslide and the back release so that the back cannot be removed unless the darkslide is in place; there is an auxiliary shutter in leaf-shutter SLRs so that you can change lenses without fogging film. At first, these interlocks can be alarming — the camera apparently refuses to work and you are convinced that you have broken it — but in time, you get used to them.

A lack of interlocks, as found on technical cameras, monorails and large-format cameras used with reducing backs, can be equally disturbing, because you can make any of the above mistakes, and more (such as changing the lens with the dark-slide out). After a while, the discipline of removing and replacing the dark-slide, or of checking that the shutter is closed before you remove the dark-slide, or of winding on immediately after an exposure, becomes auto-

49

matic. For those who are considering such a camera, the drill is given in the panel.

Note the lack of critical edge. Older lenses, like older cameras, should be regarded with suspicion until they have been tested. This picture is from a test roll on an old Ensign with an f3.8 Ross lens, usually a first class piece of glass. As you can see, though, nothing is critically sharp.

Sequence for camera without interlocks

1 Close shutter
2 Set shutter speed and cock shutter
3 Stop down lens to taking aperture
4 Remove focusing screen and fit rollfilm back
5 Remove darkslide
6 Fire shutter
7 Replace darkslide
8 Wind on
9 Fit groundglass back
10 Open lens
11 Reset to full aperture for viewing

Obviously, some of these things can be done in a different order — you can wind on before replacing the darkslide, for example — but the advantage of following this particular sequence at that point is that the film remains uncovered for as short a time as possible, so that if (for example) the shutter is still open, you have only lost one frame instead of two.

There are also cameras which have some of these interlocks and couplings but not others. For example, the Mamiya RB67 has all the usual interlocks, but separate shutter-cocking and film-winding, which can be infuriating at first. Fitting the power backs couples the film-wind to the shutter-cocking, so that as you press the shutter cocking lever the film is automatically wound on, and for many applications this transforms the camera; but in my outfit, I have one power back (which can also be used manually) and one manual back, and I rarely worry about which one I am using.

INTERCHANGEABLE FINDERS AND SCREENS

The basic finder of the SLR is the waist-level ground-glass, but as we have already seen this presents a problem with rectangular formats unless there is a revolving back. Furthermore, if your eyesight is not all it might be, it is useful to have some form of eyesight adjustment on the magnifier, or (at the very least) a magnifier which suits your own eyesight. In addition to this, very few medium-format cameras (with the exception of Rolleiflexes) have meters built into the camera body, so if you want a meter, you have to add a metering head. Consequently, the typical alternative finders are as follows:

1) The folding 'waist-level' (actually chest-level) finder. Compact, cheap and usually supplied with the camera, these are ideal for many applications (especially portraiture and landscape) and usable for many others; but

there are also certain applications for which they are next to useless, especially action photography, where many people find it almost impossible to follow action 'backwards' in the laterally-reversed image shown on the ground-glass. All the same, these finders can be extremely useful if you want a low-level viewpoint, with the camera actually resting on the ground.

2) Eye-level finders, whether prism or mirror, are much better for action and almost indispensable in rectangular-format cameras without reversing backs, but they bring drawbacks of their own. They are inevitably bulky and some are very heavy. Most also crop a fair amount around the edge of the picture area on the ground-glass, which makes precise composition awkward, and many (especially the mirror types) are somewhat dim, and on top of all this, they are also expensive!

Although many eye-level finders are of the 'straight-through' variety, where you look in the same direction as the camera is pointing, there are also a few 45 degree types, where you look diagonally downwards into the camera. The image is still right-way-up and right-way-round, but the viewing angle can take some getting used to, so always check prisms out before you buy, especially mail-order or second-hand.

3) Metered versions of the above. These may be completely independent, so that all readings have to be transferred manually, semi-coupled (so that either aperture or shutter speed is coupled, but the other has to be set

The ultimate in versatility — at the expense of convenience — is a monorail camera. This Cambo 6×9cm monorail shows the possibilities of camera 'movements', which are further explored in Chapters 8 and 9. The centre picture shows the 'REST' position; the picture left shows the maximum possible rise, attained by raising the front, lowering the back and tilting both until they are parallel; and the one on the right gives some idea of just how flexible a monorail can be. Technical cameras, such as the Linhof, allow somewhat less movement but much easier portability.

manually), or fully-coupled, as in most 35mm cameras. Some meters work on the stop-down principle, and others are full-aperture. The most sophisticated and 35mm-like metering heads are mostly to be found on 6×4.5cm cameras.

4) Magnifier hoods. These are rigid chimney-shaped finders which usually provide somewhat greater magnification than the flip-up magnifiers built into waist-level finders, as well as adjustment for individual eyesight.

5) Metered magnifier hoods, similar to the above but with built-in meters, usually either completely uncoupled or working on the stop-down principle.

6) Sports or frame finders. These are quite separate from the focusing arrangements (focusing may be by scale or via the ground-glass) and are cheaper, lighter and often more convenient than prism finders — although different frames are required for different focal lengths, and long focal lengths do not allow very precise framing. On a few cameras, frame finders may be built into the hood of the standard waist-level finder, as in the old Rolleiflexes.

An additional advantage of these finders is that they can be used with the 'pre-release', i.e. with the mirror flipped up, the shutter closed and the auxiliary shutter open. This means that the delay between pressing the release and actually getting the picture is reduced from about ⅒ second to about ⅟₆₀ second, which is obviously extremely useful in any sort of action photography.

53

As for interchangeable screens, although as wide a range of so-called 'focusing aids' is available for some rollfilm cameras as for the better 35mm cameras, the considerably larger area of the rollfilm camera's screen means that a plain ground-glass–plus-Fresnel is usually more than enough, except perhaps for 6×4.5cm cameras. One thing which is very useful, though, is a ruled (grid) screen, especially with waist-level finders, as this means that setting up the camera is then much easier. An interesting option, as an alternative to the manufacturers' screens, is a proprietary bright screen such as the Beatty Intenscreen. Normally there is a trade-off between brightness and focusing accuracy, but the Intenscreen provides an image which is both bright *and* crisp. The only manufacturer who provides an equally bright screen, to my knowledge, is Hasselblad with their (expensive) fibre-optic screen.

With a 'view' or technical camera, the only choice is usually between a plain screen and a grid screen, and (once again) the grid screen is well worth having. Because Fresnel lenses are not usually incorporated in screens for these cameras, you may find that it makes life a lot easier if you buy one as an after-market accessory.

Technical cameras do, however, offer an alternative method of focusing and composing to the ground-glass: a coupled rangefinder and an optical finder, which may or may not be combined. The most sophisticated range/viewfinder around is the one fitted to the Linhof Technika 70, which not only has parallax-compensated brightline frames for 65mm, 100mm and 180mm lenses, but also reduces in area to allow for the narrowing of the field of view as the lens is racked out. Unfortunately, this superb camera is no longer being produced at the time of writing, though new models are still available from existing stock. For sports photography, where it is often an advantage to be able to keep both eyes open, Linhof also make a frame finder, and there is also a multi-focus optical finder. It is also possible to adapt some (but not all) 35mm finders to other formats, or to use them for 6×9cm merely by altering the focal lengths engraved on the ring.

CLOSE-UP ACCESSORIES

To anyone brought up on the 35mm SLR, with focusing to 18in (50cm) or so, the nearest focusing limit of most rollfilm cameras is going to be a nasty shock. The standard lenses on non-bellows reflexes generally stop at around 3ft (90cm) and viewfinder cameras, other than technical cameras, are about the same or a little worse.

There are good optical and mechanical reasons for this.

54

For a start, if you focus closer than about 10 focal lengths, the effective aperture of the lens changes by ⅓ stop or more, which is generally reckoned to be the limit for critical exposure in colour. Added to which, a conventional helical focusing mount which allowed the kind of extension which would be needed to focus any closer would be too large, heavy and expensive for general use. And finally, any parallax-compensated range/viewfinder which focuses closer than three feet is likely to be both expensive and bulky.

There are, however, two outstanding bellows reflex cameras, the Mamiya RB67 and the Rollei SL66, which allow you to focus down into the near-macro range without any difficulty whatsoever, though you do have to correct the exposure manually according to a scale on the focusing rail. If you regularly need to focus closer than three feet, one of these cameras is well worth considering, which is one of the main reasons why I now use RB67s instead of Hasselblads.

Alternatively, you could try a technical camera. The Technika 70, for example, is rangefinder-coupled down to about 30in (75cm), and with a standard triple-extension bellows it can focus down to twice life size with the standard lens.

Otherwise, the only choice for close-focusing is a reflex with either close-up lenses or some form of extra extension. Close-up lenses are actually a very good idea with rollfilm cameras, because the slight degradation of image quality is nothing like as important as it is with 35mm (which, as we have seen, is already on the edge), and because they involve no increase in exposure time. They are also very light and portable. On the negative side, good ones (such as the Zeiss Proxars) are alarmingly expensive (though not as expensive as extension tubes or bellows) and you always seem to end up working at a reproduction ratio which is on the borderline between two lenses, so you have to keep putting them on and taking them off. Nevertheless, for photography in the 12–39in (30–100cm) range they are ideal, and for TLRs there are matched sets of close-up lenses for upper and lower lenses, with a parallax compensating prism built into the one for the upper lens, which makes these cameras surprisingly easy to use for close-up.

Extra extension comes in the form of bellows or extension tubes, including some very good variable-extension tubes, notably from Pentax and Hasselblad. You can get as close as you like but the major drawback here is the same as in 35mm — bulk, awkwardness and inconvenience, especially with fixed-length extension tubes. Because comparatively few people want to use rollfilm reflexes up close,

these accessories also tend to be very expensive, which makes the whole close-up area one to be considered very carefully indeed before you invest an a rollfilm system. The difficulties and techniques of close-up photography with medium-format cameras are discussed further in Chapter 9 *Close-up/Copying*.

OTHER ACCESSORIES

Accessories for rollfilm cameras tend to be considerably more limited than those for 35mm cameras. This is partly because accessories for rollfilm cameras are usually larger and bulkier than those for 35mm, sometimes to the extent that they cannot be made, and partly because rollfilm does not as yet have the mass appeal of 35mm, with the result that the more abstruse or gimmicky accessories are economically impracticable. It is also partly because rollfilm cameras are usually bought by people with a clear idea of what they want from their photography, which again militates against gimmickry, and partly because few professionals see rollfilm as a replacement for 35mm in all applications, and therefore use 35mm whenever it is more suitable (or easier!) than rollfilm, which means that there is simply no call in medium format for some accessories better suited to 35mm.

The accessory most often noticeable by its absence is the motor-drive. This is no great surprise; as recently as the early 1970s very few 35mm cameras had motor-drive either, and drives are as much a matter of fashion and affluence as of practicality, at least for most people. There are a few medium-format cameras with built-in drives, notably the superb Rollei SLX and its descendants, and the long-established Hasselblad EL series, but these cannot be used manually. There are rather more cameras with add-on motors, though still nothing like as many as in 35mm, and the majority of the add-on brigade are in 6×4.5cm, which for the most part are clearly aimed at serious amateurs moving up from 35mm, though even Hasselblad now offer add-on motors. There is the Mamiya RB67, whose motor changes it from a double-action (cock-and-wind) camera to a single-action one, by winding the film electrically when you depress the shutter cocking lever. And there are many cameras for which there is simply no add-on motor of any kind: you have to rely on your thumb!

In practice, the absence of an electric thumb is rarely critical. Because of the bigger film size, rapid winding is impractical, and most medium-format motor-drives take ½−1 sec to wind on, which is not really a significant saving in time over a well-tuned thumb. The only time you really

need a motor-drive for rollfilm is when you need a remote release, though this may be more often than you think: for example, it can be surprisingly useful in a portrait studio.

Filters, lens-hoods and other lens attachments have already been dealt with at the end of the last chapter, and flash is covered in Chapter 7, so the only other major accessories we need to cover here are tripods and camera bags.

A good tripod is essential for most types of medium-format photography, and indeed could improve most 35mm photography beyond recognition. It is important to distinguish between the tripod itself, and the head. The main thing to guard against is vibration, which originates wherever a camera is supported by a single undamped metal spar. Long extension posts in the middle of a tripod are a fruitful source of vibration, and the tripod head is often another. In fact, some of the spindlier pan-and-tilt heads can be a disaster area. The tripod itself need not be any more massive than a good 35mm tripod, because the weight of the camera is actually a stabilising influence, but a solid head is indispensable. Rather than a pan-and-tilt head, I actually prefer a heavy ball-and-socket with a ball at least an inch (25mm) in diameter, such as those made by Linhof or Kennett Engineering. Smaller heads are often little more than toys. Not only are such ball-and-socket heads lighter, smaller and less vibration-prone than pan-and-tilt heads; once the camera has been levelled, you can always rotate it on the camera platform for a 'pan' effect.

Both Linhof and Kennett also make some other interesting camera supports. Linhof's little levelling head allows only a relatively limited movement, but it is admirably light and compact and cannot allow the camera to flop over as an untightened ball-and-socket joint can do. Kennett make a first-class (if unconventional) tripod, the Benbo, which can be set at the most extraordinary angles on all sorts of terrain, but there are many other tripods which are also good; my wife and I own half a dozen between us, from a massive ex-UK Government Vinten which can support an 11×14in camera, via a Benbo, a Gitzo and a top-of-the-line Cullman (most amateur tripods, even by manufacturers like Cullman, are pretty flimsy and wobbly) to a Leitz table-top model which is invaluable when tripods are theoretically banned. We have yet to find the 'all-purpose' tripod, and each of the different models has its own strengths and weaknesses; the relatively crude Gitzo, for example, is admirably compact and still very rigid, so it is our travelling tripod when weight or bulk are critical such as when travelling on foot by air or by motorcycle. Economising on tripods is rarely a good idea, as cheap models

It is often foolish to buy new equipment when you can often do more by exploring the equipment you already have. This 1946 flathead Harley-Davidson was shot with a standard 90mm lens and a standard waist-level finder on a Mamiya RB67; the waist-level finder is ideal for this kind of low, dramatic viewpoint. *(Shot on ER)*

wear out rapidly even if they do not wobble when new: I have long admired Gitzo's slogan, *Conçu a durer, pas a jeter* — designed to last, not to throw away.

Just as there is no universal tripod, so is there no universal camera bag — and the weight and value of a medium-format outfit makes a good camera bag essential. Like most professionals, I actually use two types of camera bag: hard cases for travelling and soft cases for use on location. Foam-padded Zero Halliburtons are my favourite hard cases, though I also use Adapt-All and I know several people who swear by Rox. Among soft cases I particularly admire Billinghams, particularly the second generation with the 'post-board' inserts. I also own an excellent cheap, padded camera back-pack made by Coast (the model is now sadly discontinued). The following are the big things to watch out for with any camera bag; accessibility, because all the gear in the world is no use if you cannot get to it quickly when you need it; protection (and remember that soft foam provides insulation against vibration, which can be just as great a destroyer of cameras on a long journey as knocks, which are better fended off by hard foam); portability, because you are actually going to have to carry this bag without ruining your back or sawing up your hands; and inconspicuousness, because some camera bags might as well have STEAL ME written all over them.

A Mamiya 645 outfit is no more trouble to carry than a 35mm outfit, but precisely because it is a medium-format camera there is more incentive to carry (and use) a tripod. Trying to hand-hold this picture, especially with the 150mm lens used, would not have been a good idea!

CHOOSING AND BUYING A MEDIUM-FORMAT OUTFIT

From the information already given, you should have acquired quite a fair idea of the range of rollfilm cameras available, and of the strengths and weaknesses of different types. Although I have quoted examples in the text, I have not tried to give a blow-by-blow account of all the different models on the market, partly because new cameras are constantly being introduced and partly because you can get all this information in greater detail, and probably more enjoyably, by going through the manufacturers' catalogues and visiting camera shops; and this is what I want to talk about next.

Before you choose a new system you should have a good idea of what you want and of the kind of photography you want to do with it. That way there will be little danger (for example) of someone selling you a Mamiya RB67 as the ultimate sports and action camera: it may be the ultimate for some applications, such as portraiture, but ultimate for sports photography it is not. In the second half of this book

A print from a 6×9cm negative (rollfilm back on MPP Mk VII) allows you to feel that you are getting inside the subject; the minutely different planes of focus give a real feeling of depth. The 'open shadows' of rollfilm are also very much more difficult to achieve with 35mm. *(FP4/Perceptol)*

I try to give a fair and accurate assessment of the best (and worst) camera types, and relevant accessories, for different applications. What you are looking for, therefore, is a camera which best meets those specifications and which suits you. Camera store owners can and do tell endless stories of people who chop and change from one system to another, often losing a small fortune in the process, and who are never really happy; they can also point to other customers who have stuck with the same system for years, and only add to it when some genuine improvement is made. Finding 'your' camera is a matter of temperament, of experience and even of physique — height, size and strength. Do not be misled into thinking that just because a professional whose works you admire, or a friend, uses a particular camera that it is the camera for you.

You are probably also looking for a system which will allow you to expand in the direction in which you want to go, but not necessarily looking to buy a massive outfit at first; rather you want to buy *only* the equipment you immediately need, and to add to that equipment *only* when you feel that your lack of a particular lens, or back or other accessory, is limiting your photography. With the price of most rollfilm equipment, such prudence is rarely difficult!

And how do you look for this wonderful camera, this system at the end of the rainbow? The only answer is 'hands-on experience', or in less affected jargon, playing with the gear in question. Until I had a chance to use an RB67, I thought they were bulky, heavy and awkward; now I know that they *are* bulky and heavy, but for me they are certainly not awkward, and I am not at all sure that I could currently be persuaded to change to another rollfilm SLR system. As a rule the only way to play with the

equipment and to get serious advice (as distinct from sales talk) is to go to a *good* camera store. By this I do not necessarily mean an expensive camera store — I could name a couple of discount merchants where I can get far better service than in some very expensive London and New York stores — but a camera store where the cameras *are* in stock, where the staff *do* know what they are talking about and where you are not made to feel that they have better things to do than waste their time talking to you.

To get the best service, do not go at the busiest time of day, which is usually a Saturday afternoon (in New York, where nearly all the best camera stores are Orthodox Jewish, on a Sunday), and do not try to score points off the sales staff — unless they are patently wrong, or rude. If you ask their advice, *listen*; they will tell you a lot more that way than if you are constantly arguing. And whatever you do, do not waste their time with endless questions and then go and buy the camera somewhere else because it is slightly cheaper: you will almost certainly ruin your chances of ever getting good advice again. I am not telling you to waste your money on snob appeal, but I do believe that spending a little extra at the right store repays you many times over.

Finally, do not neglect the second-hand, 'demonstration' and shop-soiled counter. Because new models are brought out far more rarely in medium format, you can often get current-model equipment at enormous savings, and because most medium-format cameras (with the exception of a few 6×4.5cm models) are built to take a professional pounding, a late-model low-mileage camera with no visible signs of wear will probably function as well as new. Of course, insist on the best guarantee you can get, never buy anything without testing it, and be very wary of equipment which has obviously been used hard, because even cameras wear out — but never despise a camera just because someone else has owned it before.

There are also many cameras still available which are no longer made, but which are capable of taking first-class pictures, and which cost only a fraction as much as most new current-production cameras. I have already mentioned TLRs, but there are also several SLRs, including the East German Praktisix (which seems to be resuscitated and improved, with Schneider lenses, under the Exakta label) and the old Bronica S2A; while second-hand 5×4in technical cameras and monorails for use with a rollfilm back (most accept currently available rollfilm holders) can also be a bargain.

5 · Film and Metering

Film and metering are two subjects so inextricably bound together that they must be treated almost as one. Most 35mm users are so accustomed to through-lens metering that the use of separate hand-held meters requires some explanation, while the techniques required for exposure determination needed in order to obtain the best possible results with the three kinds of commonly used film — black and white, colour transparency and colour print — are sufficiently different that they ought to be considered separately.

Only a few medium-format cameras — notably from Rolleiflex — are supplied with fully-coupled built-in through-lens metering as standard, and the techniques for using these are the same as for 35mm. Rather more cameras can be fitted with some form of metering head, but the vast majority in professional use are devoid of any form of metering at all.

Add-on metering heads vary from the fully-coupled (for the Mamiya 645, for example), via semi-coupled to the totally uncoupled. An example of the semi-coupled head is the least-sophisticated metering head available for the Mamiya 645, where the lens aperture is coupled to the meter, but the shutter speed reading must be manually transferred from the metering head to the shutter-speed dial on the camera. The Mamiya RB67 offers a choice of uncoupled metering heads, which amount to no more than separate meters which happen to read through the lens: shutter speed must be manually transferred. The mechanics of using the various heads are more appropriately described in the cameras' instruction books than here, but it is worth being aware that the kind of automation and metering which is taken for granted in 35mm is extremely rare in medium-format, though it is likely to become increasingly common in 6×4.5cm cameras.

Some rollfilm cameras also have (or can be fitted with) external (non-through-lens) uncoupled meters. The Hassel-blad meter knob is one of the best-known of these, and the Linhof Technika 70 has a built-in Gossen meter. Both of these are selenium types, and therefore not particularly sensitive, but in good light they are surprisingly accurate and they are, of course, battery-independent!

The main aim of this chapter, though, is to preach the

gospel of incident-light metering. All reflected-light meters — whether through-lens or not — are based on the assumption that the 'average' subject reflects 18 per cent of the light falling on it. This assumption is often astonishingly true, as witness the effectiveness of most such meters. But all photographers — amateur, semi-pro or pro — have experience of the non-typical subject. The two extreme examples are a subject with a pure white background, and a subject with a pure black background. In the first case, a reflected-light meter will still aim to reproduce that 'average' 18 percent grey, and the white background will come out unacceptably dark while the subject in front of it will be completely underexposed. In the second case, the background will be lightened, and the subject will be grossly overexposed.

There are various correction factors, based on experience, which we can apply in such circumstances, but they are all in the nature of guesswork. If we measure the light falling on the subject rather than the light reflected from it, we stand a very much better chance of getting the correct exposure; and as most hand-held meters provide a means of measuring incident light, it is a source of never-ending amazement that more people do not use this method of

No reflected-light meter is going to give you an accurate reading when there is as much whitewash about as there is inside the brewery at Lacock Abbey, once home of William Henry Fox Talbot, the famous early photographer. Incident-light reading plus bracketing is your only real hope. *(Linhof Technika 70, 65mm Super Angulon: Agfachrome 100)*

exposure determination, which is as near foolproof as can be. The reading does not even have to be made from the subject position, though this is usually best; instead it can be made from any convenient position where the light is the same as that falling on the subject, as long as the relative orientation of subject, meter and camera are maintained. The incident light dome is *not* automatically pointed at the light source, but rather towards the direction from which light is falling on the subject. And that is all there is to it!

The best meter in all but very poor light is probably the Weston Master, not only because it is extremely accurate and consistent (I once tested four Weston Masters of widely varying vintage, one against another, and the variation in readings was under ⅙ stop) but also because of the additional information which is shown on the dial: we shall come back to this when we move onto metering techniques for different types of film. Furthermore, a selenium cell is much less sensitive to variations in the colour of the light and it responds much faster and has no significant 'memory' while CdS meters require several seconds to reach an accurate reading. In poor light, the easy winner is the Gossen Lunasix/Lunapro series which can read moonlight; the silicon-cell versions escape most of the drawbacks of CdS cells, as described above.

There are, however, occasions when you can neither get close enough to the subject to get a subject-position incident-light reading nor find a spot with equivalent light falling on it. In these cases, you will have to use a reflected-light reading, but you can greatly increase your chances of getting the effect you want by using *selective-area* metering.

In the most extreme form, selective-area metering is 'spot' metering, where you take readings of a single area which you want to reproduce in a particular way in the image, or a series of readings of several areas which you then average out in some way in order to get the exposure you want. Selective-area metering is carried to its highest form in the Zone System, where the sensitivity range of the film is divided into various zones, and each of these is assigned a value. For example, the lightest area which will be differentiated in the image from a pure white could be assigned Zone 8, the lightest area in which there is to be any detail or texture — a white painted roughcast wall, for example — could be Zone 7, and the zones would progress via the various greys (Zone 5 is traditionally an 18 per cent grey) through to Zone 3, the darkest tone in which detail is to be visible in the print, and Zone 2, the darkest tone which will be distinguishable from a pure black. The deepest black of which the paper is capable is then desig-

The Weston Master V is regarded by many (including me) as the ultimate hand-held meter. I have modified this one with zone numbers on the dial right-hand side, in addition to the regular indices.

nated Zone 1, just as the brightest white is Zone 9. There are actually three or four different 'zone systems' in current use, all differing slightly from Ansel Adams's original scheme, but the important point about all of them is that they furnish an internally consistent and logical way of judging exposure.

Although there have been some mind-bogglingly complicated treatises on the Zone System, and although in most of its forms the Zone System works only for black and white photography, its most valuable lesson is simply this: by choosing the zone in which you want a particular tone to reproduce in the final photograph, and by using selective-area metering, you can exercise enormous control. For example, a Caucasian skin tone is normally assigned to Zone 5½, but if you use a zone-calibrated meter and assign it to Zone 7, you will get a lighter and more ethereal effect which would be well suited to a high-key treatment. On the other hand, if you assign it to Zone 5½ (not all zone purists allow halves!), you can get a richer, deeper print. In a 'classical' zone exposure, the print tones bear a one-to-one relationship with the subject tones, but refinements of the system allow the tonal range to be compressed (usually by increasing exposure and decreasing development) or expanded (by decreasing exposure and increasing development), but at the expense of losing this one-to-one relationship. The Zone System is a tremendous tool for getting the very best print of a subject, but it is too complicated to discuss further here[1]. True Zone System *aficionados* not only establish personal film speed indices (typically a third of a stop to a whole stop lower than the manufacturers' recommendations) and personal development times (typically up to ten per cent less than the manufacturers' recommendations), but also buy their film in bulk and batch-test it. At this point, it is only reasonable to direct the reader's attention either to the book mentioned in the footnote or to one of the many books devoted solely to the Zone System, and to say that although it may seem an insane amount of trouble to go to, the results can justify the efforts. For the present, it is probably best to move on to the different metering techniques needed for different types of film.

METERING FOR BLACK AND WHITE

The maximum tonal range which a carefully-processed black and white film can encompass is about 256:1, or 9 stops. In other words, the lightest part of the subject can be

[1] See the section on the Zone Systems in *The Creative Monochrome Image*. David Chamberlain, Blandford Press, for further information.

256 times brighter than the darkest, though it should be emphasised that sloppy technique, including over- and under-development and poor exposure determination, can reduce this range considerably. If the tonal range of the subject is any greater than the film can handle, you will have to sacrifice either the brightest highlights or the darkest shadows. In black and white photography, the normal technique is to expose for the shadows, and let the highlights take care of themselves. Furthermore, the best high-silver papers (such as Ilford's Galerie) are hard put to record even 128:1, or 8 stops, so you must either lose one stop (in shadows or highlights) at the printing stage or compress the tonal range by controlled re-valuation of the film speed and altered development.

With an incident light meter and any brightness range of less than 9 stops, you have no problems; just take the meter reading and use it. If the brightness range is greater than 9 stops — which you can estimate visually, or use a reflected-light meter — you will need to decide whether you want to sacrifice the highlights or the shadows. If it is the highlights, then give *more* exposure, in order to reveal detail in the shadows; if it is the shadows that are to lose detail, then give *less* exposure, in order not to burn out the highlights.

With a reflected light meter you will need to take a number of readings, from highlights and from shadows. Ideally, use a Zone calibrated meter so that (for example) you place a Caucasian skin tone (use the back of your hand if you happen to be Caucasian) on Zone 6, a rough-cast white wall on Zone 8, and so forth. With any luck, all these readings will indicate the same exposure. If they do not, you will once again have to decide which end of the tonal range you wish to sacrifice. Again, give extra exposure if you want to favour the shadows, less to favour the highlights.

Even without a zone-calibrated meter, you can work very easily with reflected light if you use the *U* and *O* marks on a Weston Master. Instead of using the main index, you read the darkest shadow in which you wish detail to appear and use the *U* index on the dial. Alternatively, read the lightest area in which you want detail to appear, and use the *O* index. If you use the main index for an overall view, and set the meter accordingly, then *O* and *U* will be opposite the limits of underexposure (hence *U*) and overexposure (*O*) respectively, and you can check highlights and shadows against these indices to make sure that they are inside the permitted tonal range. For real sophistication, you can adapt your Weston to Zone calibration by adding stick-on Zone numbers to the dial, as shown in the illustration.

No meter on earth is going to be much help with fireworks, which is why it is a good idea to stick with a single film and learn its vagaries. Long exposures (1 second or more) and small apertures (f8 or less) are best for this sort of sky-burst: this way you can record the background reasonably well, without 'burning in' the fireworks into white streaks. (*Mamiya RB67, 90mm Sekor: ER*)

If on the other hand you persist in using an integrating reflected-light meter, *i.e.* if you are not taking limited-area readings, but reading the subject as a whole, you have to make *two* mental adjustments, *in opposite directions*. First, you have to decide whether the subject is, taken as a whole, lighter or darker than an 18 per cent grey. There is no way of measuring this, except by reference to an incident-light meter, so you have to rely on experience. If the subject is *lighter*, you will need to give *more* exposure than the meter indicates; otherwise, the 18 per cent grey picture will come out too dark when compared with the light-coloured subject. If the subject is *darker*, you will need to give *less* exposure. How much more, and how much less, will depend on how much lighter (or darker) the overall subject

is than 18 per cent. Then, if the tonal range exceeds 9 stops, you will also have to adjust for the shadows or highlights as before, which means giving *more* exposure for shadow detail or *less* exposure for highlight detail. Confused? So am I! And yet this is the technique which you *have* to use with any through-lens meter which does not offer selective-area metering, and which you have probably been using until now. Incident-light metering is obviously far, far easier and more accurate, which is why I always use it whenever possible.

A fundamental truth in exposure determination is that the 'correct' exposure is the one which gives you the effect that you want, even if this is 'over' or 'under' in conventional terms. There is no point in wandering from the manufacturers' recommendations about film speed and processing just for the fun of it, but if you find that variations in technique and approach give you a result which you prefer, then use the variations.

As for film choice, there is little to be said. I generally use either Pan F (ISO 50) or HP5 (ISO 400), both from Ilford, but the Kodak and Agfa equivalents are also very good. I rarely use medium-speed films, because I see them as an unnecessary compromise. I believe that it is better to have speed when you need it, and to go for the finest possible grain otherwise, but I know that many disagree with me. An interesting possibility is using HP5, but developing it in Perceptol fine-grain developer: the effective emulsion speed is reduced to ISO 200–250, but the grain structure is very modest and the tonal range is, I think, superb.

METERING FOR COLOUR REVERSAL

Metering for colour reversal (transparency) film differs from black and white metering in three important ways. First and most obvious is that you are no longer dependent on tone alone to differentiate between different parts of the picture, you also have colour. This may sound self-evident, but you can still be caught out on it. A red motor-car against a green hedge may have tremendous colour contrast, but virtually no tonal contrast: you do not have to worry about this in colour, but in black and white you do. Second, although the tonal range which a colour reversal film can record acceptably is at least as great as the tonal range which a black and white film can record, the range across which colour can be acceptably recorded is much smaller: if the brightness range is much greater than about 8:1 (3 stops), or at most 16:1 (4 stops), then the colours of tones which fall outside this range will be unacceptably 'washed-out' if overexposed, or murky if underexposed. In

studio photography the lighting can be manipulated so that the tonal range is within these limits; on location, however, and especially in the open, you have to sacrifice tones which fall outside this range, though you may sometimes be able to use fill-in flash on the principal subject; we shall return to this later in the section on colour negative films. Third, the convention in colour photography is to expose for the highlights, and let the shadows block up — the exact opposite of black and white practice. The reason for this lies, once again, in the limits of the effective tonal range of the film. If you exposed only for the shadows, you would have a great deal of burned-out highlights, which looks horrible, whereas with black and white the losses in the highlights are negligible and usually acceptable.

The Zone System terms, about 'lightest tone distinguishable from white', 'lightest tone showing texture', and so forth are made rather more comprehensible by this picture. This is one of the very few occasions in this book where I have 'cheated': it was shot on FP4 in a Nikon, using a 55mm Micro Nikkor. If you examine the very fine detail, you will see where it is 'mushy' compared with a medium-format shot.

You would expect Hasselblad to know a thing or two about print quality. Look at the way this publicity shot holds detail in the chrome and in the body. I suspect that the tonal range must have been compressed in development — in addition to use of very flat lighting — in order to achieve this result.

Once again, incident-light metering comes to the rescue. Using the reading straight off an incident-light meter, with no modification whatsoever, will give a perfectly adequate reading for most subjects. If you want extra detail in bright highlights, such as the texture of a *broderie anglaise* dress or a damask tablecloth, you have only to give a half stop *less* exposure in most cases, or a whole stop for a blindingly white subject. If you want more detail in the shadows, a half stop or a stop *more* exposure is what is needed. This is easy to remember, because you obviously give less exposure if you do not want the subject too bright, or more if you do not want it too dark. Compare this with the mental gymnastics described above for reflected-light readings, and remember that exposure for colour reversal is considerably more critical than for black and white!

You can, however, use a limited sort of 'zone' reading for colour transparencies. The Weston Master meter, in addition to all its other markings, also has *A* and *C* indices one stop each side of the main index. Using *A* for the shadows and *C* for the highlights indicates the realistic limits for first-class colour rendition, just as the *U* and *O* marks do for black and white.

Although changing the first development time for reversal materials changes contrast and effective film speed (just as for black and white), the extent of the possible change is limited and usually leads to unacceptable colour or grain,

Sometimes, high contrast in printing can be used to add an intentional feeling of starkness and mystery to a picture: where is this door, and where does it lead? *(MPP Mk II with 6×9cm back, 6in (150mm) Tessar: FP4/ Microphen)*

etc if taken beyond very modest limits. There are, however, photographers who regularly underexpose by a third of a stop and have their transparencies 'pushed a third' to clean up the highlights. There is now far less need to do this than there used to be, and (for my money) the Kodak Professional ISO 100 films deliver more than acceptable quality without resorting to this ruse. This and Fuji's ISO 50 material are easily my favourite films, and if I need anything faster I normally use Ektachrome ISO 200, pushed one stop to ISO 400 if need be, though for mixed lighting (including fluorescents), ISO 400 filmstocks seem to be superior. Like many people who shoot transparencies for reproduction, I prefer a slightly 'heavier' image than is ideal for projection, perhaps a third of a stop darker, which means that the films are effectively being rated at an exposure index (EI) a third of a stop faster than the manufacturers' recommendations — EI 64 for ISO 50 materials, and EI 125 for ISO 100. The term 'exposure index' is used to distinguish this practically-determined figure from the ISO (International Standards Organisation) speed, which is determined according to strictly defined procedures. All the same, do not be afraid to set your meter according to your own preferences, rather than according to the box's recommendations!

As an aside, it seems that 'amateur' 120 reversal films are on the way out, and that we shall have to buy 'professional' films only in the not-too-distant future. Although professional films deliver better quality in the studio, especially when it comes to delivering truly neutral whites, it is debatable whether the difference is detectable in most types of outdoor photography. And it is at least arguable that professional films are actually inferior for some purposes, including the more rigorous types of travel photography, because they are more sensitive to poor storage than their humbler (and cheaper) brothers.

For the ultimate in colour fidelity and exposure accuracy, it is best to buy your film in bulk and batch-test it, which enables you to establish a personal exposure index for all film of a given emulsion number, and to establish what colour corrections (if any) you wish to make using CC filters, as described in Chapter 3. This kind of testing is, however, only useful if two conditions are met. First, it must be properly conducted, shooting the film under controlled (and typical) conditions, and then comparing it with previous test results. Second, it must be realistic. If you shoot out of doors, under varying light conditions and habitually bracket your exposures, the value of super-accurate batch testing is at best marginal. In studio surroundings, by electronic flash, you may find it essential.

METERING FOR COLOUR NEGATIVE

Colour negative film is another kettle of fish again! To begin with, best results are normally obtained with modest overexposure. I have seen learned tracts explaining this, but I am convinced more by experience. I habitually rate ISO 100 colour negative film at ISO 64 for rollfilm and ISO 50 for 35mm 'happy snaps', another example of the way in which one can establish personal exposure indices. This obviously results in a somewhat denser negative than usual, and amateur-oriented processing labs have been known to mutter darkly about 'bloody professional negatives' when faced with this technique.

The tonal range across which colours are acceptably rendered is about the same as for colour reversal film (perhaps a little greater), though because you are using a neg/pos process, there is some scope for dodging and burning at the printing stage.

The main uses for colour print film in serious photography are portraits, weddings and landscapes. With portraits, you can usually control the lighting to ensure the correct tonal range, and if your tastes run to still-lifes you can do the same there. For weddings you may find that fill-in flash helps to even out the lighting on the principal subjects, though you must make sure that they are reasonably equidistant from the flashgun. In landscapes there is very little you can normally do!

6 · The Medium-Format Darkroom/Projection

First-class darkroom technique is a fit subject for a book in itself, but it is worth making a few observations here on the ways in which medium-format darkroom work differs from 35mm with which I assume you are already familiar. If you do your own processing and printing, or if you want to project your pictures, you may well find that you have to invest in a good deal more than just another camera system. Developing spirals (and sometimes tanks), enlargers and projectors will all be different. This chapter is mainly about darkroom equipment and techniques, though there is a short section at the end on projectors.

Of course, if you use only colour transparency materials, never want to print your pictures and are always shooting for reproduction rather than for projection, none of this will affect you! Similarly, if your main interest in moving up to medium-format photography is the commercial exploitation of portraiture, confirmation, bar mitzvah or wedding photography then there is no real need for you to become involved in the darkroom side of things; it will be far easier, and more profitable, to use the services of the various professional labs which are specifically set up to deal with this sort of work.

But if you are interested in black and white photography, either as a fine art or as a commercial undertaking, you will probably find it a good deal more rewarding to print your own black-and-whites yourself. It is true that there are some first-class commercial black and white printers about, but they are few and far between and their prices are often terrifying; hiring them is really only practical if you are suddenly earning so much money from your photography that you can afford their rates. Besides, there is a great deal of satisfaction to be had from making your own prints, and there is the opportunity to crop, burn and dodge in *precisely* the way that you want, working towards your vision of the perfect print, rather than having to communicate what you want in words.

Again, if you are interested in producing the finest possible colour prints, commercially or otherwise, you will usually do best to undertake your own printing. In this case you may wish to consider the pos/pos route rather than the usual pos/neg one. Many people find that Cibachromes produced from transparencies are vastly more attractive

than any other form of colour print, and it is undeniable that the process is a good deal easier to master. The standard ultra-glossy Cibachrome is not suitable for all applications, and the eggshell-finish Cibachrome Matt is not to everyone's taste, but if they do suit your purposes they may be a good option. There are other direct-reversal processes, including some which make use of instant-picture technology (Agfa's is generally agreed to be slightly better than Kodak's Ektaflex), but Cibachromes deliver the best quality of all.

FILM PROCESSING

There are more differences than you might think between processing 35mm and 120 black and white film. I have assumed that for colour processing you will let a profes-sional lab do it, as they are usually quicker, more reliable (it's true — you are more likely to make a mistake than they are) and often cheaper as well.

The immediately obvious difference lies in the loading of the reels, and the only answer here is the same as with 35mm — practice. Rollfilm is undoubtedly harder to handle, especially the initial loading of the film onto stainless-steel reels, and the biggest bugbear is crescent-shaped fingernail markings caused by crimping the film as you are loading it. For really critical subjects it is as well to

Loading 120 film onto stainless steel spirals is very difficult indeed, because the film is so much wider and thinner than 35mm. Many people prefer to use plastic spools instead, though the tanks for these often use up much more chemistry.

A good medium-format enlarger, such as this De Vere 203, requires quite an investment. It is true that you can get equally good results with a cheaper machine and a first-class lens, but the De Vere will make everything so much easier.

make two exposures anyway, so that if the first frame is marked, the second will (God willing!) be all right. You can load one 120 spiral into the same size tank as holds two 35mm spirals, which at least saves on buying new tanks, but you do have to use the same amount of chemistry (and time) to develop ten or twelve rollfilm exposures as you would to develop 72 frames of 35mm.

The second difference is that if you look at the manufacturer's recommendations for developing 120 film, you will frequently find that they recommend developing 120 films for longer than 35mm, even for the same emulsion. I must confess that I have never bothered to find out why this should be so, but it seems to be correct: development times are frequently 25% longer for 120 in order to get the same print contrast and gradation as you get with 35mm. It is a fair comment that sloppy technique is more tolerable (or at least, less disastrous!) with medium format than with 35mm, but it still pays to work to 35mm standards of cleanliness, and to control time and temperature just as carefully, if you want the very best quality that the bigger format can give.

Thirdly, although most 35mm enlargers are of the diffuser-condenser type (see below) some 120 enlargers are of the diffuser type, which means either that you have to use a harder grade of paper when printing or that you have to develop the film to a higher contrast index. This means leaving it in the developer for even longer, and it also means that the effective film speed is increased slightly, typically by up to half a stop, so you will need to have your development technique in mind when you expose the film.

Finally, although you can use either single-shot or replenishment processing with 120 just as with 35mm, the arguments for replenishment are stronger for 120 because you use twice as much developer per film, as already mentioned above, and the cost of single-shot developing is therefore twice as high. Even so, the extra expense of single-shot developing is not really significant when set against the improved consistency of single-shot processing; and by buying a larger size of developer the cost differential is reduced still further, so on balance it is probably best to use a diluted single-shot developer.

ENLARGERS AND ENLARGING
Obviously, the techniques of printing medium-format negatives, whether black and white or colour, are the same for 120 as for 35mm. The only minor difference is that the bigger formats let more light through, so you can use

Hasselblad's 'giant Carousel' (though Carousel is a Kodak trade mark) is the Rolls-Royce of 6×6cm projectors — but it will still not handle 6×7cm.

smaller enlarger lens apertures or shorter exposure times or both.

If you are only used to using a 35mm enlarger, you may have quite a bit to learn when it comes to selecting something which can handle medium format as well as 35mm: so, unless you are sure that you are never going to use 35mm again or unless you are going to keep your 35mm enlarger and buy a medium-format model as well, you will need a multi-format enlarger. There are several things to watch out for here.

The first is the largest format which the enlarger can handle. It can be a false economy to buy an enlarger which can handle nothing larger than 6×6cm, because you may well move up to 6×7cm if you really become keen on medium format, and the ability to handle 6×9cm will come in handy if you ever get a technical camera which uses a 6×9cm back. If you are buying new, then 6×7cm may be a reasonable maximum; if you are buying second hand, where 6×7cm enlargers are rare, you really ought to go for 6×9cm.

The second is the type of illumination. If you buy a condenser enlarger, you will do best to get one in which the condensers can be changed according to the format in use. This ensures that the light is used as efficiently as possible. Ideally, for a 6×9cm enlarger you should have 6×9cm, 6×6cm and 35mm condensers, but 6×9cm and 35mm will usually be enough (there are rarely special condensers available for 6×7cm and 6×4.5cm). If you use a condenser that is designed for a smaller format on a larger one, there is

severe risk of uneven illumination, and if you use a larger-format condenser with a smaller format image, the light will not be used efficiently and the penalty will be longer enlarging times.

If, on the other hand, you have a diffuse light source, there will be no need for different condensers, but you will usually have to put up with long exposure times for the smaller formats. There are two different kinds of diffuse-source lamps in use, the cold cathode head and the mixing box type. Cold cathode heads use what amounts to a coiled or zig-zag fluorescent tube, with sheets of opal glass or Perspex (Lucite) for additional diffusion. As their name suggests, they run cold, and they are also very efficient and compact, but they can only be used for black and white enlarging because the spectrum produced by the discharge tube is not continuous. The mixing box types are mostly colour enlargers, in which the light is bounced around inside a white-painted box between the lamp housing and the negative carrier, to ensure that the colours are evenly mixed and there are no 'hot spots'. A few enlargers provide different-sized mixing boxes for different formats, but these are neither particularly convenient to use nor particularly effective. It is usually easier to put up with a longer exposure time than to swap boxes.

As has already been mentioned, a major difference between condenser and diffuser enlargers is that the light

'Superslides' can be shown in most 35mm projectors, and the increased area and unusual screen-filling shape make them a real eye-catcher. For presenting medium-format transparencies for reproduction, black sleeves like this one are ideal.

Trying to get someone else to print a picture like this 'aerial' of New York City from the World Trade Center could drive you mad; so there is a strong case for doing it yourself! *(Mamiya RB67, 50mm Sekor: ER)*

from a diffuse source is 'softer'; that is, it requires a contrastier negative than does a condenser enlarger in order to produce a print with the same tonal range. An additional difference, which is optically closely related, is that condenser enlargers show up scratches, dust, fingermarks and other flaws on the negative with merciless clarity, while diffuser enlargers tend to make these less obvious. Many people also feel that a diffuser enlarger gives a smoother

79

tonal gradation than a condenser enlarger, though this is open to dispute. In practice, there are very few true condenser enlargers about, because most so-called condenser enlargers use an opal lamp as the light source, which is diffuse to start with, so they should properly be called condenser/diffuser enlargers. Even so, condenser/diffuser enlargers do show up dust and scratches far more clearly than do diffuser designs.

Because the cost of dichroic filters rises dramatically as they increase in size, you are likely to discover that a dichroic colour head for medium format costs disproportionately more than for 35mm; of course, the as yet smaller demand for medium-format equipment only makes this problem worse. One solution to this problem is to use gelatine colour filters in a drawer instead of a dichroic head; another is to buy second-hand.

A third consideration in choosing a multi-format enlarger is convenience — to wit *how well* it handles the different formats. Some enlargers which are a dream with 120 can be a nightmare with 35mm. The main consideration here is the negative carriers, which may be double-glass, single-glass or glassless, and you will either have to use different carriers for different negative sizes or be able to adjust the frame size in a single carrier.

Although for 35mm there is little or no need for glass carriers — the film can be held flat enough without — opinions differ when it comes to the larger formats. My own view (supported by use on many different enlargers) is that a well-designed glassless carrier is more than adequate for 6×4.5cm and 6×6cm, good enough for 6×7cm and just about adequate for 6×9cm. The big disadvantage of glass carriers, of course, is that each sheet of glass introduces two more dust-collecting surfaces, so a conventional glass sandwich carrier has six dust-collecting surfaces (two sheets of glass plus the film), a single-glass carrier in which a sheet of glass is used to hold the film over an aperture has four, and a glassless carrier has only two. Of course, a lot depends on your own darkroom and working methods, and quite honestly I have had very little trouble with dust with single-glass carriers (though double-glass carriers are another story). I use Dust-Off 'tinned wind' to blow negatives clean before putting them in the carrier, and this seems to work very well; I also have a wide, soft Chinese brush which is very useful.

If you have separate carriers, you can obviously have glassless ones for the smaller formats (or at least for 35mm) and glass ones for the larger formats if you think that they are necessary. On the other hand, separate carriers can be expensive, and unless you store them carefully they can

collect dust while out of the enlarger. The two main advantages of combination carriers are that the better designed ones are very convenient to use (though some of the others are disastrous), and that you can mask off any unwanted portions of the negative as well as setting the film aperture to *exactly* the correct dimensions. This is particularly useful with 6×7cm and 6×9cm negatives, because actual sizes can vary comparatively widely. My Mamiya RB67 produces 56×68mm negatives, while my Linhofs produce 55×72mm. It is true that this is a maximum difference of only about ⅙in, but even this can be significant! If you do have fixed-aperture separate carriers then at least be sure that the gate is *bigger* than your negatives, and consider filing them out if they are not; blacken the edges afterwards. The problem then is that you have non-image-forming light showing around the edges, which is a wonderful source of flare.

Whatever sort of carrier you use, it should work conve-

This is from the very first film I ever shot on my own Hasselblad. I had been printing from 35mm for years, but I was stunned by the quality which was now so easily attainable. (500C, 80mm Planar: FP4/Perceptol)

niently with all formats, not just with some. If the machine can handle both the largest rollfilm size and 35mm conveniently, then it can probably handle the intermediate sizes too.

The last thing to consider with medium-format enlargers is the lens. As with camera lenses, the requirements for medium-format enlarger lenses are not as stringent as those for 35mm, so you can use comparatively simpler and cheaper designs. For black and white, all but the cheapest lenses are normally adequate, the more so because you can normally use them at somewhat smaller working apertures than for 35mm.

The standard focal lengths for enlarging are the same as the standard focal lengths for camera lenses so, in theory, you need an 80mm lens for 6×6cm and 6×4.5cm, a 90mm lens for 6×7cm and a 105mm lens for 6×9cm. In practice, most people find that a single lens is adequate; using some 80mm lenses with 6×9cm may be pushing your luck, but a 90mm lens will usually cover 6×9cm more than adequately, and a 105mm lens can obviously be used with all formats. Be sure to check the maximum enlargement size on the baseboard, though: a lens which allows 12×16in (say 30×40cm) on the baseboard with 6×7cm will only allow 8×12in with 6×4.5cm.

BUYING SECOND-HAND

If you intend to print only black and white, you may well be able to find a first-class, professional-quality enlarger at a bargain price, either by scouring the used camera stores or by reading the small ads. Most professionals will not be interested in old medium-format black and white enlargers, because they usually need colour as well, and at the moment only a few serious amateurs want anything more than 35mm. With colour, you are likely to find prices rather higher, but you can still pay as little as a half or a third of the price of a new enlarger for an excellent used example.

If you are offered a second-hand enlarger, it pays to check the following points:

1) The general condition and rigidity. There should be no play in the controls and no wobble, even when the head is at the top of the column. Check that the baseboard is not warped. For dichroic heads, check the condition of the dichroic filters (without touching them!).

2) The parallelism of negative carrier and baseboard. On some models this is adjustable; on others it is not. Check either with a spirit level or by projecting the image of a piece of finely scratched fogged film onto the baseboard.

3) The availability and price of any accessories which you will need, and which are not included in the price. These can include extra negative carriers, lens panels (if applicable) and condensers. Also check the availability and price of spares and consumables: condensers, filters and lamps.

PROJECTORS FOR MEDIUM FORMAT

The range of projectors available for medium-format transparencies is much more limited than for 35mm. The features are usually less impressive, and prices are in general far higher. This is obviously because few people project medium-format transparencies, though the effect when they are projected is often magnificent. Basically, there are three options for medium-format projection.

For 6×6cm and smaller transparencies, mounted in 7×7cm standard projection mounts, you can choose from a fair range of projectors including the excellent Hasselblad version (which resembles a monster version of a Kodak Carousel), the straight-magazine Rollei projectors and the simple push-pull models in which slides are individually changed; the last are available both new and used from a number of manufacturers.

For 6×7cm transparencies, the choice is extremely limited. You can either use old-fashioned magic lantern projectors (which will also handle 6×9cm and even quarter-plate), or you can use the big, simple, but very well made and expensive Linhof projector.

The last option is the maverick. The 4×4cm 'superslide' format can be mounted in 5×5cm (2×2in) standard mounts and projected in most (but not all) projectors suitable for 35mm. There are two major advantages to the superslide format when it is compared with 35mm. It is larger and brighter (the area is about twice as great as that of a 24×36mm transparency masked to the usual 22×34mm), and because of the square format you can also use the full screen area, without worrying about portrait and landscape format. Superslide presentations can be very impressive indeed, and you can make superslides by cutting and masking larger transparencies or by using the special 4×4cm back available for Hasselblads. Until recently, you could also use 127 cameras such as the Baby Rollei, but 127 colour reversal film is no longer readily available. The only reason why you cannot use all 35mm projectors for superslides is that on some (usually the cheaper models) there is vignetting at the corners of the projected image.

7 · Lighting

If you already have lighting, then there is absolutely no reason why you should not continue to use exactly the same lighting techniques and equipment as you have been using with 35mm — including using no lighting equipment at all, if that is what you want. But because moving up to medium format usually implies an increased commitment to photographic technique, there must be a place in a book such as this for a section on lighting and lighting techniques. If you are already familiar with this subject, you may wish to skip this chapter; alternatively you may like to use it as a refresher.

There are four main considerations when considering light: intensity, source size, direction and colour. *Intensity* is the one with which we are all most immediately familiar, and Chapter 5 *Film and Metering* covers all that need be said here.

Source size is more important than it might at first seem. A point source gives a very hard, directional light which casts very sharp shadows; think of bright sunlight, or a bare bright bulb or a flash gun. A larger or diffuse source, on the other hand, gives a much softer light and may cast no shadows at all: think of a white sky on a cloudy, rainy day. Between these two extremes are all kinds of different source sizes, each of which produces its own special effects.

Direction is another topic which is more complex than it seems. Millions of years of evolution have accustomed us to sunlight, a single source which comes more-or-less from above — though unless we live in the tropics, we expect it to cast a slanting shadow to a greater or lesser extent. Lighting from below is curiously disturbing, and so are multiple light sources which cast more than one shadow. Unless we make some attempt at reproducing 'natural' lighting when we use additional lamps, we are unlikely to achieve much success.

Colour is something that we are all aware of, when we think about it, though the capacity of the eye to adapt to quite a wide range of colours and see them all as 'white' can fool us quite easily. Variations in colour are not that important with black and white film (though they still

matter), but with colour film they are critical. In order to understand the colour of light, the easiest approach is to consider *colour temperature*. If a perfect 'black body' is heated it will give off light in a continuous spectrum, and the hotter it is, the more blue the light will be. A familiar example of variation in colour with temperature is a welder's torch, which burns with a (comparatively) cool yellow flame when the welder is not using it, but which glows a fierce bluish-white when it is heated for cutting or welding. In the real universe, there are few, if any, perfect 'black bodies', but enough things which are heated behave in a sufficiently similar way to this imaginary object for us to be able to use the concept.

The colour of any light can be defined in terms of the temperature to which a 'black body' would have to be heated to produce that light. This is a little confusing, because it means that the *hotter* the source is, the more blue the light is — and we normally think of blue as 'cool' and red as 'warm'. Nevertheless, it is not that hard to get used to, and after a while you can actually perform the difficult trick of saying that you need a warming (= amber) filter because the colour temperature of the light is too high, or a cooling (= blue) filter because it is too cold. For example, a candle burns at about 1750° Kelvin, a temperature scale based on absolute zero (about −273° Celsius), and its yellowish light is therefore said to be at 1750°K. A domestic electric lamp runs at about 2800°K, rather hotter and therefore rather more blue, and photo-lamps burn at 3200°K or 3400°K depending on type. The noon-day sun corresponds to about 5000–5500°K, but because of all the blue sky which surrounds the sun; the effective colour temperature of daylight is normally taken to be 5800–6000°K, while the colour temperature of the sky alone may be as high as 20,000°K. Near dusk or dawn, though, daylight is much more reddish and can be as low as 4500–5000°K. Electronic flash is balanced to give the same light as standard daylight; in other words, the colour temperature of the light is about 6000°K. Some tubes run a little more blue than this, and require a CC05Y filter to bring them back to daylight, and others (especially the 'gold tube' models) run a little warmer, *i.e.* yellower.

Although our eyes can accept all of these colours of light as 'white', we know that they are not all the same colour. We can see that a candle burns with a yellowish flame when we compare it with daylight, and we know that the world looks blue when we look out from a lighted room at dusk; conversely, if we are out walking at dusk, lighted windows look yellow. Colour films are not blessed with the same degree of adaptability as our eyes (or, indeed, with any

This dramatically lit portrait of an actor in traditional *Lhamo* costume was the product of dire necessity. It was pouring with rain outside and the auditorium was pitch dark, so I made a virtue out of necessity by using an open door to provide side-lighting and letting the background go dark. A Lastolite reflector, held on the right by an assistant, furnished some filled-in light. (*Linhof Technika 70, 100mm/f2.8 Planar: ER*)

86

adaptability at all), and they must therefore be constructed or filtered to respond to a particular colour of light. In normal use, there are two types of colour film, *daylight*, balanced for 5800–6000°K, and *tungsten*, balanced for 3200 or 3400°K, depending on type; as colour temperatures rise, comparatively small changes in colour temperature tend to become less and less important. Even with black and white films the yellowish light of a tungsten lamp produces slightly different results from the blue light of daylight or electronic flash, and it is often forgotten nowadays that many black and white films are less sensitive to tungsten light than to daylight. An ISO 125 (daylight) film, for example, may only have sensitivity of ISO 100 when exposed by tungsten light, though some modern films have the same effective speed in either type of light.

If daylight-balanced film is used under tungsten lighting, the results are very orange-yellow and the image seems to be almost monochromatic. If a tungsten-balanced film is used in daylight, the opposite will happen and the picture will be very blue. Either film type can be filtered for use under the other type of illumination, so (for example) by adding a blue filter to a tungsten-balance film it can be made to give accurate colours by candle-light. For the utmost accuracy, a colour temperature meter can be used to indicate the colour temperature of light, and by comparing this with the colour temperature for which the film is balanced, the correct filtration for neutral colour balance can be determined. Two useful rules of thumb are first, if you do not have exactly the right filters needed then use the closest you have, and second, if you are going to err, then err on the warm side. A slightly warm-toned transparency is almost always more acceptable than one which is bluish.

There are no problems until we start trying to mix light sources. Then we are likely to find irremoveable blue or yellow shadows, and produce a picture in which the colour balance looks very strange indeed. The only possibilities here are to use light sources of the same colour temperature, or to filter the light sources themselves.

Unfortunately, putting blue acetate filters over photofloods is simply not a good idea, because they melt, and while it is possible to cover windows with amber filters, it is expensive and awkward. Cinematographers use blue dichroic filters over tungsten lamps, but these are very expensive indeed and somewhat fragile, so unless you have a studio from which daylight can be entirely excluded, you would be well advised not to use any form of tungsten lighting for colour photography.

An even greater problem arises with fluorescent lamps. Because these do not emit a continuous spectrum, it is

actually impossible to filter them to give a good colour rendition with either daylight or tungsten film. In most cases, a CC30M will give tolerable results with daylight film, or you can buy one of the proprietary FL-D or FL-A filters but again these give nothing better than a barely acceptable result. Even with black and white film, fluorescent lamps can give some pretty unpleasant effects. Their bluish or greenish light accentuates skin blemishes and can confer a corpse-like pallor, as anyone who has examined their face in an aircraft lavatory's mirror will know! Any mixture containing two or more of daylight, tungsten light and fluorescent light is likely to prove very difficult indeed.

I said earlier that effective lighting must (usually) resemble natural lighting, unless some unusual effect is required. To this end, lights are normally used in three ways. First, there is the *key*, which is the main light and casts the shadows; this corresponds to the light of the sun. Second, there is the *fill*, which (as its name suggests) fills in the shadows and determines the lighting contrast, and corresponds to skylight and the light reflected from surroundings. Finally, there are various *effects lights*, such as 'kickers' used to put on highlights, or backlighting to accentuate hair; these have no real counterpart in nature, but they create the same impression as, for example, sunlight sparkling on water, or a jewel catching the light.

The key is normally a fairly powerful light (though the total power of the fill may be greater), and it is more-or-less

Basic tungsten lighting, such as that provided by low-cost Photax units, can be incredibly versatile — but using it is harder work than using more sophisticated (and expensive) equipment

Bowens's Monolites are so widely used that 'Monolite' is often used by photographers as a generic term to cover similar products by other manufacturers.

strongly directional. It is normally positioned slightly above the subject and to one side, in order to show the modelling or roundness of the subject: the more oblique it is, the more it will show the modelling. The fill is much less directional, and usually comes from in front of the subject. As described in Chapter 5, lighting contrasts for colour film should not exceed 4:1 and may even be as low as 2:1. In some cases, when shadowless lighting is required, there is no key light, or rather, the key and the fill are combined. In other cases, a reflector can be used instead of a fill; light spill from the key light is bounced back into the shadows from a sheet of white-painted board or expanded polystyrene, or a purpose-made reflector such as a Lastolite. Finally, the effects lights are normally very directional, either focused (as with a spotlight) or 'snooted' or both.

The ways in which these various types of light are used are described at greater length in the appropriate chapters of the second part of this book, as are special techniques such as backlighting, rim-lighting and the use of 'tents' or enclosures for all-around lighting: what we are concerned with in the rest of this chapter is the equipment itself.

A big northlight (or 'swimming pool') would normally be used to obtain flat, non-directional lighting on a polished metal statuette like this. You would need to be fairly lucky to have a studio which provided a reliable north-facing window! (Linhof Super Technika IV, 105mm/ f4.5 Apo Lanthar: Agfachrome 100)

ON-CAMERA FLASH

There are only two real differences between on-camera flash for medium-format and for 35mm. The first is the method of attachment. Very few medium-format cameras offer a hot-shoe, and even on those that do it is likely to be a part of an interchangeable finder. On the Mamiya 645, for example, it is mounted on top of the prism, and the basic camera comes with a waist-level finder. Many cameras do not even have an accessory shoe, so mounting on some sort of bar under the camera is essential. The big 'potato masher' or 'hammerhead' guns often sit more comfortably on this than do the smaller guns which are usual in 35mm, and also provide a much more comfortable grip. Second, because the lenses on rollfilm cameras are usually slower, you will need a fairly powerful gun if you plan on using flash at any distance or if you want to stop down for depth of field.

A third point, which will affect you if you are used to dedicated flash or off-the-film flash metering, is that such sophistications are as yet relatively unknown in medium-format cameras, though they can certainly be expected to spread. Because these features are rarely of use to professionals (news men tend to use 35mm, and others use studio flash), there is no great pressure on manufacturers to incorporate them.

There are also a couple of things worth noting about

Hasselblads. First, the rail along the side of the body which bears the camera's name is actually a form of accessory holder and accepts various Hasselblad bits and pieces. Second, the older 500C and 500C/M models have an additional flash socket on the body, which is triggered by the opening of the rear auxiliary shutter, though only at shutter speeds of ⅛ second or longer (or with a shutterless lens). This can cause much woe if it is used instead of the main socket on the lens, which is presumably why it was deleted, but it can be useful if you want to make up a copying-stand using a bellows and a shutterless lens.

With leaf-shutter cameras, do check that the M/X lever (if fitted) is set to X for electronic flash. If it is not, the delay between firing the flash and opening the shutter (essential for giving flash bulbs time to light up) will mean that the flash may be over before the shutter is open. The additional setting on this lever, found on some cameras and labelled V, is a self-timer and not a flash setting at all; it can normally only be set when the shutter is cocked. Many people actually tape this lever in the X-synch position, so that it cannot be moved by accident or by the idly curious.

STUDIO FLASH

For studio lighting, electronic flash has many advantages. It is, as we have already seen, the same colour temperature as daylight — and unlike incandescent lamps, which change in colour balance as they age, that colour temperature remains constant. Electronic flash runs a lot cooler than tungsten lighting, and uses less power; it is quite an experience to work, for example, on a car shoot, where up to 50Kw of continuous lighting may be used. Although the initial cost of the flash equipment is considerably higher than continuous lighting, the running costs are much lower; not only is power consumption less with flash, but you do not have to keep replacing short-lived bulbs.

It is quite possible to use several ordinary on-camera flash guns with slave cells to fire them, but this is a very difficult way of going about things. It is far easier if you have 'modelling lights' incorporated in the flash and if the guns themselves are reasonably powerful.

The basic portable studio flash kit consists of a couple of mains-powered flash heads with built-in power packs and modelling lights, a pair of lighting stands, two umbrella-type reflectors, a slave cell and a flash meter. Such heads are available in varying powers, from about 80 watt-seconds (joules) to about 400 watt-seconds, and the output is usually switchable to one half, one quarter, one eighth and sometimes one-sixteenth power. Modelling lights may or

It is possible to fit all kinds of accessories even to portable units. This Bowens set up gives some idea of the versatility available with a multi-light set-up.

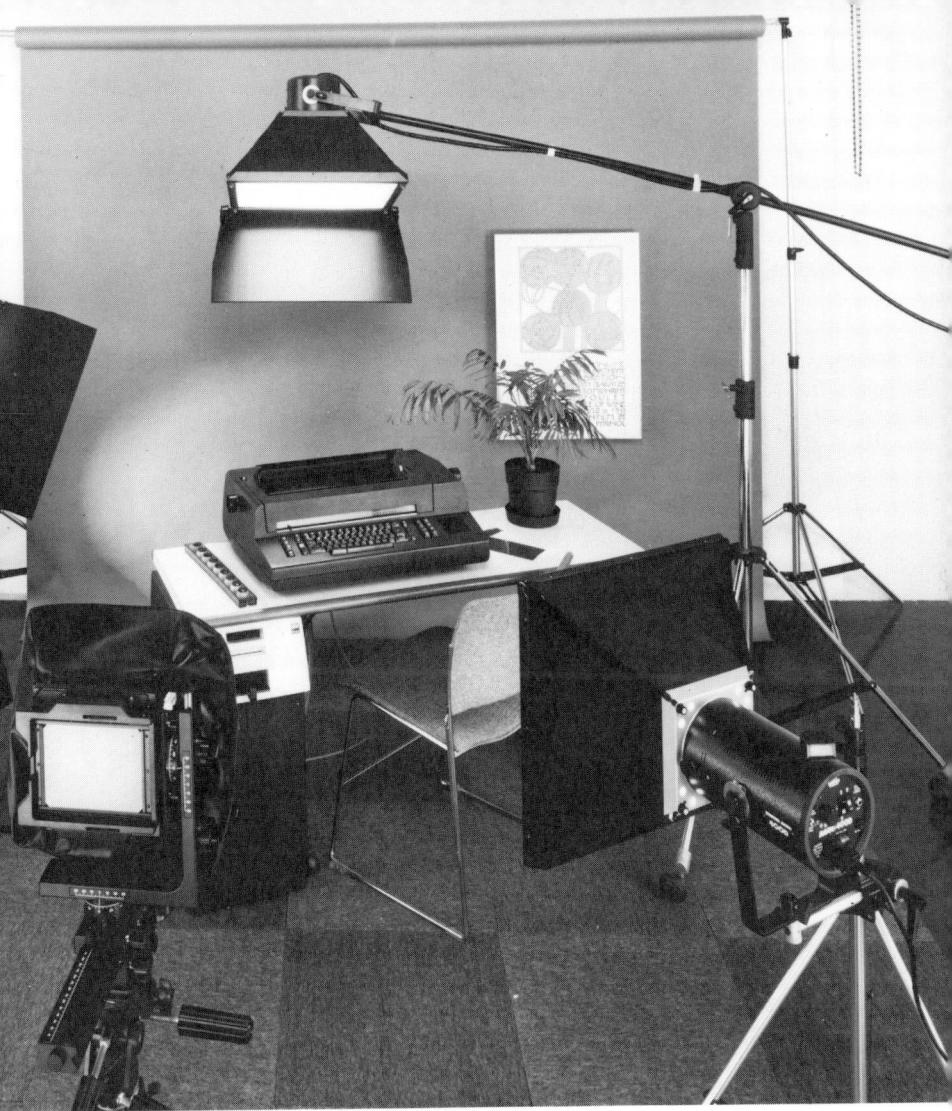

may not be switched proportionately though it is obviously better if they are. 'Professional' units will usually have all the features listed above, while 'amateur' units are usually less robust, tend to be at the bottom end of the power range and may miss out on the full range of power reduction options and on proportional modelling lights.

Normally, the camera will be connected to one of the heads by the synch lead, and the other head will be fired automatically by a slave cell which is triggered by the first but a useful technique can be to fit *both* heads with slave cells, and use a small, low-powered on-camera flash as a trigger. Unless you are very close to the subject, the output

of the on-camera flash will be negligible (and you can always point it away from the subject anyway), but it does free you from trailing cables and potential poor connections and breaks, etc.

Rather than indulging in complicated calculations based on the guide numbers of two different flash-guns at two different distances from the subject, the usual technique is to use an incident-light flash meter at the subject position. Although these used to be very expensive and not terribly reliable, there are now several reasonably-priced units on the market which are more than accurate enough, though with any serious flash work it is a good idea both to bracket and (preferably) to make Polaroid tests as well. Flash meters may be either cordless (in which case the flash may be fired either manually or with the camera) or synch-lead types, in which case a test button on the meter fires the flash.

The heads can be used as bare-bulb flash, or with various sizes of reflector and diffuser, or 'snooted' for effects. If you want to increase the versatility of the outfit, adding a third head is normally enough for most people. If you need more light than this you should consider a different kind of flash system, with a separate power pack and several heads, with the output of the pack switchable between the various heads. The smaller versions of such outfits, typified by the Bowens Quadmatic, are hardly less portable than the integral-head type but do allow the use of rather more sorts of head. The most important of these is the 'northlight' or 'swimming pool', a really big diffuser at least 4ft (130cm) square and possibly as big as 4×6ft (130×190cm). These are ideal for use as a fill light, and tend to be considerably more efficient than umbrella-type diffusers/reflectors, as well as allowing less spill. A smaller version of the same thing, sometimes known as a *fish fryer*, is made by some manufacturers.

Beyond the Quadmatic, you are running into truly massive and distinctly non-portable equipment such as the big 5000 joule packs by Strobe and the like. If you know enough about lighting to need one of these, then I suspect that you are reading this book more out of interest than because you need information.

With all of these big guns, remember that you are dealing with potentially lethal electric charges, and treat them with respect. Do not, as one of my friends did, casually press a flash tube back into its socket on a 'swimming pool' connected to a Strobe 5000; it threw him across the room and he still has a burn scar the size of a small coin on his thumb. He was lucky; some people have been killed this way.

INCANDESCENT (CONTINUOUS) LIGHTING

There are three main reasons for using incandescent (or continuous) lighting instead of flash. The first is cost, especially for amateur equipment: the sort of basic outfit already described for electronic flash would cost only about a quarter as much if it were tungsten instead of electronic, and a familiar meter can be used. Admittedly, you have the expense of replacing bulbs, but although this may add up over the years, the expenditure each time is not all that great. The second is that incandescent lighting is simple. If you can wire a plug, you can diagnose and cure most of the faults which are likely to arise. The third is that some people find it easier to work with a continuous source, rather than relying on modelling lights, experience and intuition.

Incandescent lighting is certainly very attractive if you only want a couple of lights — and a modest outfit can be surprisingly versatile, as we shall see in the second part of this book — but it is not such a good idea if you want to build a full studio outfit. Although the equipment is comparatively cheap, which makes it look quite easy to build up a larger outfit, there are major problems. To begin with, building a big fill, equivalent to the 'swimming pool', usually involves a lot of lights. The usual solution is to construct a big trough with anything between four and a dozen lamps, and the heat output is tremendous. The smallest size of photoflood readily available is 275W, and as these things radiate rather more heat than an electric fire of the same rating, four lamps kick out 1.1Kw (roughly the same heat as a 1.5Kw electric fire) and the 3.3Kw of twelve lamps provides as much heat as a four or five kilowatt fire. And that is before you start on the key light and the effects lights! This points up the second major objection. It is quite easy to use four or five kilowatts of light in a portrait studio, and not that difficult to use ten. Although this may be useful for keeping nude models warm, most people rapidly find it too hot, as well as rather dazzling. Another objection is that you dare not use incandescent light for anything which can melt or wilt, because it will.

You can improve matters somewhat by reducing the power of the lights when you are not actually exposing, by using a dimmer switch or a series/parallel switch, but you will need fairly heavy switchgear because you may be handling twenty or more amps, which brings us to the third major objection: most domestic supplies cannot handle the kind of current that is needed. A typical English 240 volt system can only deliver a little over 3Kw through a 13 amp switched plug, and with an American 110 volt system even a 30 amp fuse can only transmit about 3.3Kw. If you can

stay within these limits, though, using such a switching system will not only make life more comfortable; it will also radically improve lamp life, especially if you always switch the lamps on at reduced power and warm them up before going to full power, because it is the surge voltage through a cold filament which usually blows a lamp. On the other hand, the switchgear will probably cost you as much as an electronic flash outfit.

This concludes the section on the technical side of medium-format photography, and the rest of the book is devoted to typical applications of medium-format equipment and techniques.

PART TWO

Introduction

The second part of this book deals with twelve main applications of medium-format photography. As in the first half of the book, I have assumed a basic familiarity with 35mm equipment and technique, and have concentrated on the ways in which using medium-format equipment differs from 35mm technique. As I have said before, medium-format cameras are not suitable for every type of photography, and where appropriate I have pointed out those areas where medium format can be used with advantage, and occasionally where it would be better to stick to 35mm. The remaining chapters of this book cover a range of amateur and semi-professional subjects, and are in alphabetical order, as follows:

8 · Architecture

Unquestionably the best medium-format choice for architectural photography is the technical or monorail camera with movements, and the last part of this chapter is devoted to explaining the use of these movements. The second choice must be a reflex camera with shift lenses and the third is either a reflex or non-reflex with interchangeable lenses, especially wide-angles. Any camera with a ground-glass should be used with a grid-ruled (checked) screen, as this makes lining up verticals much easier.

No matter which camera you use, though, there are certain ground-rules which remain the same. You must choose carefully your season and time of day, and you must also decide which aspects of the building you want to emphasise or concentrate upon, and then show them. Both of these observations may seem obvious; but when you look at a great many pictures, you can see how often they are ignored.

The question of season, weather and time of day is one which any professional will automatically think about, but which is all too often neglected by most amateurs. It is not just vegetation which shows the march of the seasons; the quality of the light throughout a year is different, and any people who are in shot may well be dressed differently. For most people, spring and summer have more positive associations than winter, while autumn is a tricky season, not least because fallen leaves (and man-made rubbish, such as pieces of paper and chocolate-wrappers) can be piled up by autumn winds and change the impression which a scene creates. Again, bright and sunny weather creates a different mood from rain-lashed streets. If you have to shoot in wet or gloomy weather try shooting at around dusk, as the natural light begins to fade and the lights of the buildings come on. This helps to create the impression of a haven of warmth of shelter, while using the reflections of the light to create visual interest in the picture; the topic of low-light photography is dealt with at greater length in Chapter 12 low light photography.

Finally, time of day affects the direction from which the light comes, and may well affect the haziness of the atmosphere as well. At dawn, the air is usually at its cleanest and the light is from the east; lunch time, when the sun is at its peak, may be the only time that sunlight

penetrates into the concrete canyons of a great city; and evening, when shadows lengthen again and the light reddens, has a magic of its own which can be captured by camera. Dust and exhaust fumes may create a completely different mood from that of dawn, quite apart from the way in which streets become crowded when people are returning home. Sometimes you may have to wait two or three minutes for the sun to come out from behind a cloud, sometimes you may have to return later in the day and sometimes you may decide to come back on another day or in another season. Some photographers always carry a compass, which gives them a good idea of when may be the best time to return, when scouting out a new location. It is only by going to such lengths that the very best pictures can be obtained, and even if you have neither the time nor the inclination to do this, you can accomplish a good deal by applying the techniques as far as you can.

When it comes to choosing an aspect of the building and portraying it, you inevitably approach your subject with some degree of bias. Some photographers swear that they come to their subjects with no preconceptions, with their minds a pure Zen-like mirror waiting to reflect via the medium of photography the true likeness of whatever they

This is neither the fairest and loveliest office block in the land, nor the best picture of it (see the following spread), but it does show how movements are used. It was impossible to photograph the building 'square-on', because it would have involved working in the middle of the road. The first picture shows the 'zero movement' picture; the second shows the use of cross, to obtain — if you will forgive the pun — a 'middle of the road' picture; and the third shows how rise is added to cross to give parallel verticals. *(MPP Mk VII, 6×9cm rollfilm back: FP4/Microphen)*

see. I do not see how this can be anything but nonsense. Even if you genuinely have no preconceptions when you first see your subject, you rapidly acquire some, and by the time you are ready to point your camera and press the shutter, you will already have made plenty of value-judgements and decisions.

The process by which you arrive at your decisions is entirely your concern. For example, I happen to like Glasgow and to dislike Edinburgh, and the way in which I portray most of the buildings there will reflect my feelings. You may well decide to concentrate on a particular period, or on the way in which local people and visitors interact with a particular building, or on details and ornament or on semi-abstract arrangements of lines, tones and colours. But unless you have some idea of what you want to say, you are unlikely to be able to say anything much. Even in architectural photography, commitment is the key to success.

Usually, wide-angle lenses are a *sine qua non* of architectural photography. Even if you can get a long enough shot to use a standard or even telephoto lens, you are likely to find that there are always people, car-parks, flagpoles, lamp standards, walls, hedges and all sorts of

It is sometimes disputable whether 'correcting' verticals is desirable, as a certain impact can be gained from allowing these to converge. Nevertheless, it is always good to have the option . If I had had the Linhof with me instead of the Mamiya, I would probably have used the 65mm Super Angulon and shot both. I should also have waited until the junction was clear! *(Mamiya RB67, 50mm Sekor: EPR)*

Queen Elizabeth I called St Mary Redcliffe 'the fairest and loveliest parish church in all the land.' Here, converging verticals really would have been unacceptable. Note how the darkening at the top of the picture, where the lens is running out of coverage even at f22, is no great disadvantage in a clear blue sky. *(Linhof ST IV, 100mm/f5.6 Symmar-S: ER)*

other things to come between you and your subject. About the only application for a long-focus lens is in photographing details — gargoyles on churches or ceiling paintings — and then, you are likely to need quite surprisingly long focal lengths.

If you have a camera without movements, you will usually need either to use the widest lens you can get (and throw out a part of the image) or to accept that you will have to tilt the camera backwards and get the familiar 'falling over backwards' effect.

An unsuspected use for 6×12cm and 6×17cm panoramic cameras arises here: they provide a hand-holdable camera with 'instant' rising front, and even if you discard half the negative, you still have a respectable-sized picture. If you have a 'shift' or 'PC' lens you can enjoy at least some of the benefits of the technical or view camera, though you will be restricted to one or at most two focal lengths.

One of the great advantages of a technical camera with movements is that you can often use a standard lens, and

that even quite a modest wide-angle such as 65mm on 6×7cm can be far more use than (say) a non-shift 50mm lens on the same format, because it allows you to compose the image much more carefully and exclude unnecessary material. If you have a camera which can accept 6×9cm backs as well as 6×7cm, it may be worth using the larger format for the extra bit of area at the top — though if you have run the lens out of movements there is no benefit in the larger size.

Whatever camera you use, be prepared to spend time looking for the best viewpoint. It is all too easy to shoot and run, when you would get a far better picture by moving around a bit and trying to get all the elements of the picture into the most harmonious combination, as well as excluding the undesirable elements mentioned above. Pay attention to backgrounds, to prominent signs, to scaffolding, to graffiti and to the hundred other things which can detract from an image. See whether you can eliminate them, or at least make them less prominent, by changing your viewpoint (including raising or lowering the camera position), by hiding them behind something else, or by changing the apparent perspective with a different focal length. Look out for interesting reflections and for dramatic features which can be emphasised by placing them in the foreground and using an ultra-wide lens, and wait for people to complete the image if needs be; a doorway with a person in it can often look much more effective than an empty one. Make sure that they are the *right* people, ones who complement the scene — or wait until there are no people around, if that is what you want. And once again, consider the use of camera movements for the ultimate in photographic control.

Camera movements — only briefly mentioned before this — are of two kinds: decentring movements, which affect the position of the image on the film, and swing and tilt movements, which are used to change the plane of focus and the apparent shape of the subject. Swing movements are about a vertical axis, and tilts are about the horizontal axis. In architectural photography the decentring movements are more useful, though swings and tilts also have their place.

Page 37 shows the circular image thrown by a 150mm/ f5.6 Symmar, working at f22, on a piece of 10×8in film. The camera is absolutely square-on to the subject, and there is consequently no 'falling over backwards' effect as there would be if the camera had been tilted. It is obvious that the area of the rollfilm format could be placed on the image in several ways, so as to get several different pictures. Most especially, by moving the camera back downwards,

relative to the lens, it is possible to show more of the upper part of the image area (remember that the image in the camera is upside-down). In practice, moving the lens upwards relative to the film (a rising front) is usually easier than moving the film downwards relative to the lens (a falling back), and has the same effect.

In the picture of the Bristol office block, both rising and cross movements have been used to get the most effective picture. It would have been possible to get the same effect by moving the camera six feet to the right and using only the rise, but it would have meant standing in the middle of a busy road — hence the usefulness of the cross movement. Cross movements come in handy whenever there is a building, a fountain, a river or a road which stops you placing the camera just where you would want it; though one of the more esoteric uses lies in taking a picture of a mirror, apparently square-on, without showing the reflection of the camera. A little thought will show how this is done.

Because the image is being projected obliquely when movements are used, the shape is slightly distorted or stretched. This is a familiar phenomenon near the edge of the field with ultra wide-angle lenses, but it occurs slightly even with standard lenses, and when a 65mm lens is taken to the limits of its movements it can be noticeable. It is rarely a problem, but it is a phenomenon to be aware of. In addition — and also as a result of the oblique projection — the areas of the picture furthest from the lens axis receive less exposure than those on axis; for the scientifically minded, the energy of the light falling on the film falls off as the fourth power of the cosine of the angle of incidence. With colour film this results in a slight and perfectly graded darkening of the image from the centre outwards, which can actually be an advantage with blue skies as it makes them appear all the richer. Finally, when the lens axis is so far from the centre of the film that the circle of sharp coverage no longer extends to the edge of the picture, the outer limits of the image suffer first from loss of image quality and then from vignetting. This can be easy to miss when you are working at the limit of the camera movements, with an image which is pretty dim at the edges to start with. Experience will usually remind you when to stop, and remember that the covering power of any lens increases as it is stopped down.

On most technical cameras you can wind the front up quite easily, and you may also have a cross front. If you have only a rising front then you can, of course, obtain a cross by turning the camera on its side (which also turns a tilt into a swing and *vice versa*). There is, however, another

way of obtaining rise and cross, and this is sometimes the only way of obtaining them with monorails.

The essence of the rising front is that the film remains parallel with the plane of the subject; it is the tilting of the camera back which produces the 'falling over backwards' effect. But if you tilt both the front and the back forwards by the same amount, so that they remain parallel with each other, and then tilt the whole camera so that they are both parallel with the subject, you have effectively created a rising (or falling) front. Swinging the front and back about a vertical axis can be used to create a cross front in the same way. This technique may, of course, be combined with existing rise and cross movements but it can be very easy to run the lens out of movements unless you watch the edges of the field like a hawk. It is also important to watch the outer areas of the screen for cut-off caused by the bellows. With wide-angle lenses on 5×4in and larger monorails, it is customary to use soft 'bag bellows' which will not bind and can be pulled out of the way when they cause cut off.

This is not the only use for swings and tilts, though. They can also be used to hold a receding plane in focus without stopping down, using the Scheimpflug Rule. This states that if the subject plane, lens panel plane and image plane all coincide at a common line, then everything which is in the subject plane will be in focus on the image plane — the effect is shown in the next section, on close-up photography. You can prove why this should be so, quite easily, by using the standard optical formulae, but it is easier just to accept it.

If you are photographing a row of houses, or a receding wall covered with paintings, the swing front can be invaluable, as it changes the plane of focus without changing the shape of the projected image. If you do not have a swing front, or if it has insufficient movement, you can use the swing back instead (or in addition), but the trouble here is that swinging the back also affects the angle at which the image is projected onto the film (and groundglass), and hence the shape and size of the image as well. Of course, it is quite possible to swing the back, and then to move the whole camera so that the back returns to its original orientation with respect to the wall, but this does require a little extra mental effort.

Camera movements therefore give you control over apparent perspective, in the fashion of a 'PC' or 'shift' lens, together with control of image sharpness and apparent shape in a way that is otherwise impossible. This explains why they are invaluable not only for architectural photography, but also in many other kinds of work. Further notes on their use are given in the section on close-ups, on

When photographing the famous temples of the Western Enclosure in Khajuraho, where tripods are banned, I sometimes used the rising front on my Technika 70 by raising it 1cm, and 'guesstimating' the effect in the viewfinder. I found this technique surprisingly accurate and successful with both the 100mm lens and (as here) the 65mm super Angulon. *(Shot on ER)*

studio and still-life photography, and on landscapes. The same techniques are also applicable to the architectural aspects of industrial photography, and to the more adventurous reaches of nude and glamour photography.

Medium-format cameras have their strengths but they are not usually the best choice for anything more than the most modest close-ups, especially of three-dimensional objects or of anything moving. The basic reason for this is simple enough: depth of field depends almost solely on subject magnification, and a frame-filling image on a medium-format camera is necessarily magnified more than a frame-filling image of the same subject on 35mm. From this it follows that a lens of given focal length must be extended more to produce a frame-filling image on rollfilm, which means that a considerable increase in exposure will also be required for close-ups. The net result of all this is that depth of field is usually unacceptably small and that exposures are usually unacceptably long — so long, in fact, that you may run into *reciprocity failure,* which is covered in some detail in Chapter 12 *Low-Light Photography.* A third problem is the risk of vibration, which is exacerbated by long extensions. This effectively means that reflexes cannot be used without the 'pre-release', so that vibrations due to the movement of the mirror (and the rear shutter, on leaf-shutter reflexes) can be allowed to die away. Finally, at

Depth of field is often a problem with close-ups using medium-format cameras, so swings and tilts for holding receding planes are even more relevant here than in architecture. Both pictures were taken with a 150mm Symmar wide open at f5.6, but in the second one the front was swung to meet the requirements of the 'Scheimpflug Rule', as described in the previous chapter. *(MPP Mk VII)*

the long extensions required for close-up photography, the image is inclined to be dim and difficult to see.

The only real exceptions to this jeremiad are flat copying (including transparency duplicating), where depth of field and subject movement are unlikely to be a problem and focusing can be carried out at leisure, and close-ups in the medium range (up to about one quarter life size on the film) which are usually consummated most easily with close-up lenses rather than with extra extension unless — like the Rollei SL66 and the Mamiya RB67, or a rigid-bodied camera with a macro lens — the extra extension is built in. Admittedly, some manufacturers are very much more helpful than others. Most Rollei SLRs are supplied with reversible standard lenses, and twin cable releases (and the appropriate rings) can be used with many systems to retain diaphragm automation. Another point is that most lenses for medium format stop down rather further than their counterparts for 35mm but this runs you once more into diffraction limit problems.

For copying, the arrangements for the material to be copied are the same as for 35mm; two lights at 45 degrees each side of flat copy, or trans-illumination for slide copying. When copying oil paintings, beware of 'flashback' reflection from the brush-stroke ridges in the paint itself: either use polarised light sources and a polarising filter on the camera, or very large diffuse light sources (studio electronic flash and umbrella reflectors are adequate except for unusually bold brushwork or palette-knife painting).

Details of shadowless lighting for small three-dimensional objects are given in Chapter 17 *Studio and Still Life Photography*. The lens on the camera should be one which is known to give good resolution and a flat field when used for extreme close-ups. This effectively rules out lenses such as the 50mm/f4.5 for the Mamiya RB67, even though their short focal length makes them superficially attractive. No matter how good they are in normal use, they cannot be expected to compete with simpler non-retrofocus designs at great extensions. The perfect camera from the point of view of image quality is probably a Linhof, or something similar, fitted with a Symmar or (my personal favourite) an Apo-Lanthar. Not only do you have triple extension but you can also use lith films in cut-film holders for high-contrast copying, or develop your exposures individually for maximum control.

You can also adapt enlarger lenses or even macro lenses intended for 35mm if you need large magnification ratios, as you may do when copying slides, for example. Another possibility is process lenses of short focal length, which are optimised for close-up work and are incredibly sharp. With these you can use either bellows or extension rings (especially variable extension rings) and some manufacturers even make blank lens mounts for fitting special-application lenses (Hasselblad even do a shuttered version!). These techniques also apply to static subjects, or to those subjects where you can use powerful electronic flash close-up. It is *not* usually a good idea to use specially adapted lenses which stop down to f64 or so, as resolution on these will be dramatically limited by diffraction, especially at long extensions where the effective aperture may be as low as f1000.

If focusing is a problem, which it often will be, then either substitute a screen which allows aerial (parallax) focusing or draw a cross in the centre of the ground-glass screen, on the ground side, and put a drop of fine oil on it. This works well with plain etched screens such as the one on the Linhof, but may wreak havoc with sophisticated plastic-backed screens on some cameras! With either the aerial or the oiled screen, you can now focus by moving your eye slightly from side to side; if the image and the cross stay in the same relative position, then the image is in focus, but if there is any parallax movement between them, it is not. This is an extremely accurate, if slow, method of focusing and works well even at small apertures.

Remember to compensate for the increased exposure needed. You can usually calculate this most easily by measuring the total extension and dividing it by the focal length of the lens. The effective aperture can then be calculated by multiplying the marked aperture by $N/(N-1)$,

This filigree butterfly was photographed at rather over life-size on the film, which led to a considerable depth of field problem. Even after I had used the camera movements I still had to shoot at f22. On the other hand, the original transparency is considerably more impressive than a 35mm shot would be, and the extra quality is also visible in reproduction. *(Cambo 6×9cm monorail with rollfilm back, 105mm/f4.5 Apo-Lanthar: ER)*

110

where N is the figure you have just calculated. Most cameras have a mark for the focal plane, and you can discover where to measure from on a non-retrofocus lens by setting the focusing movement to infinity, and measuring the nominal focal length of the lens from the focal plane mark. Alternatively, use the following table of magnifications for convenience, multiplying the indicated exposure by the correction factor to obtain the required exposure at the marked aperture:

Magnification	Correction Factor
1/10 life size	1.2×
1/5 life size	1.35×
1/4 life size	1.5×
1/2 life size	2×
3/4 life size	3×
Life size	4×

The only other thing to watch out for is vibration or slippage of the focusing mount or copying stand after focus has been set. The same ground-rules, especially concerning extra exposure, may be used when utilising the built-in extra extension of the cameras mentioned above, though the increases are usually marked on the focusing rail or lens standard.

As already mentioned, close-up lenses are usually the best solution to modest close-ups with other cameras, as no increase in extension is required, the lenses themselves are comparatively inexpensive, and the slight loss of optical quality should not be significant at f5.6 or (preferably) f8–f11. As a typical example, the 1-dioptre Proxar used with an 80mm Planar on a Hasselblad allows focusing from 22½ to 45in (57 to 114.3cm), with reproduction ratios from about 1/12 life size to 1/5 life size; the 2-dioptre version with the same lens allows focusing from just over 17in to nearly 25in (43cm to 63cm), for reproduction ratios from about 1/6 life size to almost 1/3 life size; and if the two are combined, the ranges are just under 15in to just over 18in, from 1/4 life size to nearly 1/3 life size. All focusing distances are given *from the focal plane*; distances to the lens are 5¼–5¾in less, according to how far out the lens is extended. When using two Proxars together, put the stronger one closer to the lens, and stop down to at least f8.

Finally, remember that swings and tilts can be as useful in maintaining focus in the close-up range as in architecture, though this is a subject more thoroughly covered in Chapter 18 *Studio and Still Life*. There is also additional useful information on close-up accessories in Chapter 4, on page 54.

10 · Industrial Photography

Industrial photography is a subject rarely attempted by even the most serious amateur, and indeed many professionals have no real idea of where to start, but it can be a fascinating and financially and artistically rewarding field. It is, moreover, one which is particularly well suited to medium-format photography. Its combination of architecture, people and detail draws on the principal strengths of medium format and exposes few of its weaknesses. The traditional approach was to use 5×4in cameras for grand 'Set Pieces', and for the ultimate in quality it is probably still necessary to use large format, but rollfilm can give a very good account of itself indeed.

The ideal medium-format camera for industrial photography depends on your personal preferences, but 6×7cm will undoubtedly come closest to the sort of quality delivered by large format. The twin-lens Rolleiflex was the favourite of many masters of industrial photography for pictures of people, and the Hasselblad has probably taken its place, though both should normally be used alongside a 5×4in camera for the architectural side and for details. If you want a single camera which can handle all the aspects of industrial photography, the choice is probably between a Mamiya RB67, which lacks only movements, and a Linhof Technika, which is a bit less convenient than the Mamiya but rather more versatile, with ground-glass focusing for architecture and detail, and the rangefinder for photographing people.

The aim of the professional industrial photographer is normally to show off the company's buildings or plant to the best advantage; to say something about the people who work there; and to show what they make and perhaps what it does. The photographer's main concerns in any sort of industrial photography must be to get a good idea from the company of what they want, and then to get on with the people who can help him get his pictures. The skills involved are as much personal as photographic. If the thought of marching into a company and asking if you can take pictures alarms you, it need not; provided that you are a competent photographer and that you explain to them that you want portfolio pictures, or pictures for stock (see Chapter 16) they will more often than not welcome you, especially if they think that they can get some good publicity out of it. There are three main things to remem-

ber. First, do your homework beforehand, so that you do not ask unnecessarily stupid questions. Second, keep all promises, whether you promise pictures to the people you photograph or to the management. And third, remember that you are a guest; that nobody has to help you; and that the people who are showing you around undoubtedly know more about the business than you do. Keep out of the way, and never do anything which could endanger anyone (especially using flash without warning), but do not be afraid to ask people to pose, or to repeat some manoeuvre, if you think it would make a good picture.

Taking the three divisions — plant, people and product — in turn, the majority of the techniques applicable to plant photography are covered in Chapter 8, which deals with Architecture. Both external and internal pictures for industrial photography need the same attention to detail, background and viewpoint that you would give to any other type of architectural work. On occasion, though, the plant itself may be too complicated, or simply too big, to show in a single shot; in which case the basic drill is to take one view of the main entrance or front facade of the building and one (or more) view(s) of whatever you think is the most attractive side. Take the advice of your contact at the works, and also consider whether you could do better by moving back for a long shot, or perhaps climbing a nearby tall building and looking down for a pseudo-aerial shot. In addition to these external views, try to concentrate on recognisable aspects of the process: the pipes and flame-off in a refinery, the mash kettles in a brewery, or a view of a car assembly line which shows clearly that the product is a car (it is not always that obvious what is being made on a production line!). Look out, too, for dramatic shots — a shower of sparks from a weld being ground down, the glow of molten metal being cast or red-hot metal being worked, or the drama of a huge and powerful machine at work. With these, be particularly careful about safety, as the most dramatic subjects are usually the most dangerous.

When you photograph people, make sure that they are doing something both comprehensible and relevant to the company's activities. For example, a research chemist might be examining the colour of a liquid in a flask; a worker in a paper-mill might be handling stacks of huge sheets of paper, with heavy gloves to protect his hands from the sharp edges; a brewer might be inspecting malt. Be sure to check that they really are doing something meaningful, and listen to their advice. If you merely ask them to do something that looks good, you may create an unintentional 'howler'. If you are going to need captions

114

The problems of industrial photography: air-borne paint drifts surprisingly far, and does lenses no good at all, so I protected the 90mm lens on my Mamiya RB67 — there was no room to use anything longer — with a skylight filter. *(Shot on ER)*

for your pictures then take notes as necessary — a pocket tape recorder makes this easier, and also looks very efficient!

Watch out for possible danger all the time, both to you and your subjects; when you are concentrating on photography it is easy to forget about other things. If you are using mains-powered flash, be careful about snaking cables, and **never** fire the flash without first asking permission and then warning *everyone* first. Try not to disrupt production at all, especially if there is a production line where interfering with one stage can cause havoc later on, and even if

115

people are willing to interrupt what they are doing, do not make them waste too much of their own, their employers' or your time.

If the company prides itself on its leisure facilities, on its staff canteen, or on some other aspect of employee welfare, then concentrate on this, but do not let it distract you from all the other possibilities; and if (for example) the staff canteen is particularly awful, do not dwell upon it.

Under the final heading, *Product*, you can use four different approaches, either singly or in combination. First, you can show the product being made. Most people are intrigued to see how a familiar object is manufactured, so there is scope here for eye-catching pictures. Second, you can show 'catalogue shot' pictures of the product, shot either at the factory or in the studio. Third, you can show the product in context; a beer-engine in a bar, a desert patrol vehicle in use in the desert, or a compressor installed in a garage. And fourth, you can produce a 'concept shot', in which the product is presented as it would be in an advertisement, whether realistic or fantastic. Obviously, the last two approaches are likely to take you out of the factory or office where you shot the original pictures — but if you have made your mark there, they may well be willing to help you follow up your original shoot in this way.

The problems of industrial photography, again: this magnificent 'set piece' was shot on a Hasselblad SWC (38mm/f4.5 Biogon), with an exposure of 2 seconds — which is not remarkable until you learn that the photographer (Colin Glanfield) was suspended in a mobile crane bucket, together with a shop steward, in order to allow the medium-high viewpoint which avoids converging verticals.

11 · Landscapes

Landscape photography is an immensely difficult art and one which arouses strong feelings. It is probably more true of landscape photography than of any other branch of the craft that a great photographer with a box camera can produce better pictures than an indifferent photographer with a Sinar, Imperial or Deardorff, but it is also true that a medium-format camera provides something like the perfect combination of image quality and portability for most people. It is also a branch of photography in which I am deeply interested, and in which I am never satisfied with my own work; so this section may have a more philosophical bent than is usual.

The adherents of the Gospel according to St Ansel Adams, as propagated by the Blessed Eliot Porter and others, maintain that a 5×4in camera is the very smallest with which one ought to approach the majesty of nature; a 10×8in is conducive to a State of Grace, and purchase of a 14×11in means that a photographer can happily miss out the initial stages of beatification. Those who believe in this particular variety of salvation through works seem to glory in the martyrdom of having to carry massive cameras. My Imperial 14×11in weighs 20lb without lens, dark slides or tripod, and the complete outfit weighs well over half a hundredweight.

There can be no doubt that a cut-film camera is wonderful for the production of fine prints from original black and white negatives, and that a contact print is inherently 'juicier' than an enlargement, but no-one who has seen the work of Yoshikazu Shirakawa (Pentax 6×7cm) and Hiroki Fujita (Hasselblad) can seriously doubt that in colour at least, medium format can produce the most stunning results. It is a closer question in black and white, and you have to be very careful indeed and to embrace the full glory of the Zone System (see Chapter 5) to produce really dramatic landscapes, but there is no question but that it is possible. To be fair, Ernst Haas has shown how 35mm can be used too, but no matter how much I admire Haas's work, I still cannot help returning to Shirakawa's *Himalayas* and *Eternal America*.

The addiction of many serious landscape photographers to their massive cameras points to the most essential truth about this branch of photography. Rather than being an

interest it must be an obsession, if you are to produce the very finest pictures. You must be obsessive about technique, about detail and, above all, about waiting for the perfect picture. A great landscape photographer will think nothing of returning to the same place again and again, in different weather conditions and at different seasons, to get exactly the picture that he wants. He does not just see the landscape before him: he sees that landscape bathed in light of a particular colour, coming from a particular direction. Most serious landscape photographers carry a compass, and the really serious ones carry a visualisation device manufactured to help the designers of solar-heated houses to work out the exact direction of the sun on any day of the year.

The camera you use is of secondary importance, though once again I would enter a case for a technical camera such as the Linhof. Not only are Linhof-tested lenses superbly sharp, but the 6×7cm format can record more detail than smaller ones, and there are occasions when camera move-

10×8in and 11×14in cameras are all very well in the mountains, but if you want to include foreground interest you will have depth of field problems. I would have needed to stop the 17in lens on my Imperial 11×14in down to f256 or so in order to hold both the bridge and the landscape beyond! (*Mamiya RB67, 50mm Sekor: ER*)

Medium format is easier to carry than large format in situations like this! The use of a tripod and a slow shutter speed allowed an attractive blurring of the water. (*Mamiya 645: original on ER*)

118

ments can prove useful — especially for close-ups, where (for example) a tilt can help show the desert floor expanding apparently infinitely from the foreground. But Shirakawa and Fujita are vastly better landscape photographers than I, and they use rigid-bodied cameras, though it must be admitted that Fujita also carries a Linhof 5×4in with him.

There is a place for impressionism and blur — as Haas has so ably shown — but as a general rule one of the attractions of a fine landscape is its almost tactile quality, and this is something you can improve by particular attention to detail. Even in pictures which show rushing water as an impressionistic blur, by use of a long exposure, the rocks and surroundings usually look best when razor-sharp.

In the search for ultimate quality, it is best to begin firstly by using either a tripod or a very high shutter speed to remove even the suspicion of camera movement. I would have said, 'Always use a tripod', without any qualification, but I am told that many of Shirakawa's Himalayan shots are aerials — and a tripod is very little use in an aircraft!

Secondly, always use the sharpest film reasonably available. Fuji's ISO 50 material is probably ideal, but if you have difficulty in getting it, do not go beyond Kodak's ISO 100.

Thirdly, pay great attention to exposure and development. This does not necessarily mean giving the scientifically 'correct' exposure, but it often does mean bracketing and choosing the best exposure from among two or three, and it always means using the best and most consistent lab that you can find, and preferably shooting only batch-tested film.

Fourthly, always endeavour to use the lens at its optimum aperture. Either test it yourself, or rely on the rule of thumb that f2.8 lenses perform best at f5.6–f8 and slower lenses perform best at f8–f11, though you will find exceptions either way. Any lens which is not diffraction-limited by f11 (i.e. which is not resolving 90 lp/mm centrally at f11, after which the performance as you stop down can only deteriorate) should be regarded with suspicion.

Fifthly, consider your filters with care. I fully accept that on occasion effects filters (such as those manufactured by M. Coquin) can be used to enliven commercial pictures and may well lift them from the ranks of the ordinary to the very good — indeed, my own filter-enhanced photograph of the Taj Mahal on page 18 is one of my favourites — but I do not recall ever having seen a truly great landscape picture shot with a 'trick' filter. Remember, too, that effects filters are mostly far from optically flat, so that

you are in effect adding a soft-focus filter along with the effect. The best filters are gelatines, which are optically of no consequence whatsoever (at least when they are clean), closely followed by first-class optical glass filters such as the Hoya HMC range.

In addition to these purely photographic techniques, there are a number of others which apply, even if you are using a snapshot camera. For example, do not be afraid to wait. Landscape photography, like fishing, is probably best undertaken as a solitary and reflective pursuit, because if you have anyone with you, they will probably get bored, and then the moral pressure to grab the picture and run can outweigh the creative pressure to wait until it comes out right. Admit, too, that there are times when you cannot get a picture, and put away your camera if you know that you will be disappointed with the result. Taking a mediocre picture saps your resolve to come back and do it properly, and when you see the results you are likely to be even more depressed. Lastly (and apparently in direct contradiction to the previous point), if you are sure that you will never pass that way again, do not be afraid to take a snapshot, even in the most appalling weather, but do not make the mistake of showing the picture to anyone else! Instead, keep it to remind yourself of a place that was so beautiful that you could not, on that particular day, do justice to it. At the very least it will awaken pleasant memories: at most, it can fill you with resolve to return. This is not really in contradiction to the last piece of advice, and what it amounts to is advice to switch off your critical faculties sometimes. Never take a bad 'serious' picture — one that you know you will be disappointed in — but do not be afraid to take a 'non-serious' picture in which you invest neither great effort nor great hopes.

Perhaps the most important thing of all, though is that when you want to take pictures of a place then choose a place about which you really care. Do not be misled into thinking that you care about a place merely because you care about other people's photographs of it; much as I genuinely admire Ansel Adams's pictures, and the places which he photographed, I do not for a moment think that I could take the same sort of pictures that he did, because I do not *see* Yosemite and the Californian Sierras in the way that he did. I much prefer to work on a smaller scale. The colour pictures reproduced on these pages are among my favourite landscapes from my own work and from that of Frances Schultz, and they deal with much smaller themes than Adams ever did. Again, you may have noticed that there are many city pictures in this book: I find the cityscape much easier to photograph than nature, which

The crystalline air of the mountains, especially after a snowfall, gives wonderful effects. *(Hasselblad, 80mm Planar: Agfachrome 100)*

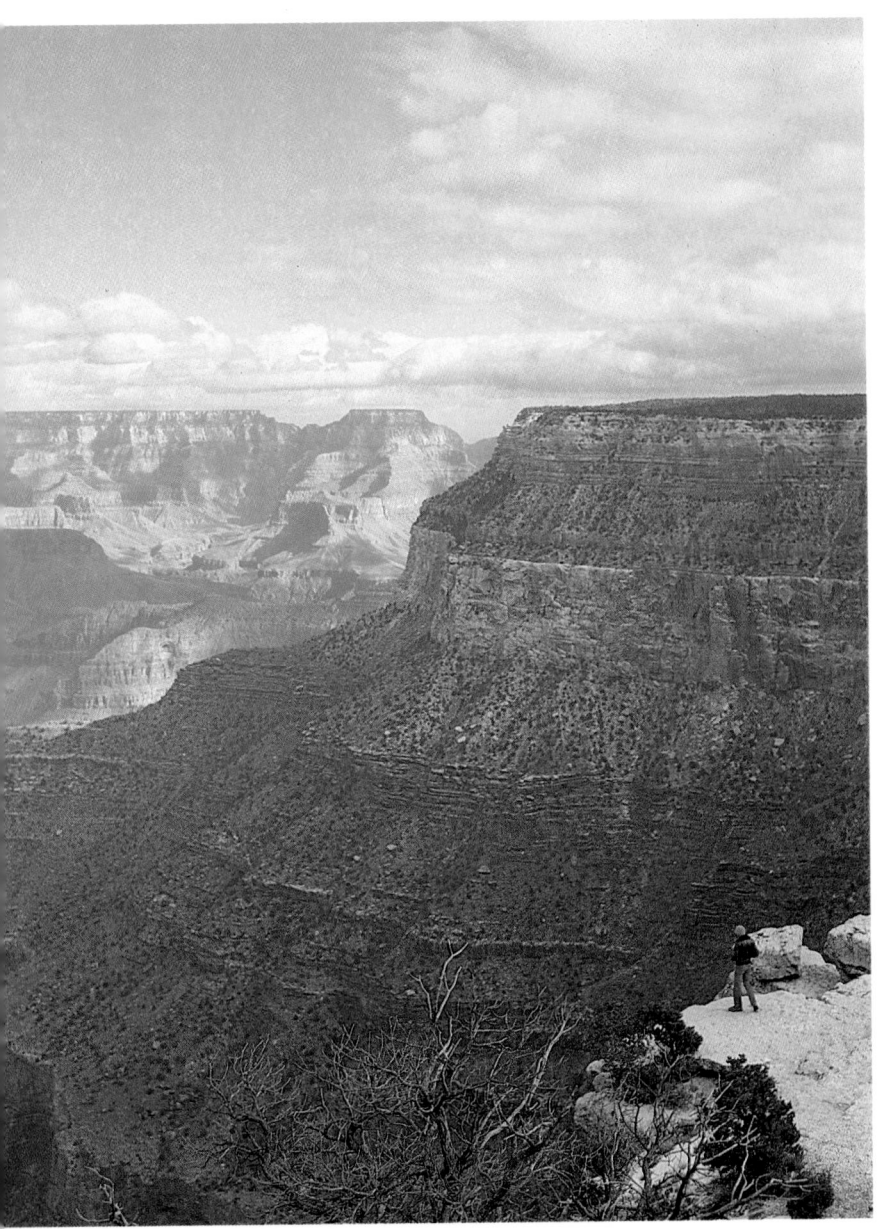

I like to include a figure for scale in shots like this. The blue haze may give good impression of vastness, but one day I'd like to try a sharp picture too! (*Mamiya RB67, 90mm Sekor: EPR*)

seems to me to be much more diffuse. And, unlike Adams or Shirakawa, I often like to have people in my pictures. I do not pretend for a moment to be a landscape photographer in their class, but I do want to do what I can as well as I can.

12 · Low-Light Photography

There are two kinds of low-light photography, hand-held or with a tripod. Although most people associate medium-format photography with the latter, the former is still quite possible.

The usual trinity in any kind of low-light work is fast lenses, fast film and long shutter speeds. Although most rollfilm cameras are ill-supplied with the first, there are such gems as the 80mm/f1.9 for the Mamiya 645 and the 110mm/f2 for the Hasselblad, though they are expensive and depth of field is extremely limited at anything under 6–10 feet (2–3 metres). On the other hand, f2.8 is not really all that slow, and that is the speed of the standard lens on most 6×4.5cm and 6×6cm cameras and a few 6×7cm cameras. Fast film is a much more fruitful hunting-ground, because the larger image (when compared with 35mm) allows faster, grainier film without any significant loss of quality. This has already been covered in Chapter 5 *Film and Metering*.

It is often possible to get away with surprisingly long shutter speeds with medium-format cameras, for two reasons. The first is that the increased weight of the camera (relative to 35mm) often allows a more stable grip as inertia stops shake. Waist-level finders — with the camera suspended on a neck-strap, and held firmly at chest level with a gentle pull on the strap — are particularly good for this. The second is that because the magnification of the larger image is less than with 35mm, the effects of camera shake are also magnified less. The only fly in the ointment occurs with single-lens reflexes, where mirror-induced shake can be significant. Without some sort of sports finder (or guesswork), you cannot use the pre-release, so SLRs are not the best cameras for hand-held low-light work utilising slow shutter speeds. A twin-lens reflex, or a non-reflex camera such as a Plaubel Makina or even Linhof Technika is best; the twin-lens camera can usually be held more steadily, but framing and focusing is normally easier with the non-reflex, viewfinder camera. Many people find that they can manage 1/15 second with impunity, 1/8 is not out of the way and 1/4 or even 1/2 may be practical in some cases. Inevitably, the likelihood of camera shake increases with longer exposures and you will be well advised to make several exposures. For example, I know that with a Linhof

at $1/15$ I am virtually certain to get one picture free from perceptible camera shake if I take three exposures, whereas with a Rolleiflex I can go to $1/8$ or even $1/4$ for the same success ratio. All the usual techniques for minimising shake can be used, including firing the shutter whilst breathing out, and resting or wedging the camera somewhere for increased stability. Using a wall or a table for support can permit exposures of a full second or more, and one of the advantages of a waist-level finder is that you can rest the camera on a knee, or sit cross-legged and hold it in your lap, and still see to focus and compose.

Using camera supports brings us into the realm of tripods, and before going on to the full-sized versions it is worth mentioning table-top tripods, especially the Leitz version, used with either a Leitz ball-and-socket head or a bigger and heavier Kennett Engineering version. These can often be used where full-sized tripods are either impractical or forbidden, and provide a useful halfway house between hand-held photography and photography using a tripod. I rarely travel without one, and have often found it invaluable. Monopods are another possibility (fewer places seem to object to these than to tripods) but I have never found monopods particularly successful in avoiding shake, and they are usually bulkier and less convenient than miniature tripods anyway.

The 80mm/f1.9 is the fastest lens readily available for a medium-format camera, which makes the Mamiya 645 seen here a prime choice for hand-held low-light photography.

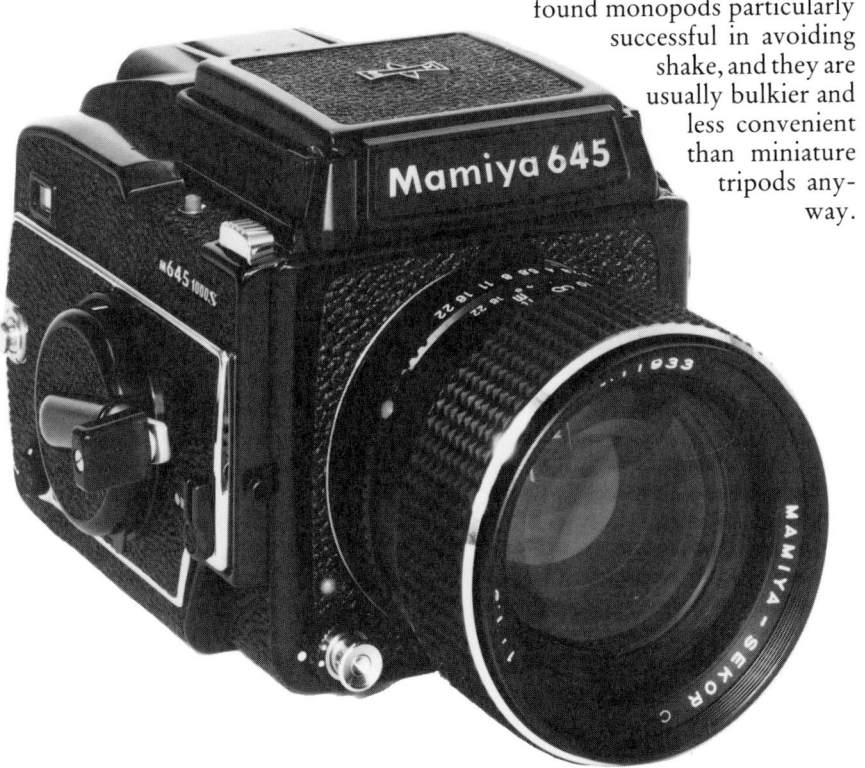

The choice of tripods has already been dealt with in Chapter 4 on page 57, and there is nothing further that really needs to be said. If, however, you find that you need small apertures and long exposures — or even large apertures and long exposures — there is one phenomenon which may be unfamiliar to 35mm users, namely reciprocity failure.

The so-called 'Reciprocity Law', which states that you can always compensate for a decrease in aperture with a proportionate increase in exposure, does not hold good at very long exposures (or at very short ones either for that matter, though that does not concern us here). Although you may have been aware of this fact intellectually, the chances are that you may never have encountered it practically, because very long exposures are much less common with 35mm than with rollfilm. Most films are designed to have a linear reciprocity response across a certain exposure range, usually about $1/1000$ second to 1 second for black and white film, $1/1000$ to $1/10$ second for

The best 'night' shots, like this one in downtown Las Vegas, are usually obtained just before the last light leaves the sky. *(Mamiya RB67, 50mm Sekor: EPR)*

daylight-balanced colour film, and ¹⁄₁₀₀ second to 10 seconds for tungsten-balanced colour film, where longer exposures are normal. The amount of extra exposure which is required when you go outside these design limits varies greatly from film to film, but typically you might require ⅓ or ½ stop extra exposure when using daylight-balanced colour film at 1 second, 1 or 2 stops extra when using it at 10 seconds, and 3 or 4 stops at 100 seconds.

Unfortunately, it is not only the exposure characteristics which change when you go outside these limits: the colour balance is also affected. With negative films, correction is sometimes possible at the printing stage, but with reversal films filtration is needed at the time of exposure. Once again, the filtration requirements for different films vary enormously, and the colour shifts can be in one direction for one film and in another direction for another, but you will usually need something in the CC05–CC10 range at one second, and CC20–30 at 10 seconds. The former can often be ignored; the latter cannot. The only source of accurate information on reciprocity failure is current data sheets from the film manufacturers. There is no point in giving details here, because the figures are different for every film and, as manufacturers are constantly updating

These colourful Tibetan dancers were captured on ISO 64 Ektachrome with a 100mm/f2.8 Planar on a Linhof Technika 70, hand-held for ⅛ second. Do not be afraid to break the rules, either for experiment or if there is no other way of getting a picture.

even familiar emulsions, any figures would be out of date before the book was even published.

The last topic to cover here is exposure determination. This can be very difficult in poor light, because contrast ranges are often enormous and because meters often run out of sensitivity. On the other hand, it is often possible to get an perfectly acceptable result over a wide range of exposures, especially at night. A 'correct' exposure of (say) a street scene can be anything from a mostly-black view, in which you can see a few lights and perhaps some people window-shopping, to an image almost as bright as day where the shop windows are substantially burned out. Incident light readings at the places which are to register as normal on the film are of the most use; if the meter will not read, then stand at the subject position and take a reading from a piece of white card and give four times the indicated exposure or, with selenium meters, point the cell at the light source and give five or six times the exposure. This latter trick is less useful with other meters because of their narrower acceptance angle and (with CdS cells) because of their 'memory'.

13 · Nature and Animal Photography

Few serious natural history photographers rely solely on medium-format cameras. The main drawbacks are (as ever) the restricted range of lenses, their small maximum apertures and the limited depth of field in the close-up range. But there is still the constant demand for the highest possible image quality, and one advantage of a medium-format camera which is not immediately obvious in this application is the potential for selective enlargement. For example, with a 500mm lens on 35mm you are covering a much smaller subject area than you are with a 500mm lens on rollfilm at a given distance or subject size on the film. With the long, slow telephotos available for medium-format cameras, the image quality is likely to be the same on rollfilm as on 35mm, so you can point your camera in the right general direction and not have to worry quite so much about precise framing. The main uses of medium format in natural history photography are therefore as follows:

1) Photography of less timid or dangerous animals from modest distances, using hides or stalking.
2) Photography of more dangerous or timid animals using remote control.
3) Photography of plants.
4) Photography of tame animals, laboratory specimens of all kinds, and inert materials.

No one camera is ideal for all these applications, and there tend to be three favourites. The first is undoubtedly the Hasselblad, particularly the EL/M. The 500mm/f8 Tele-Tessar and, to a lesser extent, the 350mm/f5.6 Tele-Tessar (equivalent to approximately 300mm and 200mm respectively on 35mm) are fairly big lenses, but they are quite handy by rollfilm standards and there is no doubt that the technical quality is superb. The EL/M is a relatively light camera, extremely reliable and can conveniently be triggered remotely, especially with the 70mm back to obviate unnecessarily frequent reloading. The leaf shutters are particularly useful in close-up, where flash is often used, and the lack of $\frac{1}{1000}$ and $\frac{1}{2000}$ sec shutter speeds or, for that matter, a true $\frac{1}{500}$ is not particularly important in view of the modest speed of the lenses. Focusing in the nearer ranges is not too inconvenient with Proxar close-up

lenses, and the Hasselblad probably comes closest to being the general standard by which other medium-format cameras are judged in this field. If remote control is not necessary then the 500C/M comes into its own, as it is considerably lighter and cheaper than the EL/M; it does not seem unreasonable to assume that the add-on motor model, just introduced at the time of writing, may in time replace them both, though natural history photographers are justifiably conservative about adopting new cameras. Similarly, the Rollei SLX must make inroads into this market, not least because of its auto-exposure facility, which is a major advantage when a camera is remotely operated.

The second most popular, and often the first choice for close-up, is the Mamiya RB67. It is big and heavy, it is true, but the built-in extension makes it ideal for distances closer than three feet (one metre). The Rollei SL66, which might seem at first sight to be a serious alternative, misses out

When photographing animals, the answer to depth of field problems is exactly the same as when photographing people: the eyes are the critical area, and if they are sharp, a certain loss can be tolerated elsewhere.

130

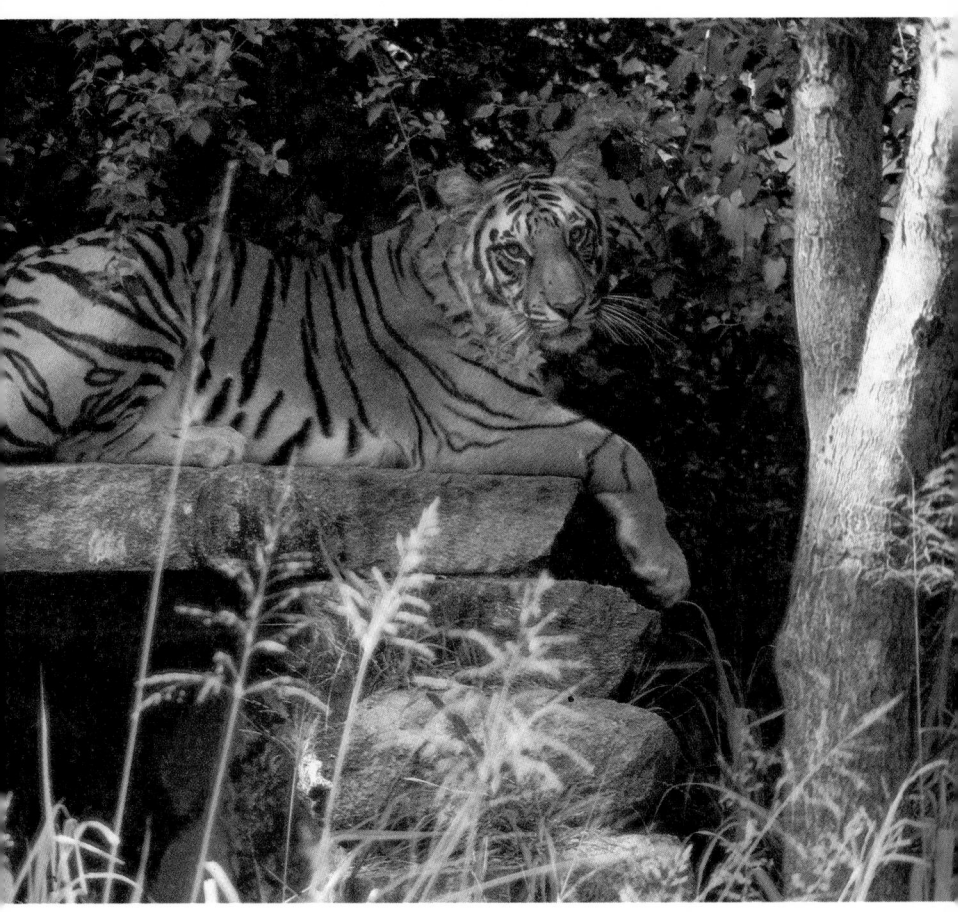

One of the advantages of the 6×4.5cm format is that you do not need unbelievably large, expensive lenses. A 210mm lens on a 6×4.5 is equivalent to about a 150mm lens on 35mm, which is (just) sufficient for a picture like this, though I am sure that the tigers in Bangalore Zoo, where this was shot, could escape if they put their minds to it. Note that even over so short a distance, the heat and dust of southern India is enough to take the fine edge off definition.

because it has a focal-plane shutter and is therefore less convenient for flash photography. Trailing third, but vociferously defended by their proponents, come technical cameras and monorails. For many types of studio work, especially close-ups and, in the case of technical cameras, hand-held work, these are unsurpassed even if the longest easily available lenses are of fairly modest focal length.

Although these are the three favourites, they are by no means the only options. A fourth possibility, which is admittedly rather specialised, is to fit a rollfilm SLR onto the back of a 5×4in monorail, thereby creating a king-sized bellows unit which allows infinity focus even with long lenses and provides the option of movements if required. Ready-made adapters are available for a number of SLR/ monorail combinations, with Hasselblad/Sinar almost the industry standard. It is not difficult to adapt an old quarter-plate camera for very little cost. You can use either a shuttered lens or (in the case of cameras equipped with

131

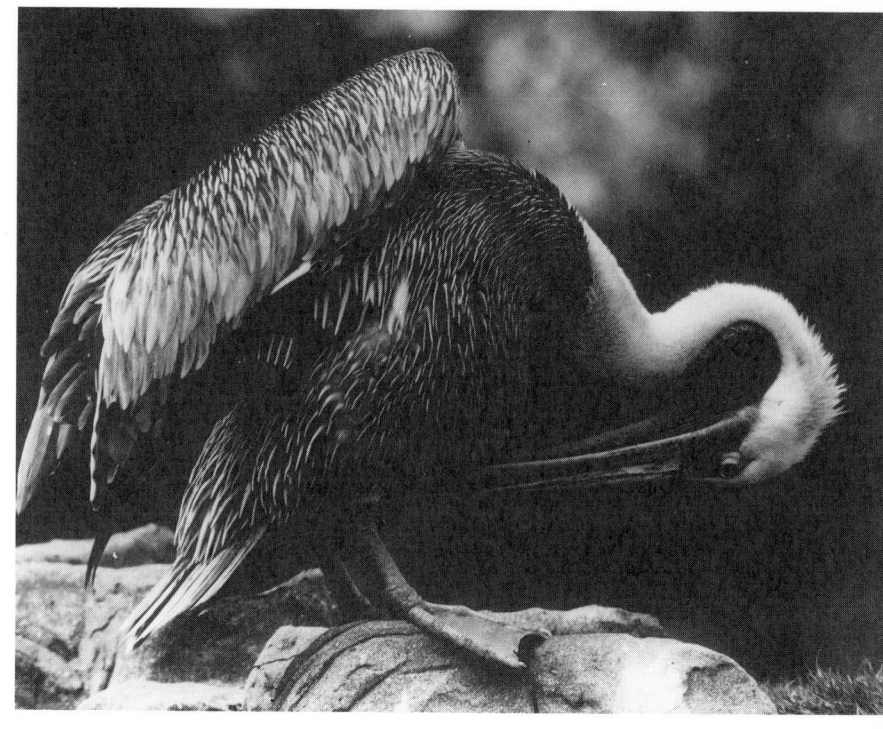

focal-plane shutters) the camera's own shutter. As a fifth possibility, I believe that there is a great deal to be said for 6×4.5cm cameras. The Mamiya 645, with its focal-plane shutter, not only allows the use of a first-class range of Mamiya lenses, but also introduces the possibility of fitting all kinds of specialist lenses by means of custom adapters. Mike Fear, who took two of the pictures on this spread, has adapted lenses as diverse as an ex-Alpa 360mm Tele-Xenar and a 300mm/f4 East German lens (which proved capable of delivering extremely good results).

A 300mm/f4.5 East German lens with a custom-made adapter seemed like the ideal solution to a telephoto for the Mamiya 645, but it was still not long enough, and this is a blow-up from an almost exactly 35mm-sized section of the negative.

Medium-format cameras are normally used on tripods for natural history photography, and the Benbo sealed-leg tripod is probably the best available for use in adverse conditions. Otherwise, there are no special techniques to be used. The main things to remember are the delay between pressing the release and actually taking the picture, which can be a problem with reflexes, and the never-ending battle to get enough light on the film; specially made flash brackets, or one of the very best commercial models available, are the usual answer here.

For further information on all aspects of nature and animal photography, see *The Wildlife Photographer*, by Bob Gibbons & Peter Wilson, Blandford Press, 1986.

14 · Nude and Glamour

Many people draw a distinction between 'artistic' nudes and 'glamour' pictures or pin-ups, but the distinction is often feeble at best and the standard of photography in the better men's magazines such as *Penthouse* or *Men Only* is vastly higher, and more 'artistic', than many of the nudes which one sees at a camera club exhibition. It is not easy even to draw a distinction between artistic photography and well-produced pornography: painters throughout history, even in the Victorian age, have shown how a picture can be both erotic and artistic, as witness the works of Alma-Tadema or Boucher, and this applies in the world of photography.

It is, however, fair to say that glamour photography is unlike any other form of photography. For a start, there must always be some suspicion about your motives — in the model's mind, if not in yours. Unless you are paying the model, or unless the pictures are clearly to your mutual benefit, as in the case of 'test shots' where a young model or would-be model wants pictures for her portfolio, then she is doing you a favour. And unlike, say, landscape or architectural photography, this is not a field you can readily enter without already possessing a fair degree of skill. The best way to acquire that skill is through conventional portraiture (see Chapter 15), as well as through more innocuous shots of fully-clothed actresses, singers and so forth.

A point also worth making is that glamour is one of the easiest areas in photography to make a complete fool of yourself and a complete mess of the pictures, so you need both confidence and skill in order to succeed, as well as a determination to get it *right*. A half-hearted approach simply is not enough.

Whatever sort of nude, semi-nude or glamour photography you undertake, there is a great deal to be said for using a medium-format camera.

To begin with, texture is all-important in many types of nude photography. It may be the delicate texture of a model's skin; it may be the contrast in texture between the model and jewellery or smooth clean background paper; it may be the luxurious texture of the surroundings or clothes, of silks and satins and furs. With the exception of those photographs in which line and form are everything —

133

which some people try to pretend is 'classical' nude photo-
graphy — the rendition of texture is fundamental to this
sort of work.

Tonal gradation is scarcely of less importance, and it is
notoriously easier to get smooth gradation with a larger
format than with a small one. This is especially true if you
are using soft focus lenses, which are difficult enough with
medium format and are a very blunt instrument indeed
when used with 35mm.

A less obvious advantage, but one which should not be

A more conventional
pin-up than the one
opposite, it still reveals
a willingness to
experiment, on the part
of both the model and
the photographer.
(Latiff: Mamiya RB67)

Glamour pictures need not be revealing; even a shy model should be reasonably willing to pose for a picture like this. *(Latiff: Mamiya RB67: original on EPR)*

overlooked, is that the photographer who uses a medium-format camera appears more professional than one who uses 35mm. If you use amateur models or want to persuade aspiring professionals to pose for portfolio shots, you gain considerably in credibility if you use a medium-format camera.

And a final advantage is that if you want to sell your pictures then medium format is almost mandatory. This is not only because of the advantages in texture and gradation, but also because picture editors see a lot of work every

day, and so far as they are concerned medium format has two big advantages. First, it shows that the photographer is serious; many people have not the faintest idea of what makes a good picture of any kind (let alone a good glamour picture) but encouraged by television and magazine advertisements which tell them that they can be a second David Bailey just by buying the right camera, they submit the most appalling 35mm rubbish to magazines. If you doubt this, just look in the 'Readers' Wives' section of any magazine that has one. Second, medium format is easier for an editor to see. Why risk going blind looking at 35mm transparencies when there are bigger pictures to look at?

Opinions vary concerning the best camera, and it is fair to say that this is a field where you can produce excellent work with almost any camera that you feel happy using. My own favourite is the Mamiya RB67 (again!), but I know other photographers who prefer Hasselblads, big Pentaxes and Bronicas, just about the whole spectrum, though mostly reflexes for accurate composition and framing.

Two of the most difficult aspects of nude and glamour photography are, however, essentially non-photographic: finding a good model is one, and finding a location is the other. Working with amateur models is difficult enough at the best of times, but working with a reluctant amateur model is altogether too difficult. For glamour work it is much better to work either with would-be professionals or — better still — with girls who have already gained a foothold in the world of modelling. A good portfolio is, after all, an essential prerequisite for a model and a girl who has not yet had the range of experience necessary to fill a portfolio has to get the necessary pictures somewhere.

The big advantages of working with an aspiring professional are that she will be willing to work at getting the right picture; that she is likely to have ideas of her own, as well as listening to your suggestions; that she is unlikely to be unduly shy; and perhaps most important of all, that she is likely to be good looking. The last is particularly important. The old line about there being beautiful girls all around you is simply not true, as you can confirm by making a list of all the girls you know who are as attractive as the average girl in a good magazine. The only type of picture in which an aspiring professional model may not be interested is the 'classical' nude, especially if it is in black and white and, most particularly, if her face is obscured as it so often is in this sort of photograph.

If you do not know any models personally, and you cannot track any down through the friend-of-a-friend routine (which is usually incredibly effective), you have problems. In London, New York, Paris and a few other big

cities, you may be able to set up a relationship with one or more model agencies to photograph their new or up-and-coming models; and if you can show them good enough examples of your work they may even contact you if the occasion arises. The work you show them need not even necessarily be glamour, though in that case you will need to explain fairly clearly just why you think you can handle this sort of photography. Outside the big cities, few agencies are willing even to let their girls know that you are looking for models for test shots.

Locations can be an even more vexed problem than models. Hiring a studio with background paper is fine for some types of picture, and is all you need for classical nudes, but if you decide to do this, do inspect the studio first, ascertain how much they charge for clean background paper, and make sure that there is both warmth enough for the model to pose and somewhere private for her to undress. It is also as well if the studio you choose is in a reasonable part of town, as a seedy address can put the model off badly. For many purposes, though, you will do better to use a room or apartment decorated in the right way. Professionals use location-finding agencies if they do not know of a suitable place but this is an expensive way to do things and, once again, you will do far better to try through friends and friends-of-friends. When you do find a place, pay very careful attention to detail — coffee-cups, alarm clocks and bedside lamps (which usually look best switched on, though you sometimes need to replace the bulb with one of lower wattage) — and be particularly careful about lighting. A sheet of tracing paper taped over a window not only provides a beautifully diffuse light but also improves privacy and may help to make the model less inhibited or nervous.

You may consider going to one of the many studios which advertise glamour sessions, but be warned, you only get (at best) what you pay for. They can be very useful as a means of learning the basics of glamour photography, but you should not expect to produce first-class pictures. If you hire the studio solo and are lucky with the model you can learn a great deal, but if you go along to the regular sessions, with anything up to a dozen other photographers, you may not get very much out of it at all. The best of these studios are a long way from the sort of thing you see in the magazines, and the worst can be truly awful.

When you do take the pictures, remember three things. One, not everyone photographs the way they look. There are highly professional models who look beautiful on film but do not attract a second glance in the street, and there are others who look gorgeous in life but simply do not

I find this very unrevealing picture by Latiff more glamorous than many much more explicit shots — and I have a built-in prejudice against smokers! It shows, though, that there is no substitute for the photographer's personal vision in any type of photography. (*Mamiya RB67*)

record well on film. Two, there are many girls who look very good from a particular aspect, but are very ordinary from any other angle. A girl with an unremarkable full-face appearance may have a superb profile, or *vice versa*. Three, although it is very hard to be totally honest about your own motives, do try to distinguish between your desire for a picture and your desire for the model and be warned, a shoot which goes well can leave both the photographer and the model pretty excited by the end!

15 · Portraiture

Portraiture is one of the most important applications of medium-format photography. The normal end product is a colour print — often of considerable size — and 35mm is simply unequal to the task of delivering adequate quality even at 10×8in, let alone 20×16in. A medium-format camera not only surmounts that difficulty; it also creates a sense of occasion which can be very important for certain types of portraiture.

The essence of all portraiture — professional or otherwise — is lighting and posing, but within those limits there are several kinds of portraiture. There is the formal indoor studio portrait; the formal indoor portrait on location; the formal outdoor portrait (a rare breed); the informal or semi-formal portrait; the child portrait; and the animal portrait. It may seem strange to include animal portraiture in this section but the techniques are substantially the same as for human portraiture, and many people love to have a good portrait of a favourite pet either on its own, or with themselves or their children. Photographers who specialise in portraiture in people's homes often find that when they are asked to take a portrait of a child they are asked to take it with a dog, and then, if they have an eye to the main chance, they will take a picture of the dog as well!

Portraiture is a much less stressful form of commercial photography than taking pictures of weddings (q.v.) or other ceremonial occasions, because it is only rarely that there is no opportunity for a reshoot, and because people are generally more relaxed about portraits. On the other hand, they are also more critical; at a wedding you can get away with no more than a clear record of the principal events (see Chapter 20), but the standards of portraiture are very high indeed. Leading portraitists such as Godfrey Argent of Baron Studios in London, or Edward St Maur of Bath, are very impressive photographers by any standard, and if you want to succeed in this field you would do better to model yourself on them than on the local 'High Street' man. After all, the cost of film and lighting is the same for a bad portrait as for a good one, but the good portrait photographer can charge a lot more...

You can shoot anything, from a dramatically-lit needle-sharp picture which shows every line and wrinkle to a

Even passport pictures can be carefully shot. In order to get an image which Jenny, his wife, could live with for the next ten years, Colin Glanfield used soft available light, make-up and a Softar attachment on his 150 mm Hasselblad Sonnar. *(1/15 at f/4 on HP5)*

flatly-lit soft-focus portrait and still show the 'real' subject, but the secret of successful commercial portraiture is to produce an image which the subject likes. You may need to talk to the subject about this, or you may prefer to show different types of portrait and ask which the subject thinks would suit them best. Show pictures of people of comparable age and appearance, if at all possible, as you do not want elderly dowagers demanding to be made to look like debutantes! As with many other aspects of photography, a methodical approach helps you to keep everything under control, and the main areas for attention are lighting, equipment selection, posing and camera position. We shall look briefly at each of these in turn before going on to consider the various types of portrait described above.

Getting down to the baby's level is the most important thing in this sort of portraiture. Purists may say that the child's head is disproportionately large, but the parents loved the picture and ordered dozens of copies. *(Rolleiflex TLR)*

LIGHTING

The basic techniques of lighting are covered in Chapter 7, and the types of lighting described there still hold good. The *key*, coming from above the camera and to one side, determines the position of the shadows, and the *fill* determines the lighting ratio. As a rule, dramatic or contrasty lighting should only be used for 'character' portraits; highly directional side lighting, and a lighting ratio of 8:1 or more (3 stops) will produce a dramatic effect, while for general purposes a three-quarter light and a 4:1 ratio will be more suitable. In general, a softer light is more flattering, and for children and young girls a very flat light is often

'Large heads', as close-up portraits are usually known, require superb technique if they are to be successful. We are accustomed to studying faces closely, and we study pictures of them mercilessly. Note particularly the use of clothes, the balance of lighting and the use of depth of field.

best for portraying a delicate complexion, with a lighting ratio of no more than 2:1. A completely flat and direction-less light is, however, rarely attractive.

Heavily snooted effects lights can be used to add high-lights to jewellery or fur, or to backlight hair, but these should be used with discretion. It is all too easy to backlight a young girl's hair too brightly, as a few minutes examination of any magazine will show. Rimlighting can be surprisingly useful, both for character portraits — the sort of thing that Oliver Cromwell called 'warts and all' — and for girls, where you want to emphasise downy softness.

Consider your subject's comfort when setting up the lighting, and try neither to take too long nor to dazzle them unnecessarily. You should have the lights already set up roughly in the studio, and on location you should be able to arrange the lights quickly and easily. If you have to mix artificial light and daylight then remember the difficulties

which can arise with colour film: electronic flash is far easier.

Portable reflectors, especially Lastolites, can be extremely useful on location, and if you decide to use available light for your portraiture — a perfectly reasonable approach — then there is nothing to beat reflectors for providing fill-in 'lighting'. In the studio, large flats fulfil the same purpose. If you do use available light, the rules quoted above for lighting ratios apply, just as if you were using artificial light.

EQUIPMENT

The often-quoted advice to use a longer-than-standard lens for portraiture can be a little hard to understand until you see the difference to apparent perspective that focal length makes. While a standard lens is perfect for group pictures and satisfactory for full-length or even half-length portraits, if it is used for a head and shoulders or, worse still, 'large head' shot the slight exaggeration of perspective will make an ordinary nose look prominent and a slightly prominent nose look like that of Cyrano de Bergerac. Even with seated portraits, the slight flattening of perspective produced with a longer lens makes arms and legs look neater and less awkward. Another advantage of the longer lens is that it keeps the camera a reasonable distance from the subject, and allows a more relaxed pose.

You do not need a very long lens, and indeed you are likely to find anything over about 150mm rather inconvenient. You end up too far from the subject, and you need a very large studio. A slight increase, such as the 127mm for the Mamiya RB67, is ideal, and with a Hasselblad you might use anything from the old 100mm/f3.5 Planar, through the 110mm/f2, the 120mm/f5.6 or the 150mm/f4 or f2.8. Large apertures are useful if you want selective focus, but too-large apertures (anything larger than f4 or so) can lead to depth of field problems even though they make focusing easier.

An option which is much more readily available to the medium-format user than to the 35mm user is soft focus, as already described in Chapter 3. Most medium-format cameras boast a soft-focus lens in the line-up, although rather surprisingly the Hasselblad does not (instead, you have to use Softars, which are the next best thing to a true soft-focus lens, and which are certainly easier to control). Very slight soft focus may be used in formal portraits of men, but the only place to use lashings of this is when photographing either young girls (where it can create a very romantic effect) or vain old ladies, where it can lose wrinkles quite magically — and profitably!

This complex-seeming portrait relies more on detail and visual richness than on complicated lighting. In order to hold some light in the window, a single 500W lamp was used, with a large sheet of expanded polystyrene as a reflector. (Jan Podsiadly for Stafford Miller; reproduced by permission)

142

The actual model of camera you use is not important, though a waist-level finder is usually pleasanter to use than an eye-level one, and makes it easier to position the camera below the eye level of the subject. The Hasselblad, or any square-format camera, is fine and the Rollei SLX is said to be particularly fine. If you want to use 6×7cm, the ideal is one of the big Mamiyas, because of the revolving back facility. An important point is that once the camera has been set up, the photographer should look *over*, not *through*, it at the subject. This establishes a much more personal relationship between the photographer and the subject, and generally makes for a far better and more natural portrait. This is, of course, one of the reasons why a tripod is indispensable for serious portraiture.

POSING AND CAMERA POSITION

Except for glamour photography, which is a law unto itself, posing is mostly a matter of looking natural. It is also inextricably mixed up with the positioning of the camera, which is why the two are considered together here. Some of the 'rules' given below may seem strange and old-fashioned, and indeed they are, but they do provide a framework for analysis. You can break any or all of these rules, and still produce very fine portraits, but unless you are able to verbalise what you want you may have considereable difficulty in eliminating what you do not want, and in explaining to your subject why you are asking for a particular pose.

A camera at the subject's eye level usually presents a very straight sort of image, with no particular feeling. This is the angle for purely record shots, or where the personality of the sitter or the kind of lighting employed does all that needs to be done. Shooting from below the eyeline tends to emphasise height, power and strength, all the things we think of when we talk of 'looking up to someone'. It also emphasises heavy jowls, long (or double) chins and weight, so it is to be used with discretion. Shooting from above the eyeline can carry connotations of 'looking down on someone', but on the other hand it also emphasises a domed forehead which can be useful if you want to give the impression of an intellectual, and baldness, which can be a nuisance with vain men.

If the subject is facing the camera more-or-less directly, then the subject should normally look straight at the camera. Eye-contact is a powerful force in many portraits. Otherwise, the subject should look in whatever direction looks natural. In profile, neither straight ahead nor at the camera is appropriate; corner-of-the-eye looks record odd-

ly and so does an eye which shows too much white, so the subject should look ahead, but slightly towards the side on which the camera is situated.

With three-quarter profiles, take particular care with the nose. Try to arrange the pose so that the nose either does not break the line of the cheek at all or else breaks it decisively. Just why the tip of a nose breaking this line should look awkward I am not sure, but it does. Expressions should be as unforced as possible: a teeth-bared smile very rarely comes naturally to most people, and a smile which shows the top teeth is hard to sustain convincingly for long. If you can capture a smile then do, but a rather calmer expression may suit most people better. The only real exception to this is the smile of a small child, which is more akin to laughter: these are hard to photograph, but very rewarding.

So far, we have assumed that the subject is holding his or her head more or less level, and in practice this is normally best. Any more than the slightest tipping forwards leads either to some very odd expressions, or to a look of gloom and depression, and tilting the head back is rarely as attractive as the people who do it are prone to imagine; it makes the chin look prominent, throws the Adam's apple into undue prominence and emphasises jowls mercilessly. Tilting either way, forwards or back, also leads to fore-shortening, which usually looks odd.

The positioning of the arms and legs is a subject which could fill a chapter in itself, and which requires either great detail or the sketchiest coverage. The main things to avoid are comfortable, but awkward-looking poses such as some-times occur with crossed legs; 'trapped areas' where the background is seen between, say, the crook of an elbow and the body; rigid right-angles at knee and elbow, which usually looks stiff and uncomfortable; and immodest poses, usually those in which the crotch is too prominently displayed.

Finally, the hands should always be shown at their full length, or engaged in doing something, even if only en-twined with each other. The thing to avoid here is a head-on foreshortened view, with the hands pointing straight towards the camera: this normally makes hands look stubby, clumsy and ugly.

INDOOR FORMAL PORTRAITS

Formal portraits in a studio setting require little more explanation than has already been given. Formal clothing may be an advantage, though the contrast between a very formal and proper portrait, carefully lit and posed, and

informal clothes or a deliberately outlandish appearance, can provide plenty of room for experiment. Outside the studio, the main things to watch out for are details — backgrounds, windows providing awkward cross-lighting, electric wall sockets, vases growing out of heads, ruffled carpets, dirty ashtrays and countless other things. For some reason, these are always far more easily spotted in a photograph than through the viewfinder, so a Polaroid Land test print can be an excellent investment.

Because the formal portrait is inclined to be shot to formula, it should be possible to get exactly the shot you want with no more than a single roll of film, unless your subject is a particularly difficult or unattractive one. In this case, you may decide to try several of the techniques mentioned above in turn, in order to get the 'least worst' picture.

OUTDOOR FORMAL PORTRAITS

This is a rare type of picture, normally only taken of military men, the more flamboyant politicians and royalty. A low camera angle and a commanding expression normally go together well. Because there is no way of controlling overall lighting, fill-in flash or an assistant holding a reflector may be required to even up the lighting ratio.

GROUP PORTRAITS

These are particularly tricky, because you need first of all to arrange all the people present in a harmonious group which gives the impression of being a whole, rather than just a collection of people who happen to be in the same picture, and then you need to be sure that you show all those people in the best possible light. The classic example of a difficult group portrait is a wedding group, where it is virtually impossible to please the bride, the bride's mother and the groom's mother with the same shot.

The first part, building the group, is usually best done on very conservative or even Victorian lines. Aim for a roughly pyramidal structure, with the most important person clearly the centre of attention not only of the camera, but also of the others in the group. Unlike individual portraits, where the subject normally looks at the camera, the people in portraits of small groups (up to four or five) generally look best if they are looking at each other — though one of them may look at the camera, and if it is plainly a souvenir or record shot, such as a Government cabinet, a company board, a football team or a boat's crew, they will normally all look at the camera.

146

The second part, securing good pictures of them all, is best solved by taking plenty of exposures — two or three rolls is not too much — in order to get the combination of expressions which looks best. Select what you think are the best and let the subjects fight over which ones they want!

INFORMAL AND SEMI-FORMAL PORTRAITS

These are increasingly fashionable nowadays, when no-one wants to be seen as remote or aloof, but despite this the techniques are surprisingly similar to those needed for the old-fashioned formal portrait. The main difference lies in the use of less formal clothes and props. In a semi-formal portrait, the subject is normally shown as if he or she were in the middle of working, with the desk suitably 'gardened', and the expression should be either neutral or smiling. In an informal portrait a smile is almost mandatory, which places the photographer under an obligation to work quickly if spontaneity is not to be lost.

Because you are trying to say rather more about your subject than you would in a formal portrait, it is a good idea to spend as much time as you possibly can talking to him or her beforehand. Look for mannerisms, and probe for interests. The former should help you to capture characteristic (and reasonably flattering!) poses, and the latter will enable you to keep up a conversation and inject a touch of liveliness if your subject begins to flag. Of course,

Re-creating the 'naughty' atmosphere of an Edwardian pin-up is an interesting technical exercise in lighting, posing and photography. This original was probably shot on a half-plate camera.

147

these techniques are also applicable to a formal portrait, but there you must be careful not to reveal too much about your subject in the final picture. A formal portrait is, after all, akin to a mask, whereas an informal portrait should be more revealing.

The truly informal portrait is more in the nature of reportage, and although you can apply some of the techniques in this chapter or those in Chapter 16 to taking a picture of, for example, someone reading the paper or making a model boat, medium-format photography is not particularly suited to the genuinely spontaneous shot.

CHILDREN

It is perfectly possible to take adult-style formal and informal portraits of all but the youngest children, and the results are often far better than if you deliberately set out to take a different style of picture. The natural dignity of many children is immense, and they welcome a chance to show it. Attention spans can be short, so it is best to have the lighting set up before your subject arrives, and to shoot fast — and to shoot plenty of film, because expressions can be mercurial. It is very important, though, to come down to the child's eye-level. Children's heads are disproportionately large by adult standards, and a high viewpoint will only make this worse, quite apart from the already-mentioned psychological connotations of 'looking down' on people.

If you do decide to take an adult-style portrait then keep lighting ratios low. Dramatic lighting looks odd with the unformed features of a child; and flatter lighting will be better at rendering the delicate texture of a child's skin. Do not be afraid, however, of bright colours and rich textures, as the contrast between these and a child's skin can be very effective. When printing the pictures go for as rich a colour as possible, because this makes the child look healthier (parents rarely want their offspring to look pale and uninteresting) as well as emphasising the crispness and freshness of childhood, when everything is so new.

With very young children you will get more natural and pleasing pictures if they are doing something they like, preferably in familiar surroundings, and if they are not too far from their mothers. Babies are usually at their best in their mothers' arms — they tend to sprawl a bit otherwise — and excitable toddlers need to be given something to play with, though even this is unlikely to keep them in one place for long. If your studio is not set up for photographing small children, watch out for little fingers among the electronic flash, and sticky fingermarks on expensive lenses.

148

ANIMALS

Animals can be photographed with their owners, and particularly pleasant pictures often result from their being shown with children — though this soon brings home the old actors' (and cinematographers') adage about never working with children or animals, because it is murder to do and they always steal the show.

Most pets have to be photographed fairly quickly, before they get bored and leave. Pets also tend to move quickly, so pre-focusing and moving the whole camera back and forth until it is sharp is usually a good idea. An interesting point here is that although you can focus on a cat's eyes and let the rest go soft — the animal just looks fluffier — if you try the same trick with a dog it looks out-of-focus. This problem is, of course, made worse by the fact that most breeds of dog have quite long noses, which requires considerable depth of field, whereas most breeds of cat have short noses.

The animals should have been fairly recently fed, though not yet ready to sleep after their meal: alternatively, try to catch them after a nap. The main technical point to note is the tremendous light-absorbing power of fur. An exposure one, two or even three stops more than indicated by an incident-light meter will be necessary if the fur is not to 'block up', except in the case of white (or very pale) cats, where the indicated exposure or even a stop *less* is normally correct. Fill-in flash is extremely useful for this, and a small on-camera gun can add highlights. A whistle or clear-toned bell will attract an animal's attention several times, but

Dogs' long snouts always lead to depth of field problems; as with humans, the eyes *must* be sharp and the tip of the nose should be held if you can, but it does not matter too much if the ears are allowed to go out of focus. (Rolleiflex TLR)

Colin Glanfield, who took this masterful shot of one of his cats on a Yashicamat TLR, calls it 'Mephistopheles'. The satanic lighting was actually very easily achieved, as the cat was lying on its side, with sunlight striking it from below. Note how the contrasty light increases the impression of sharpness.

grows less effective each time you use it — and cats may ignore it anyway.

Cats are normally shown full-length, though head and shoulders pictures can be very effective. Limit their movement by placing them on a chair or occasional table: professional pet photographers have little turntable-top stands made. As mentioned, a recently-fed cat will normally be more docile than one which is wondering when it is next going to eat, and if it has very recently been fed it can be relied upon to wash. Otherwise, a little bacon-fat smeared on the whiskers normally provokes a wash.

Dogs are shown head and shoulders as often as full-length, and a well-trained dog should respond to its master's instructions enough to allow several fast shots before losing interest. Choose a camera angle and pose which reflects the typical characteristics of the breed. For example, alert, looking up, tongue showing for an Alsatian; perky with head cocked for a terrier; or mournful and downcast for a bloodhound. Merely by *thinking* about what the typical image of such a dog is, you can often see quite easily how to take the best picture.

Finally, always beware of taking pictures with more than one animal. The results can be enchanting, but if you want to photograph five kittens, you really need three assistants to keep catching them and putting them back on the chair, table or whatever. You will also spend hours trying to get the right picture when it is mostly a matter of luck anyway!

16 · Reportage and Action

The kinds of action photography which are feasible with medium-format photography are, quite frankly, more limited than those possible with 35mm, but for the kind of action photography which medium format can handle, the results can be excellent. The scope for reportage is slightly greater, but for true photojournalism (that is, for photography to be reproduced in a magazine or newspaper) there is little reason to use medium format; the reproduction quality is such that Kodachrome or 35mm black and white will be more than adequate. The real reasons for using medium format for reportage or action are for exhibition work, for stock photography and for book illustration — no-one who has seen David Douglas Duncan's memorable *World of Allah* could doubt that medium-format reportage can be stunning. Also, the techniques required for certain other types of photography — some kinds of fashion, for example, or dance and theatre photography — have enough in common with reportage and action photography to give this section a wider applicability than one might think.

It is important, though, to distinguish between *soft* and *hard* reportage. For these purposes, 'soft' reportage is a fairly relaxed business, where none of the subjects is likely to take a swing at the reporter, and hard reportage is the other kind. Medium-format cameras are more suitable for the former. Indeed, they are usually too conspicuous and too heavy for the latter, as well as requiring too-frequent reloading.

Which is the best medium-format camera for soft reportage is a matter of dispute. Some prefer eye-level 'giant 35mm' reflexes, such as a pentaprism-equipped big Pentax or, at least, a pentaprism-equipped cuboid camera, but others point to the noise and conspicuousness of such machines and to the inevitably long delay between pressing the shutter and actually taking the picture; you have either to use the pre-release or learn to anticipate a very long way ahead.

The most suitable interchangeable-lens non-reflex cameras — the Koni-Omega/Omega Rapid, the Fujica 690 and the Linhof Press 70 — are no longer in production, though the Mamiya-Press apparently is. Among technical cameras the Linhof Technika 70 was discontinued in 1984, leaving only the small Master Technika and the Horseman.

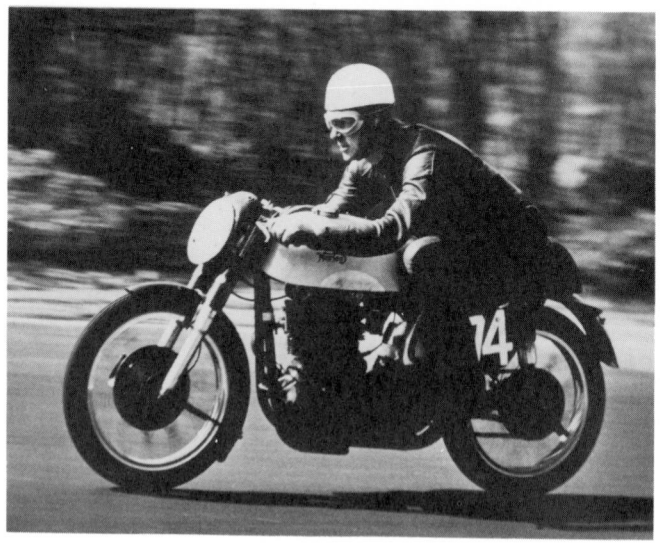

One of the great advantages of a medium-format camera for action photography is that it is possible to 'pull up' small sections of the negative without undue loss of quality. Not only does this reduce the need for a battery of lenses: it also allows you to cover quite a large area, such as the finish of a race or a large area of a football field, if you are not sure where the action will be. This shows the immortal combination of Geoff Duke and Norton, and was taken in the early 1950s by Colin Glanfield on a pre-war Rolleiflex.

The major disadvantage of technical cameras is the separate shutter cocking and film wind, which can slow you down severely and even lead to mistakes in the heat of the moment, which means they are not really suitable for fast action. One accessory well worth considering for any form of action photography is a 'sports finder', a plain frame finder which allows the camera to be used with both eyes open. With one of these, any reflex can be used at eye level, though you must pre-focus or focus by scale.

Because you are often shooting 'for the percentages' in this type of photography, it is a good idea to use 220 or even 70mm film. The Linhof Press 70 is particularly convenient in this guise, and gives you no fewer than 53 exposures on a single 70mm load.

The classic trinity of lenses for the 35mm reportage photographer is 35mm, 50mm and 90mm, and the medium-format photographer will do well to stick to the equivalents for sport and action, though he may prefer something a little wider at the wide-angle end. For 6×4.5cm, the ideal might be 45mm, 80mm and 150mm; for 6×6cm, perhaps 50mm, 80mm and 150mm or 180mm; and for 6×7cm, 50mm or 65mm, 90mm or 105mm and 180 or 250mm. An obvious drawback, though, is the small maximum aperture of most medium-format lenses, and the reportage or action photographer will do well to get the fastest available. For a Linhof, for example, the 53mm/f4.5 Biogon is excellent, the 65mm/f5.6 Super Angulon is adequate, and the 65mm/f8 Super Angulon is altogether too slow. Speed is also the reason why lenses longer than 180mm (or at most 250mm) are not really suitable, except

in the case of the big Pentax, which does offer reasonably fast telephotos, or the Praktisix/Pentacon Six if you can find the lenses you want.

The wide-angle lenses are of most use for close-quarters reportage, where getting in close gives a feeling of intimacy and rapport with the subject, and for pictures where the camera can be remotely operated — over a boxing ring, in the jumps at a horse-race, or perhaps fixed to some part of a racing car or a hang-glider, though remember the importance of maintaining balance. One photographer was almost killed when his hang-glider crashed on take-off because it was unbalanced by a motor-driven Nikon bolted to one wing-tip. Again, you may often find yourself in 'back to the wall' situations when you are photographing interiors, and a reasonably fast lens with as wide an angle of view as you can get is a blessing: the 53mm/f4.5 Biogon is a particularly fine lens, as is the equally unobtainable 53mm/f4 Super Angulon.

Standard lenses are of some use in reportage and sport, not least because a sectional blow-up can be pulled up out of the full image, but they are still more useful when the action is staged in some way — movie stills, for example, or fashion or dance — so that you can shoot from a reasonable

Another photograph from the 1950s, when footballers wore long shorts and crowds came to watch rather than to fight. Nowadays, most photographers use 35mm and ultra-fast long lenses — but do they get significantly better pictures than this blow-up from a small part of a Rollei negative?

153

distance without risk of obstruction. The importance of a fast lens varies greatly. In fashion, where you can use powerful electronic flash, you may be shooting at f5.6–f8 most of the time, but in a dance studio where flash could distract the dancers you will probably need all the speed you can get.

The longer lenses come into their own in a number of quite widely differing fields. The most obvious one is sport, though medium-format lenses of modest focal length and speed cannot really begin to compete with the ultra-long and ultra-fast specialist lenses available for 35mm. So you have to get in reasonably close, and you have to content yourself with medium close-ups because you can rarely get those really tight frame-filling pictures of an athlete's face, but as described above, you can permit yourself the luxury of sectional blow-ups, which is an option that is substantially closed to the 35mm user. A very similar application is in reportage, when you cannot get close enough to your subject, a speaker on a dais, a parade or the interior of a building where movement is restricted. This ability to 'pull up' a part of the picture is particularly useful if you are photographing the finish of a race, as you can shoot the whole field (or the leading part of it) and then pull out the winner. Again, in dance or theatre photography, you may

I chose to shoot this picture with a Leica rather than with a larger camera because the electric winder allowed me to capture the rapidly changing expressions on the little girl's face. *(M4-P: FP4/ Microphen)*

A perennial problem with this sort of reportage work is the demand for money from the subject. He was a potter who earned his living solely from making pots, and he probably earned no more than fifty rupees a day; but he still reckoned that a 20-rupee tip was too small, and wanted a hundred. *(Mamiya 645, 80mm/ f1.9: ER)*

not be able to get as close as you would wish to the stage, and a medium telephoto can be just what you need. In fashion and similar applications, you may wish to use such a lens for the slight flattening of perspective when compared with a standard lens, as well as for the increased opportunities for selective focusing.

For 'hard' reportage, you can forget all about the luxuries of interchangeable lenses. There is really only one serious medium-format reportage camera, the old twin-lens reflex. Not only are these cameras virtually indestructible; with practice you can use them very unobtrusively, just glancing down into the finder (a much less obvious move than raising a camera to your eye), and the shutters are very quiet indeed by SLR standards. You can also turn them sideways so that you are photographing the person next to you instead of the one in front of you, hold them over your head to photograph over crowds, or poke them round corners without even exposing yourself. On top of all this, they are still seen as amateur cameras, rather than as professional tools, which can ward off unpleasant interviews with the police and other interested parties who suspect you of being a reporter!

17 · Stock Photography

There is always an understandable temptation for every photographer to try to make some money out of his or her knowledge. It is, after all, a marketable skill, and the potential returns from portraiture, glamour work and wedding photography are mentioned elsewhere in this book. One lucrative area which is, however, widely neglected by both amateurs and professionals is stock or library photography. Obviously, not all of the millions of pictures which are used every day in advertising, publishing or journalism are specially shot, and a great number of them come from commercial picture libraries. With the exception of the older libraries, which may have black and white archive material, and a few specialist libraries, the bread-and-butter of picture libraries comes from medium-format transparencies.

We have already seen how medium format has the edge over 35mm where quality is concerned, and if you want to sell your pictures then rollfilm transparencies have a thick edge over 35mm. In black and white the advantage is not so great; it is true that really high-quality b/w reproduction will show up the difference between prints from 35mm and rollfilm, but in normal reproduction the shortcomings of the smaller format are concealed by the still greater shortcomings of the reproduction medium. With colour, however, reproduction quality is normally higher and the deficiencies of 35mm are clearer, but the real advantage of the medium-format image is that it is easier to see. It is common knowledge among photographers that art directors are blind (not to mention why), and a bigger transparency is simply easier to see.

Another point to consider is that reproduction rates for black and white photography are usually poorer than for colour, while the cost of producing black and white prints is very much higher than the cost of producing colour transparencies. For this reason, fewer and fewer libraries handle black and white.

The normal terms for a library are a 50/50 split of the proceeds from any picture sales. Although this sounds stiff at first, it does not look anything like so bad when you realise that the library does everything except actually taking the picture. Filing, cataloguing, storage, advertising, marketing, delivery, chasing, invoicing and accounts are all

carried out by the library. The library's experience also means that they can usually negotiate better fees than an individual could, quite apart from having many more contacts. Besides, these are the standard terms, so there is not much you can do! An important point is that the library sells *only* reproduction rights, and never copyright, so the same picture can be sold again and again to different markets.

If you do decide that you want to try your hand at stock photography then there are four main things to remember.

The first is that technical quality is taken for granted, as in any professional market. Unless variations from the

This picture was taken on California's Pacific Coast Highway, but it could be anywhere. Typical 'stock' uses might include a greetings card or use as a background for an advertisement. *(Mamiya RB67, 90mm Sekor: EPR)*

This otherwise very powerful picture is spoilt by a flag-pole on top of the tower. There is no substitute for attention to detail in this highly competitive market. *(Mamiya RB67, 90mm Sekor: ER)*

standard are both deliberate and successful, the transparencies must be sharp, clear and well exposed; note that I do not say 'correctly exposed', because quite considerable variations from correct exposure are sometimes required to achieve the most pleasing effect. When preparing a submission to a library carefully weed out any pictures where — in your opinion — the exposure did not really work, where there is unwanted blur or softness; or where there is excessive or confusing extraneous material in the picture.

The second is that you will need to submit a fair number of pictures to begin with, and to be able to promise a continuing supply of pictures thereafter, if you are to build

up a successful relationship with a library, or to make a reasonable income. The number of pictures required for an initial submission will vary widely, but one leading London library (Fotobank International/England Scene) asks for 50–100 pictures, preferably of two or three different types of subject, as a basis for assessing your work. If they like these, they will request more, so that they begin by taking at least two hundred pictures. Thereafter, they like you to add at least 100 pictures a year and preferably more, which may mean that you have to submit up to two or three times as many pictures as this in order for them to make their selection. The reasons for this are obvious. Administrative costs are lower if you have ten photographers with a thousand pictures each, rather than a thousand photographers with ten pictures each, and it is easier to build up a working relationship with a prolific photographer who is

Although still interesting in this version, the original of this picture was shot in colour and would probably only sell in colour. The school bus, an American archetype, is a brilliant yellow. *(Mamiya RB67, 50mm Sekor: EPR)*

prepared to work towards what the library knows it can sell. Often, the first two or three submissions do not sell as well as the later ones, just because it can take the photographer time to realise what sells.

The third is that a lot depends on subject matter. The library already mentioned is known as one of the best in the world for pictures of England, and they have a correspondingly high demand for pictures of England: if you want to sell sports pictures or natural history, consider a library specialising in those subjects, though equally, there is much to be said for placing specialist pictures with a general library if you can, because there will always be less internal competition. Landscapes and typical scenes always sell well, whether of your home town or of some exotic country. Pictures of places which other people are likely to visit, such as Paris, New York, or the Grand Canyon, are usually more saleable than the less frequently visited countries such as India or Burma. Pictures of, say, Tibet may claim a rarity value when they are sold, but there are never going to be as many requests for the Peak Potala in Lhasa as for the Eiffel Tower in Paris or The Statue of Liberty in New York.

The fourth is that the rules of composition for stock photographs are not always the same as they are for other pictures. Often a stock picture will be cropped to fit a particular shape in a layout, or will be used as a background for text. As a result you need a certain amount of 'working space' around the principal subject, so that the image can be cropped in a number of different ways, and you also have an advantage if there is a good-sized area into which text can be dropped. Sky, sea, sand and foliage can all furnish this sort of convenient ready-made background.

If you think that you can meet all the requirements outlined above, you can embark on the actual process of making a submission. Once you have your pictures sorted — aim for three or four hundred first-class images — you should try contacting a picture library. In Britain, for example, almost all reputable libraries belong to BAPLA (the British Association of Picture Libraries and Agencies), and there are similar bodies in other countries. With unknown libraries there is not only the risk that they will be unable to promote your pictures as effectively as a larger library, but there is also the danger that they may not be entirely honest about picture sales, so that you do not get paid the full amount due for every sale. This is rare, but it has been known, and 'payment on lawsuit' was said to be the standard terms for one library of my acquaintance. For information about picture libraries, either contact BAPLA or its equivalent body in your country, or buy one of the

myriad directories which list publishers, agents and picture libraries. In Britain, the *Writers' and Artists' Yearbook*, published annually by A and C Black, is a model of such books.

Write a preliminary letter to a library, or even to three or four libraries. Personal relationships are as important here as in any other creative undertaking, and it is always easier to work with people whom you like. If possible, arrange to take your submission in, so that you can talk to one of the picture editors; you can learn a great deal that way. Otherwise, pack the pictures securely, in individual sleeves with captions, and send them by insured post and whatever you do, do not forget to enclose return postage. Get a clear idea of how many pictures they want and how long they are likely to take to make a decision, and leave your pictures with them. Only if you are very lucky will they go through them, at least in their entirety, while you are there. If they take longer than they say give them a week or even two, and then telephone to say that you have not had your pictures back; this takes the blame off the picture editor, and shows that you are concerned merely because they might have been lost in the post.

This point about not hassling the library is an important one. The library should be more than willing to give you a 'want list' of subjects, and possibly a tip sheet about photography as well, but they will rapidly tire of you if you keep calling to ask about sales. As already mentioned, it can take some time for sales to pick up and many libraries say that you should not expect sales to get properly under way for anything up to a couple of years after your initial submission. This is one of the reasons why the contract normally binds you to a minimum period with the library of two, three or even five years. The other reason is that the effort of cataloguing and filing all your pictures is such that they do not want to have to do it, only to have you withdraw your pictures a few months later. Other normal conditions include a three or six month notice of withdrawal, which reflects the length of time it can take to get your pictures back from clients, and exclusivity, which is necessary to protect all parties: the client, so that he gets the degree of exclusivity he has paid for, the photographer, so that he knows who has sold his picture, and the library, in order to retain credibility. The library normally undertakes to try to recover compensation for lost or damaged transparencies, and to pay the photographer accordingly, but the contract expressly excludes liability for lost transparencies because it is not always possible to recover money from erring clients, and insurance for every single image would be prohibitive.

'Studio' photography covers a very wide field. A typical professional advertising studio might handle car photography, fashion, still life 'pack shots' of various kinds, more or less elaborate room sets (with props), and straightforward copying, which has already been covered in Chapter 9. The unifying factor which underlies these very different fields is simply the extent of the control which is exercised at every stage: control of lighting, of subject and camera position, and even of the appearance of the subject. Dulling sprays are used to kill reflections; flowers or packages are especially selected for flawlessness; vehicles are usually clean and polished and so forth.

Few amateurs will have the facilities to handle large-scale studio shots such as motor-cars, so here we are concerned with three types of studio work: table-top pictures of various sorts, pictures taken in improvised studios or on location using studio techniques, and copying. Portraiture and glamour photography, which are also 'studio' subjects, have their own sections.

To begin with, you can forget the nonsense which appears in most amateur-oriented magazines about 'transforming a corner of your living room into a studio'. Creating a professional-style studio requires large amounts of both space and money. The smallest realistic size of a professional studio is about 20×30 feet (7×10) metres, and even a garage is unlikely to prove suitable unless the ceiling is at least ten feet high; you are thinking more in terms of an old-fashioned barn if you want a sensible-sized studio. Even if you have that much space at your disposal — which is unlikely for most people — you will need to spend a fortune if you want a 5000 joule Strobe pack, a Cambo camera stand, an assortment of background paper, and the other things which are taken for granted in a modern professional studio — and unless you have this sort of space and these sorts of facilities you will never have anything like the freedom which a genuine professional studio affords. The best you can hope for is to produce pictures which are of professional studio quality, which is perfectly possible but does require a certain amount of work.

You already have the most useful single tool, a medium-format camera. As with many other applications the exact

Still lifes such as this old one from my files are an excellent way of learning about lighting and compositional skills, even if they are not particularly exciting in themselves. *(MPP Mk VII with 6×9cm rollfilm back, 89mm Wray lens: FP4/Microphen)*

camera you choose is not particularly important: even the big Pentax, which I regard primarily as a camera for action photography, can be used to very good effect in the studio. If you use flash, a leaf shutter is more versatile, and the 6×7cm or even 6×9cm formats deliver the best quality, both because of the increased image area and because of the greater ease with which you can examine the larger ground-glass.

The next major requirement is some form of lighting. It might just be possible to attempt a few kinds of studio photography using only available light, but not to use controlled lighting in a studio negates the whole concept of control. Even Victorian portrait photographers, working exclusively by daylight, had complex arrangements of shutters and blinds to control the direction and intensity of light. At the very least, a couple of cheap lighting stands and two flood reflectors plus one snooted semi-spot might be enough; but if you are going to take studio photography seriously then two — preferably three — Monolites or similar would be infinitely better. Add to these a couple of reflectors, which need be no more than polystyrene blocks, 8×4ft (2.5×1.2m). You can use heavier and harder-to-handle, but equally effective, sheets of white-painted plywood or chipboard; you can even use sheets of plastic laminate, though their flexibility makes these hard to handle. If you intend only to work on a table-top scale, then you can, of course, get away with smaller reflectors. You will also find it useful to have a couple of 'flags' or 'donkeys', pieces of metal or card mounted on lighting stands which are stood between the light and the subject to kill reflections. Usually, a flag is matt black on one side, and white or matt polished on the other, so that it can also be used as a reflector.

A tripod or camera stand is essential for all but a very few pictures. Only with a tripod can you check a picture in the viewfinder; walk over to the lights, or to the subject, and make some small adjustment; and then return to *exactly* the same position, so that you can judge the effect of that change. It provides a 'third hand' for close-ups; it holds the camera in positions which would be uncomfortable or unstable if you had to hand-hold the camera; it allows long exposures without camera shake; and it stops your arms getting tired. This last observation may seem humorous, but if you have ever tried hand-holding an Mamiya RB67 for a long shoot, you'll realise just how serious it is.

You will often need to provide backgrounds. Seamless background paper is one of the greatest friends a studio photographer has, because it is smooth, wide and clean; if it gets dirty, you simply tear off the soiled part and pull out

some more. Generically known as Colorama, after the name of the leading supplier, it is normally sold in rolls around 9ft (3m) wide and from about 20–100ft (6–30m). Any professional photographic dealer will be able to get Colorama (or similar paper from some other maker) for you; some also sell half-width rolls. Colorama provides backgrounds which are not easily obtainable in any other way, and although it may seem expensive it is well worth the money.

There are, however, several other kinds of background material which can be very useful. Black velvet is excellent for producing a 'floating in space' effect. Tracing paper is very useful if you want to trans-illuminate a background; stretched across a frame or laid on opal Perspex as 'translucent Colorama', this provides a clean neutral background (though some varieties do introduce a very slight tint — about CCO5M, corrected with CCO5G, for the usual favourite, Kodatrace). Coloured fabrics of various kinds and wrapping papers can also be useful, as can wallpaper, while an unexpected source of backgrounds for small-scale shots can be model shops, especially those catering to model railway enthusiasts; various sizes of brickwork, stone walls, etc can provide excellent backgrounds.

Finally, you may need costumes and props. Often, you will be able to improvise these from what you already have — some photographers maintain their own stocks of props,

This miniature 'cove' for shadowless lighting is a custom-built model from Matthew Ward, but you may be able to build something similar yourself for very little money.

and haunt junk-shops and auctions for just this purpose — but others have to borrow or hire. If your friends cannot supply what you need, you can often persuade a shop to lend you what you need, against a deposit of the full value, which is of course forfeit if you damage the goods. This was brought home to me particularly strongly once when I borrowed some motorcycles from Three Cross Motorcycles in Dorset. 'Anything you drop, you pay for,' they said, and as one of the machines was a Harley-Davidson which cost over £7000 in 1984, I took the warning to heart!

Alternatively, there are professional hire agencies of various sorts. Even quite small cities will have theatrical hire agencies (and indeed, amateur theatrical companies can be an excellent source of props), but the biggest cities also have agencies catering to movie photographers and professional stills photographers. These wonderland-like places are not cheap, but you can hire almost anything from a couple of decanters to a whole room set or indeed a whole street set, complete with street lamps, telephone booths and so forth.

All studio photography is a matter of the creation of

In a shot like this, where a certain amount of space has to be 'wasted' to allow for movement, 35mm would be incapable of delivering really critical definition, while with medium format (especially 6×7cm) and a first-class lens it would be quite feasible, however. It must be admitted, however, that many professionals would use 5×4in or even bigger, because it is then easier to see what is happening on the big ground glass. Photographer: David Whyte. Client: Ian Desborough, May and Baker Ltd. Product: Piportil (*Original on Ektachrome*)

illusion and, as such, it is similar to theatre in many ways. What the camera cannot see does not matter. It is only what it can see that you have to worry about. Model's clothes may be held at the back with pins and even bulldog clips; props may be held in place with gaffer tape and Blu-Tack; and ramshackle woodwork may support a backdrop. There is tremendous scope for ingenuity and for improvisation, and the best studio photographers are masters both of photography and of the art of creating illusion. Although the range of studio photography is great, the techniques can be adequately illustrated by choosing four aspects: fashion, which shows you how to deal with people in rather a different way from either portrait or glamour; pack shots (including shadowless lighting); still lifes; and trickery, such as double and multiple exposures.

FASHION PHOTOGRAPHY

There is a tradition of fashion photography which is closely akin to formal portraiture, and there is another tradition (due largely to David Bailey) which uses 35mm; but the

majority of fashion photography nowadays is probably between the two, and involves medium-format cameras and powerful electronic flash. Leaf-shutter cameras are the norm, especially the Hasselblad, though the Rollei SLX/SL6006 is prized for the special effects it can deliver (especially multiple exposure and rapid power wind-on), and the image quality of the 6×7cm format also encourages use of the Mamiya RB67 and RZ67, the big Pentax and the Bronica GS1.

Some people prefer to work hand-held, while others prefer a tripod, but the essence of fashion photography is normally to show the drape of the fabric and to create a mood. The drape can be shown either by having the model 'freeze' in particular poses — an experienced model can be astonishingly good at this — or by using flash to arrest movement. Either way, because animation is the essence of the picture, it is normally necessary to shoot for the percentages (a single shot may be all that you get from a roll of film). If you want to show texture, you will have to be particularly careful with lighting: using an incident light meter or flash meter, white or very pale fabrics will require slight *underexposure*, whereas velvets and dark furs will require at least one stop extra exposure, and possibly two or three. This is why, incidentally, many of the best fur shots are black and white: the longer tonal range of monochrome film is better able to handle the long tonal range of the subject.

Portraying mood is another matter, and one for which there are no such handy tips. Mood can be created photographically, by over or under exposure, by lighting, by creative use of controlled blur or electronic flash, by grain (35mm is easier here!); or you can use carefully chosen props and surroundings. Your best teacher here is a subscription to a fashion magazine, such as *Vogue*. It is particularly fascinating to compare the different photographic techniques of French *Vogue*, Italian *Vogue*, British *Vogue* and American *Vogue* at any given time. There are fashions in photography, just as there are fashions in the clothes themselves, and whether you want to follow the fashion or to devise something new, the magazines are a powerful stimulus to the imagination.

PACK SHOTS

The usual way for a professional photographer to learn the trade is as an assistant to an established photographer, and when he is doing so, pack shots, copying and processing and printing are the cornerstones of his life. They are often very boring to photograph (which is why the assistant gets

them!) but you do learn a good deal about detail, and about commercial reality, as budgets are usually low and deadlines tight.

A pack shot is typically a straightforward picture of a package or box of some kind. It is something which is used endlessly in advertising, because it is a very safe and reliable thing to show, even if it is neither exciting nor memorable. As the old jingle from Benson's, the advertising agency, has it:

'If your client screams and yells
Show a picture of what he sells.
If he still should prove refractory,
Print a picture of his factory.
Only in a desperate case,
Print a picture of his face.'

The main requirements of a pack shot are that it be clean, clear, well-lit and undistorted, and for this reason it is an excellent paradigm of a certain type of photography. Even if you never want to shoot a picture of a pack of baby food (and I never want to shoot another!), you may wish to shoot small antiques, cameras or whatever, and these are the techniques you will need.

The background is normally neutral. Colorama is ideal, though graded backgrounds (most easily achieved by airbrushing, but now available commercially) and transilluminated backgrounds (described later) can also be useful. Lighting is normally soft, and may indeed be absolutely flat: a standard set up is a huge 4×5ft/1.2×1.5m 'swimming pool', with as many as four flash tubes behind a sheet of opal plastic. For small antiques, on the other hand, you may wish to introduce a greater or lesser degree of modelling.

The object to be photographed will either be selected from a number of similar items, in order to find the cleanest and least marked (you get very funny looks in shops when you ask to see some more packs, until you explain . . .), or carefully cleaned and generally spruced up to make the pack or object look as smart as possible. If it is reflective, but not made of metal, a polarising filter will kill most reflections. For metal objects you are reduced to using a dulling spray (which can be hard to remove from awkwardly shaped objects); to dabbing with putty (ditto); to chilling and allowing condensation to form on the surface (which means you have to work quickly, as the mist soon evaporates); or to carefully constructed lighting coves (or tents), as described later. Any fingermarks need to be polished off and, if possible, the object will be positioned so as to conceal any irremoveable flaws.

The only remaining requirement is that the image shall not be distorted. This is most clearly visible when using a short focal length lens and looking down on the subject, which is — after all — the usual angle for shooting a pack shot. The effect is akin to the 'falling over backwards' phenomenon found when photographing buildings, and is dealt with in much the same way. You can use a falling front (instead of a rising front), and you can also alter image shape by tilting the back. For a more detailed discussion of this and of camera movements, see Chapter 8 *Architecture*.

Shadowless lighting, and the lighting of shiny metal objects, is a particular sub-division of the pack shot. It is very important to use a lens which exhibits the very minimum of flare, as the kind of very flat lighting required will show up this defect mercilessly, flattening colours and even obscuring detail, especially with trans-illuminated backgrounds. Zooms are usually worst, followed by retro-focus wide-angles and then fast lenses of any kind. Ideally, use a simple design — the best lenses for reflexes are usually slightly longer than standard, such as the 100mm and 120mm for the Hasselblad, or the 127mm for the Mamiya RB67. Always use a good lens hood — preferably a bellows model, adjusted to the limit before cut-off occurs (check cut-off at the working aperture, not wide open, and remember that the effective angle of view of a lens *decreases* as it is focused closer).

For some subjects, the easiest course is to use a plain background and a ringflash. But if you do not have a ringflash, or if there is some other objection, another solution is to use a sheet of clear plate glass and a soft light from above. Shooting somewhat less than straight down on the subject, with the camera lens poking through a hole cut in a piece of plain black paper, should remove all reflections, though you may have to juggle the light a bit. If neither of these methods is practical then you will have to use some sort of enclosure.

One that I have never tried, but which sounds feasible, is a plain white egg shell. With no corners, and a translucent cover which affords an absolutely shadowless light when lit from two directions outside, it should work well for very small subjects such as jewellery — though stones have no 'fire' in any shadowless enclosure. Another easy option is a cone of white paper standing on a sheet of trans-illuminated plastic sheeting. Lighting the cone as well will help to avoid a too-bright background, and flare. By cutting the cone about a bit, you can provide quite a reasonable choice of camera angles, but you are still somewhat limited. For real versatility you need some form of box or 'mini cove', a 'cove' is one of those all-white

rooms, with the corners radiused to hide them, that are used for car photography. A day's hire is about the same as the cost of a decent 35mm SLR!

If you do not need a trans-illuminated background, a simple tent is sufficient. Once, in northern India, I had the local carpenter make up a cuboid frame a couple of feet a side, and draped it with white cloth from the market place to provide shadowless lighting. The important thing with any such tent is to make sure that the side from which you are taking the picture is also reflective, so I draped white fabric across the mouth too, and secured it around the lens with an elastic band.

At home, I have a rather more sophisticated arrangement. It is a box, with floor and roof of translucent Perspex and sides and bank of white-painted chipboard, though a more sophisticated design would use Perspex for these too. On the front I use either white background paper or the same white cloth I bought in India. By taping a piece of Kodatrace to the top of the back wall, and letting it fall in a gentle curve towards the front, I get a 'translucent-Colorama' effect. Kodatrace is unusually tough, clear and free from grain or defects, which makes it far better than ordinary tracing paper for this purpose.

Even medium-format photographers use 35 mm sometimes! This is an illustration from my *History of the 35mm Still Camera* and shows a studio shot of the Nikon F in waistlevel, plain prism, Photomic, Photomic T and Photomic FTn guises, together with a weird assortment of Nikon-fit lenses including a 21mm/f4 'mirror up' Nikkor-O. Background is Colorama paper. *(MPP Mk VII with 6×9cm rollfilm back, 89mm Wray lens: FP4/ Perceptol)*

STILL LIFES

If you can manage a pack shot then a still life should pose you absolutely no problems. The only real differences are that you have to worry about composition — which is not

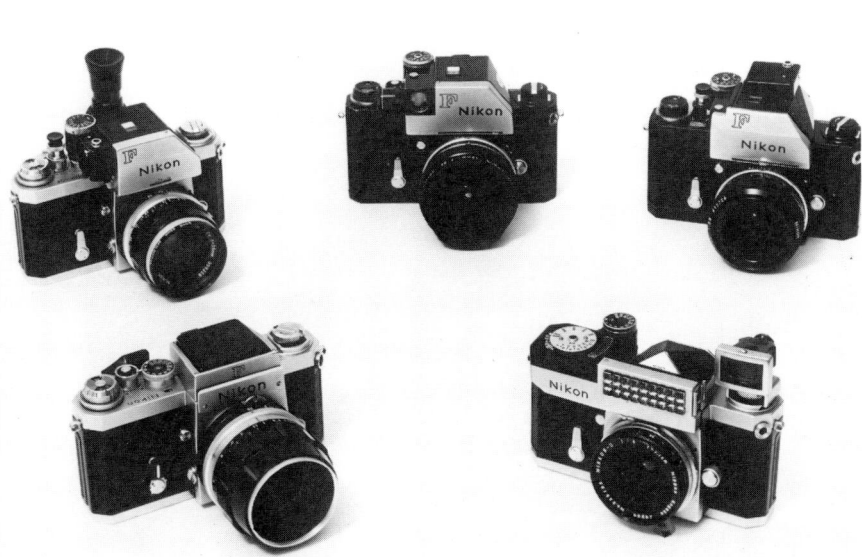

really a priority with most pack shots — and that you will, as often as not, want to use rather more dramatic lighting. You will also need to pay tremendous attention to detail. The technique obviously varies from subject to subject, but we can analyse the approach to be taken by looking at a classic painter's still life: bread, cheese and onion on a plate, together with a knife and a jug of beer.

To begin with, is the background appropriate? A gingham tablecloth might be one possibility, while damask would give another mood to the picture and plain wood would give a third. Of course, that 'wooden table' need be only a few planks laid on the studio table. Look out for details: wrinkles, marks, small holes, flaws in the wood or weave.

Next, what about the plate? Earthenware — or a plain white plate — would probably be more appropriate than fine china. You do not want it to be chipped or, at least, you want to be able to arrange things to conceal any chips. If the plate is shiny then you will either have to use a dulling spray or a polarising filter.

The bread must look fresh and appetising. You will have had to decide whether to leave it whole, to cut it or to break it. The loaf must not be too big or it may dominate the picture, so a small cottage loaf may look best. The onion must be unblemished and will look best if you leave the golden skin on: just think how rarely you encounter a truly photogenic onion. The cheese must look crumbly, but not shapeless; you may have to practise a bit using a sharp knife to get the shape you want. When you cut the onion, make sure that you use a clean knife (preferably stainless steel) so that the onion does not discolour — and leave cutting the onion until the last moment, so that it does not dry out.

The knife must be clean, even though it has ostensibly been used to cut the bread, cheese and onion. It must also be carefully arranged if it is not to flare a reflection into the lens. The tankard must look right, and if you want a head on the beer, you may do best to pour Stout just before the shot or to use a substitute, such as shaving cream, for the foam. Professional food photographers use all kinds of tricks, such as 'oiling' meat with glycerine, blowing cigarette smoke to simulate steam (it makes the food taste fairly awful!), and even having ice-cubes made up from Perspex.

For lighting, you might use a fairly strong directional light, as if from a window, and an 81C filter to create the impression of warm afternoon sun. The key light would be arranged to 'kiss' the crust, thereby revealing its texture, but a fairly flat lighting ratio would be needed to preserve texture and detail in the cut bread and onion.

A classic 'pack shot' showing the Kodak Brownie through the ages. Carefully arranged and beautifully lit, this shows how a 'simple' pack shot can be an aesthetically pleasing still life as well.

174

DOUBLE AND MULTIPLE EXPOSURES

Unless the image in a double or multiple exposure falls on a
dark area of the previous exposure, the inevitable result is a
degree of ghosting, in which you can see one image through
another. This is why black backgrounds — preferably
velvet — are *de rigeur* for the usual pictures, such as a
strobe shot of a golfer.

The ease with which multiple exposures can be made
varies widely from camera to camera, but the manufactur-
ers of most medium-format systems recognise that it is a
standard 'professional' technique, and provide facilities
accordingly. The Rollei SLX/SL6006 are undoubtedly the
finest cameras for multiple exposure, because a special

accessory allows the motor-drive to be uncoupled from the film advance and used to cock the shutter with tremendous frequency — you can select up to 10 exposures, with delays between exposures of between 20ms and 500ms ($\frac{1}{50}-\frac{1}{2}$ second). In other words you can take ten multiple exposures in around half a second, without risk of moving the camera while re-cocking the shutter. This is particularly useful for image-analysis and other shots where you want the background to remain recognisable while something else moves, and preventing camera movement is essential if you want to try your hand at 'X-ray images': a good example might be showing how the equipment in a camera case sits inside the case. The first exposure is taken against a black background, with the case open and the lid draped in black velvet — in order to show the layout of the gear — and the second shows the case only, closed.

Of course, if you want to get really clever and show the case on a different coloured background, you will need to draw the first image with a grease pencil on a piece of clear acetate taped to the ground glass, replace the black background, then reposition the case so that it matches up with the outline already drawn (in this case, it might be easier if the closed shot is done first). Here, the big ground glass of the RB67 makes life easier, and there is more risk of positioning the case wrongly for the second shot than of moving the camera.

Multiple exposures on cameras other than the Rollei SLX/SL6006 are usually a matter of releasing the film advance mechanism from the shutter cocking, and disabling the interlocks which normally prevent double exposures. This is normally accomplished with a simple lever, which should be watched carefully. More than once I have knocked the multi-exposure lever on the back of my Mamiya RB67 and worried/confused myself severely! Not all cameras allow easy double exposures, though, and surprisingly enough the Compur-shuttered Hasselblads make you go through a complicated rigmarole of firing the shutter, replacing the darkslide, removing the magazine, cocking the shutter, replacing the magazine, removing the darkslide, and shooting the second exposure, which makes a 500C/M easily the worst choice among top-flight cameras for double exposures (it is much easier on F- and FC-series Hasselblads).

19 · Travel

One photographer of my acquaintance swears that he would not bother to travel if he could not take his camera, and many people reading this book will sympathise with that viewpoint but you must be realistic. If you are travelling with other people you may have to accept that you will not be able to devote as much time as you would like to photography: for some holidays or for business trips where you have little free time, 35mm may be a better bet. On the other hand, if you take your photography seriously then you must preserve a fair degree of freedom of action and, if you intend to cover much ground, you should ideally have your own transport. It is far easier to get good pictures if you do not have to worry about carting your equipment on and off buses, and if you can pause for as long or as short a time as you please at any given place.

With these warnings out of the way, there are very few reasons why you should not use medium format very successfully for travel photography at least for less rigorous journeys. If you are on an expedition where every ounce of weight counts then 35mm (preferably Leicas) may be the best bet, though even here Hiroki Fujita treks in the Himalayas with Linhof and Hasselblad, and takes beautiful pictures which more than justify the extra effort. The only difficulty you are likely to encounter is at Customs, where you may have some difficulty in persuading them that you are not a professional journalist and where there may be limits on the number of rolls of film you can import. The old rules of 'five rolls of film or one dozen plates' still exist in some places, and although these rules are rarely enforced, it only takes one customs officer who has got out of bed on the wrong side to make life difficult, and it is obviously easier to stay under the limit if you have 36-exposure rolls rather than 120 (though 220 is a useful option if your camera will accept it). Having said that, I have never had any more trouble from carrying medium-format gear and 120 film than I have with 35mm, and I very much doubt that you will either. To avoid the dreaded X-rays, which can and do damage film, carry your film separately in a clear plastic bag, and whip it out before you let them X-ray your camera case. That way, they get something to X-ray, and your film is safe. At the time of writing this trick has always worked, even in the ferociously security-conscious countries of the Middle East. Of

course, film in the camera is at risk, but you can always travel with empty cameras.

The other thing which worries people, security, is both less and more of a problem than you might think. Although I have had 35mm kit stolen, I tend to keep a closer eye on the more valuable 120 gear, and have not — to date, touch wood — had any problems. In places like New York City, you just have to live with the possibility that you might be robbed; it does not happen often, but it can happen. In other places, such as Rome or Calcutta, you can safeguard your equipment reasonably certainly by keeping an eye out for sneak thieves and snatchers. If you look like a difficult prospect then they will probably try their luck elsewhere! You should, however, always insure your equipment for its full value. Most travel insurance policies are a bad joke, because they have very low limits for individual items, so low that they are often insufficient to pay for a single lens. If you do not travel too much, you can usually get world-wide coverage for non-professional use for up to four or six weeks a year as a low-cost (or even free) extension to your household insurance policy. Alternatively, take out a special camera policy. The insurance premiums may seem steep, but they do soften the blow if you are robbed!

Possibly, the ideal cameras for travel photography are a brace of Plaubel Makinas, one with the 80mm/f2.8 and the other with the 50mm/f4.5. Light and reliable, with a 6×7cm image and superb image quality, they are no more trouble to carry than 35mm, but they are expensive and they may not meet your requirements. After all, photography abroad is not really that different from photography at home, and the camera that suits you at home should equally well suit you elsewhere. It obviously pays to consider the type of photography you intend to do: I vacillate between my Mamiya RB67 and my Linhof Technika 70, preferring the Linhof for architectural and action shots, and the Mamiya for more general views. Incidentally, it is quite possible to use the rising front on the Technika when hand-holding the camera: a little experience will allow you to judge how much foreground will be lost, and how much more of the upper part of the image will be brought in. If you use the wire frame-finder, all you need to do is mentally allow exactly the same alteration in that as the amount of movement on the front standard. For example, with the front standard raised 1cm, mentally chop off the bottom centimetre of the image in the frame and add on a centimetre at the top: this is surprisingly accurate.

If going somewhere off the beaten track, then consider using a mechanical camera rather than an electronic one.

For me, sunset is the most beautiful time in the desert, but a sunset on its own never amounts to much. Putting a cactus in front of it leaves you in no doubt about where you are, and creates a picture with far more impact. *(Mamiya RB67, 50mm Sekor: EPR)*

Although electronic cameras are inherently more reliable than mechanical ones, if they do fail you, you may be in trouble, whereas a local repairer can usually fix a mechanical one. At the very least, always carry a *tested* spare battery. Even a new battery out of the pack can fail, and many have been known to do so.

Because of the extra cost per exposure of 120 film, and the more frequent reloading, and the fact that the weight of the camera is unlikely to be negligible, it is usually best to have a fairly clear idea of what you want to photograph. This is, of course, equally true of 35mm, but the incentives

179

are not quite as great! If it turns out that there are other things there you want to photograph, then so much the better. I once turned up at a Tibetan monastery, expecting to photograph *thangkas* (religious paintings), but found that it was the 'open day' for the parents of all the young novices, some of whom were only seven or eight. I could photograph the *thangkas* at any time, but an open day like this was another and rarer matter, so I concentrated on the food, the parents, and the games the young novices played.

Your local library is one of the most useful sources for ideas on subjects. Another can be the nearest discount bookshop, which will often have remaindered picture-books: these bookshops are an excellent source of illustrated books of all kinds, and as the photographs in them are often taken with medium-format equipment you can learn a great deal about photography by studying them.

If you are being really thorough, or if you enjoy that sort of thing, you can buy a detailed guide to the area you are visiting and plan an itinerary, complete with a list of possible shots. At the very least you should list the subjects which you want to photograph. Try to avoid being influenced too much by the pictures that you see, or you will end up making nothing but slavish copies of other people's pictures.

Although the subjects you can cover abroad are much the same as those you can cover at home there is one thing in particular to avoid, and one thing to try to do. The thing to avoid is overshooting; for it is all too easy to end up with large numbers of similar pictures of the same subject, which is expensive, wasteful, and makes it very difficult to pick out the best shots. We all do it — my wife and I have what seem like three million pictures of the Ganges bathing ghats at Benares, shot at dawn — but it is possible to make a conscious effort to reduce the problem.

The thing to try to do is to portray exactly what it is that makes a place unique — the architecture, the shops, the people's clothes, whatever. Some of these will be small, everyday things; an Indian market is characteristically Indian, though commonplace to its customers. Photograph unfamiliar brands, unfamiliar advertisements, unfamiliar produce and unfamiliar activities, such as people eating at roadside food-stalls offering everything from fresh coconuts to *jellibi*, cooked milk or fresh-pressed sugar-cane juice. In most places a photographer will run into no opposition (though some Muslim countries can be awkward), but you may well be asked for tips. This is a difficult area and one which you will have to work out for yourself. I have found that Polaroid Land pictures always go down well in any country, and that carrying a bundle of pencils to

180

If you only have a short time in a place then it is a law of travel photography that you will find the thing you wanted to photograph is disfigured with road works, mobile cranes or — scaffolding. *(Mamiya RB67, 50mm Sekor: conversion from colour, original on ER)*

hand out to children in Third World countries provides a tip which is morally unexceptionable and very welcome, but rarely leads to demands for more. In richer countries I personally don't believe in tips.

As well as these local sights there are always the grand 'Set Pieces' such as the Taj Mahal, the Eiffel Tower, the Statue of Liberty, Big Ben, and so forth. If you find it difficult to get a picture of these places then buy a few postcards. These will usually give the best 'safe' shot, and you can then try for something a bit more original and adventurous, secure in the knowledge that you have the basic picture in the bag. Do not neglect these 'cooking' pictures, because other people are usually keen to see them, and if you want to try your luck at stock photography (Chapter 17) then they are often essential. There are also the unexpected sights. I have already mentioned the little Tibetan monks, and staying with India there are such

181

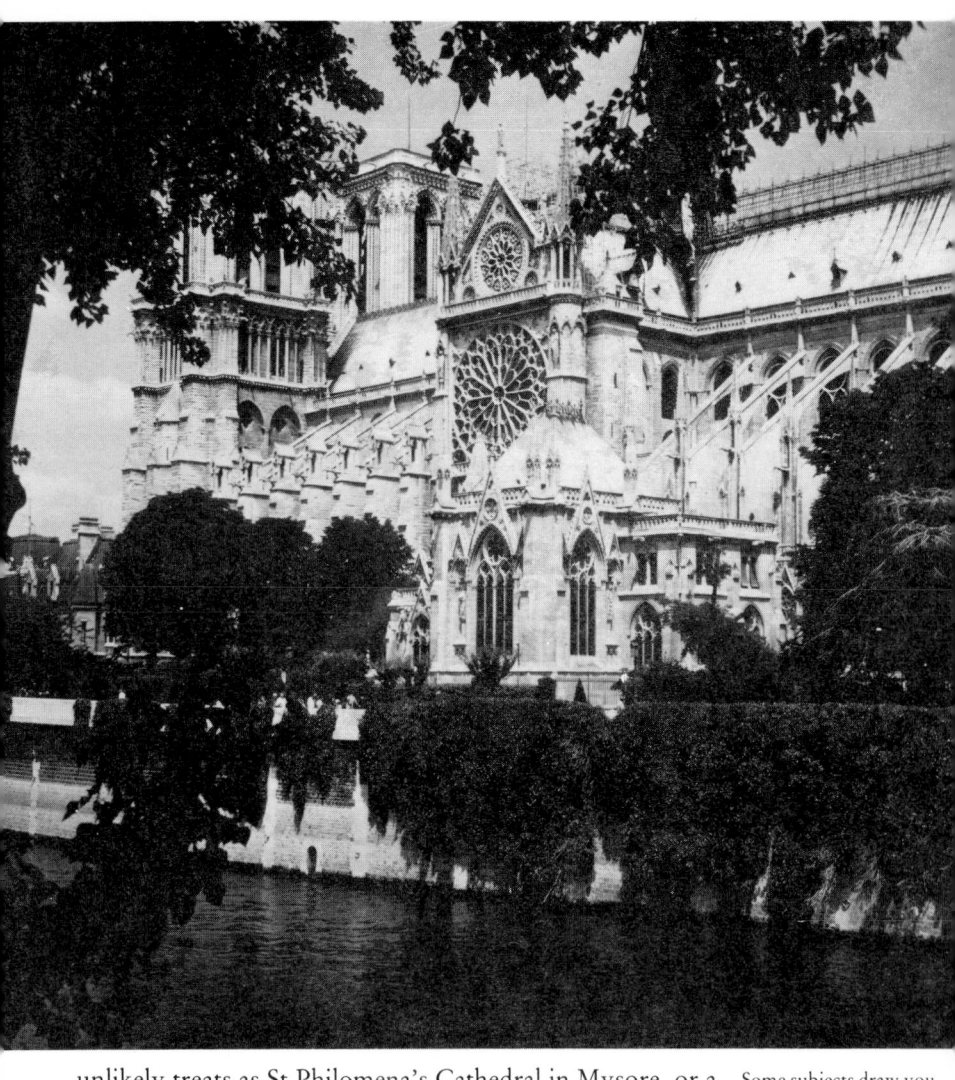

unlikely treats as St Philomena's Cathedral in Mysore, or a zoo in the same city where tigers sun themselves on the other side of a ditch which looks completely inadequate to stop them leaping across and devouring you if they feel like it, they must be well fed! Or, in Delhi, there is Jai Singh's observatory, an amazing collection of apparently abstract sculptures which are actually sophisticated non-optical astronomical instruments: their sheer size gives them their accuracy. A local guide book, or even a guided tour, can be invaluable: when it comes to tours, it is best to hire a taxi so that you can stop for as long or as short a time as you wish in order to take pictures, and so that carrying your equipment is not too difficult.

Some subjects draw you back again and again. I go to Paris at least once a year, and I always find another picture of Notre Dame. (*Mamiya RB67, 90mm lens: conversion from colour, original on ER*)

Never get so serious about your photography that you cannot take pictures just for fun, like this photograph of a classic snap-shotter at one of Dartmoor's famous 'clapper bridges'. I was taking stock shots with the Linhof Technika 70 when I saw this little cameo, and could not resist it. *(Planar 100/ 2.8: conversion from colour, original on ER)*

Although I have taken most of the examples in this chapter from India, I could have done the same for many other countries. In California, my wife and I hired a car and drove down to Tucson, Arizona, then up to the Grand Canyon and on to Las Vegas before returning to Los Angeles, where we were based. Perhaps the least organised tour we ever took was in Portugal, when we simply set off on a motorcycle and wandered through the north as well as the south. Wherever we stopped, we went to the local tourist office (the travel photographer's best friend) and picked up a handful of brochures. We also asked about local sights and attractions at the hotels and *pousadas* where we stayed. We got a lot of good pictures, but we shall get even more when we go back, because we now know what to look for, and what we missed the first time round.

20 · Wedding Photography

Wedding photography — or the photography of any ceremonial occasion — is a subject to be approached with some trepidation. There is no chance of a reshoot and unless you are absolutely sure you can deliver the goods, you should never undertake to photograph anyone's wedding. The only exception is if you are *sure* that if you do not photograph the wedding, no-one will, or at the very least, that no-one will do a better job than you will. I must confess that I have only ever covered two weddings, both under that latter condition. The results were perfectly acceptable, but I would not want to shoot another. The nervous strain is just too great, and I know that a good professional hack can obtain — without even trying — the kind of results which require real effort on my part. This section is, therfore, derived mainly from the advice of others rather than from my own experience.

As a commercial exercise — if you are convinced that you can deliver the goods — you have two choices. One is to set up on your own account, and the other is to work for an established photographer. The attraction of the former is that you get all the profits, whilst the attraction of the latter is that much of the work is done for you — the advertising, the showing of samples, the taking of the order and fixing of the price, the processing and the delivery. The income, though, is likely to be very much lower, and indeed some companies pay so little that by the time you have met your costs you discover you have been working almost for free. If I shot weddings, I should undoubtedly work for myself, and if you decide to go ahead with this form of photography then this is what I have assumed you will be doing here. The independent approach also gives you a greater feeling of responsibility and commitment, which is only fair to the people who are buying your skills. Do not set your prices unrealistically low. You may not wish to set them as high as some of the more expensive photographers around, but if you do a realistic costing of film, processing, mileage and time (including selling time, processing time, etc) it should show you that there is a lot more to professional photography than recovering the cost of your film!

If you are taking pictures as a non-commercial undertaking, you should come to a clear understanding about who is

The standard pictures, such as the bride and groom together, may seem easy — but note how difficult it is to hold detail in both the bride's dress and the groom's dark suit, quite apart from achieving a pleasant composition. (*Hasselblad*)

paying for what. What I did was to take the pictures and pay for the film and proofs as a wedding present, on the understanding that everything else — albums, final prints, etc — were the responsibility of the bride and groom, or whoever else wanted prints.

If you do want to shoot weddings (or at least, a wedding), the most important thing is to be methodical. Work out a shot list with the couple. They will probably not have a very clear idea of what they want so base the list on the following 'standards' in the panel for a typical church wedding.

Often, the most successful photographs from a pictorial point of view are individual studies — but this does not absolve you from the need to take the 'cooking' pictures as well. A touch of soft focus is often useful, especially if you are using fill-in flash, where it takes away the harshness.

Standard Photographs for a Church Wedding
1 Bride getting out of car
2 Bride on father's arm
3 Walking down the aisle
4 Kneeling at the altar
5 Putting on the ring
6 Signing the register
7 Couple at the church door
8 Group portrait with the immediate family
9 Group portrait with family, best man, and bridesmaids
10 Group portrait 'all in' — free for all
11 Cutting the cake

Although the list of shots is in chronological order, the pictures are not in order of importance. The group portrait with the immediate family is probably the most important, followed by the signing of the register, the couple at the church door and the cutting of the cake. If you are not a friend of the family, you may not be going to the reception, so cutting the cake may have to go. If you are going to the reception then try to stay sober enough to take all the necessary pictures. This is a serious point, especially at an old friend's wedding! If you are being paid to cover the wedding, you should also take care to dress appropriately. Friends can forgive a lot but there is no reason why paying customers should forgive anything. You do not have to wear morning dress, but nor should you turn up in jeans and anorak, which is far from unknown.

The shot list given is appropriate to a typical English church wedding but may require considerable modification. For an American wedding, for example, the tossing of the bouquet would be an essential shot, and for a Jewish wedding you would want the breaking of the glass, while for Greek Orthodox the pinning of money to the clothes of the bride and groom would be expected. The scope for pictures at civil weddings is normally considerably less, though the signing of the register, the family (and other)

groups, and the cutting of the cake are normally the same.

There are also all kinds of additional shots. You may want to photograph the bridesmaids and page-boys separately, either formally or informally (informal pictures of children at weddings are normally very well received), the bride with her bridesmaids, the groom arriving in his car, the going-away for the honeymoon (with the bride in her going-away dress), and so forth. The real difficulty lies not in getting these pictures, because most people are prepared

to wait a reasonable length of time for the photographer, but in making the list in the first place — and even this is not particularly difficult if you go through a plan of the ceremony and festivities with the couple. You must also seek the permission of the vicar, priest or whoever; some allow photography during the service, some allow reconstructions of selected parts of the ceremony, and some are downright obstructive.

The point about taking a 'reasonable time' is worth repeating, because no one wants to hang around while you fossick around in your gadget bag, change lenses, reload, take meter readings and generally waste time. Have the gear set up, and the settings correct, and bracket to be on the safe side or, if you are using colour negative film, rate it at half its advertised speed, which gives a handsome margin of safety and will, if anything, actually improve the image quality.

The choice of equipment and film is fairly simple. There is a lot to be said for using only a single lens, of standard focal length; for 6×7cm cameras, err on the wide side (90mm) if you have a choice. This eliminates time spent changing lenses and, because you can normally control your distance from the subject quite easily (and tell people who are in the way to move out of it), there should be no problems with needing shorter or longer focal lengths in order to change image size. On the other hand, it may be handy to have a wide-angle in reserve, both for large group portraits in small churchyards and for informal pictures at the reception. Finally, a slightly longer than standard lens (say 127mm on a Mamiya RB67) allows a slightly flatter perspective, which most people find more agreeable for close-ups such as bride and groom together or cutting the cake, etc.

The normal cameras used for wedding photography are reflexes, though some people use other types of camera. As usual, 6×7cm gives the best quality, and it is really only with 6×7cm that you ought to consider ISO 400 film. With smaller formats, grain may be obtrusive even at 10×8in. Otherwise, any camera will do, and many wedding photographers these days are using 6×4.5cm, though even this is pushing your luck with colour negative films at 10×8in enlargements. On-camera flash is also usual, but must be used with discretion if it is not to create horrible hard-edged shadows. A really powerful gun, used with a bounce attachment and mounted on a bracket so that it is as far from the lens as possible, is much better than a small gun mounted close to the lens. Do not neglect the possibilities of fill-in flash for outdoor shots and leaf-shutter cameras are all but indispensable for this, because of the freedom

188

A classic 'how not to do it' picture. This is a snapshot which I took at my brother's wedding, using a Leica with a 35mm lens and Ektachrome. Because I was so far back, the wedding group is tiny, and the grain structure of the Ektachrome is really not acceptable in this application — and colour print film would be worse! The wedding photographer who posed the group got a far better picture of the same subject, by using the right equipment at the right distance. The picture does however illustrate the diversity of expression that you have to contend with in a large group.

they give to vary both aperture and shutter speed.

Although ISO 100 colour negative film is the standard, rated at EI 50 as described above, you may wish to consider black and white, either in addition or as an alternative. It has a beauty of its own, as well a certain novelty value nowadays, and it also has the enormous advantage that a properly made black and white print on fibre-base paper has a potential life of centuries. Wedding pictures become more valuable as time goes on, and many colour prints are going to look very sickly indeed as the happy couple approach their silver wedding anniversary, never mind their gold.

Finally, remember that rapid processing is essential. It is rarely possible nowadays to have proofs available at the reception, but it is a matter both of courtesy and of commercial sense to have at least one set (and preferably two) ready for the couple when they return from the honeymoon. Use a decent professional lab, many of which offer cut-price wedding packages, and if you think that the couple would be interested, investigate the possibility of 'trick' shots such as the couple imprisoned in a brandy glass (there is no accounting for taste) and of canvas mounting.

189

Index